EARLY SKIING ON
Snoqualmie Pass

To Owen
Take your mother
skiing!

keep skiing!

John W Smith

EARLY SKIING ON
Snoqualmie Pass

JOHN W. LUNDIN

Foreword by David R. Moffett

THE
History
PRESS

Published by The History Press
Charleston, SC
www.historypress.net

Front cover, top: Ad for 1942 Silver Skis race on Mount Rainier showing Army
Ski Troops who were training there and were allowed to compete in local
ski tournaments. *Courtesy of Kirby Gilbert*; ad for Wilson's Business College ski
train to the Milwaukee Ski Bowl. *From the* Seattle Times, *January 23, 1938*;
ad for the 1948 National Ski Jumping Championship tournament at the
Milwaukee Ski Bowl. *Courtesy of the Milwaukee Road Historical Association.*
Front cover, bottom: Milwaukee Ski Bowl at Hyak showing *Seattle Times* ski classes
in the foreground, Rocky Point in the background and the Class A and B ski
jumps and judge's tower on the Ski Bowl's Olympian Hill, which were built
for jumping events for the 1940 National Four-Way Championships.
Back cover: Cle Elum resident Dorothea Voight advertising the ninth annual
Cle Elum Ski Club Jumping Tournament in 1932. *Courtesy of the Maybo family
of Cle Elum, Washington.*

First published 2017

Manufactured in the United States

ISBN 9781467137744

Library of Congress Control Number: 2017944984

Notice: The information in this book is true and complete to the best of our
knowledge. It is offered without guarantee on the part of the author or The
History Press. The author and The History Press disclaim all liability in
connection with the use of this book.

Contents

CONTENTS

Foreword

John W. Lundin worked with a group I headed that started the Washington State Ski and Snowboard Museum on Snoqualmie Pass in 2015. John has written a fascinating history of Nordic and alpine skiing on what became the I-90 corridor, beginning with The Mountaineers lodge near Snoqualmie Pass built in 1914 and extending to ski jumping at Cle Elum and Beaver Lake and skiing at Martin near Stampede Pass, the Seattle Park Department's Snoqualmie Ski Park, the Milwaukee Ski Bowl and other locations.

The Seattle Municipal Ski Park at Snoqualmie Summit, a CCC project opened by the Seattle Park Board in 1934, was the country's first ski area operated by a municipality, and where my family's involvement began in 1938. The Ski Park brought many new people into the sport, even though there were no lifts and skiers had to hike up the hill before they could ski down. Seattle Ski Club's Beaver Lake ski jump on the Summit was one of the Northwest's ski jumping centers, and The Mountaineers' twenty-mile cross-country race from the pass to its lodge near Stampede Pass was said to be the "nation's longest and hardest ski race."

In 1937, Jim Parker and Chauncey Griggs formed Ski Lifts Inc. to build rope tows at Snoqualmie Summit, Mount Baker and Mount Rainier and hired my father, Webb Moffett, to manage their Snoqualmie operations. Beginning in 1938, my parents spent weekends at the Ski Park operating the rope tow and running the concession stand, sleeping in the equipment shed. They earned $10.00 per weekend plus 10 percent of the gross revenue,

receiving $74.75 for their first month's work. The rope tow cost $0.10 a ride or $1.00 a day and made skiing accessible to a larger population.

In 1940, Seattle got out of the ski business and Ski Lifts Inc. took over the Snoqualmie Summit ski area. In 1941, my family bought a controlling interest in Ski Lifts Inc. and kept the Summit ski area open during World War II, surviving as skiers pooled their gas ration coupons to drive to the pass. My family purchased the company's remaining stock after the war and significantly expanded the ski area so it became "Seattle's famed near-home ski area," according to the *Seattle Times*. I began managing Ski Lifts Inc. in the 1980s, and we acquired all four ski areas on Snoqualmie Pass, operating them until we sold to the company Booth Creek Ski Holdings in 1997. My parents were particularly proud of their role in starting Skiforall Foundation (now the Outdoors for All Foundation), which provides ski lessons for those with disabilities. My father was inducted into the Northwest Hall of Fame in 1992 and the U.S. Ski and Snowboard Hall of Fame in 1999.

Snoqualmie Pass is unique since it is close to Seattle and has been accessible by a major highway since the teens. In January 1936, the premiere edition of *Ski* magazine said Snoqualmie Pass was "a mecca for thousands who have but a day to spend." A January 1964 article in *Sports Illustrated* said Snoqualmie Summit attracted 200,000 skiers each winter and had "the greatest number of skiers…of any U.S. metropolitan city and the greatest zest for skiing this side of Japan….Skiing in the Snoqualmie area is about as convenient as picking up a loaf of bread at the suburban A&P." The pass can now be reached in forty-five minutes on Interstate Highway 90 from Seattle.

Snoqualmie Pass is known as the place "where Seattle learned to ski." In *The Ancient Skiers of the Pacific Northwest*, Joy Lucas describes how after World War II, my father helped spur "the mass ski school phenomena" by inviting certified ski instructors to form their own ski schools. The ski schools did their own marketing and brought their students to the mountain, where they were guaranteed customers rain or shine. During the 1960s, there were at least one hundred ski school buses coming to the Summit each weekend. In 1964, around eight thousand Seattle-area students took lessons every weekend from two dozen ski schools. The 1964 *Sports Illustrated* article said, "There is nothing comparable to it anywhere…and there is probably not a ski resort in the West that does not owe a debt to the Seattle ski schools." The Summit at Snoqualmie, the present operator of the Snoqualmie Pass areas, reports that over the last five years, it averaged 50,000 ski lesson days and 500,000 skier days per season.

I know you will enjoy John's book, which captures the excitement and adventure of our sport and helps to preserve the wonderful history of the early days skiing on Snoqualmie Pass.

David R. Moffett,
President, Washington State Ski and History Museum

Acknowledgements

This book was written as part of the author's work helping to start the Washington State Ski and Snowboard Museum that opened on Snoqualmie Pass in October 2015. (See wsssm.org for more about the museum.) A number of his papers on Washington ski history appear on historylink.org, the online encyclopedia of Washington history. The author is a Seattle lawyer who has written extensively about Washington and Idaho history. He learned to ski on Snoqualmie Pass in the 1950s using wooden skis, leather boots and cable bindings, riding rope tows. He was a member of Sahalie Ski Club, one of the original ski clubs on the pass that started in 1931, and has homes in Seattle and Sun Valley.

Thanks are given to the author's colleagues at the Ski Museum: David Moffett, whose family owned Ski Lifts Inc. and all four ski areas on Snoqualmie Pass, and was the moving force behind the museum; Kirby Gilbert, longtime Northwest ski historian; Lowell Skoog, whose website Alpenglow.org contains the seminal coverage of backcountry skiing in Washington; and David Galvin, whose ski history papers can be found at Sahalie Ski Club's website, sahalie.org. Special thanks are given to Artie Crisp, senior editor at The History Press, whose thoughtful guidance and technical assistance helped to bring this book to fruition.

Pictures and materials used in this book were obtained from the following sources, whose cooperation is much appreciated: the Cecelia Maybo family from Cle Elum who provided access to the John (Syke) Brisko collection of memorabilia from the Cle Elum Ski Club, and the Archives and Special

Collections of the James E. Brooks Library at Central Washington University where the collection is now housed; the Moffett family; the Matt V. Broze family, who provided pictures from the 1938 ski jumping tournament at Beaver Lake on Snoqualmie Summit where the famous Ruud brothers from Norway competed; Walter Page; Kirby Gilbert; The Mountaineers; Sahalie Ski Club; Museum of History and Industry (MOHAI); Milwaukee Road Historical Association; Northern Pacific Historical Association; Seattle Municipal Archives; Tacoma Public Library; University of Washington Special Collections; and Washington State Archives.

Further information about Snoqualmie Pass can be obtained in *Snoqualmie Pass* by John and Chery Kinnick and *Snoqualmie Pass, From Indian Trails to Interstate* by Yvonne Prater. Stories about early skiing in Washington can be found in *The Ancient Skiers of the Pacific Northwest* by Joy Lucas, a book written for the Ancient Skiers organization.

The author owes a debt to his mother, Margaret Odell Lundin, who was faculty advisor to Seattle's Queen Anne High School Ski Club from 1938 to 1941 and took her students on the ski train to the Milwaukee Ski Bowl for free ski lessons. Finding the picture of her at the Ski Bowl in 1938 inspired the author to learn about early skiing in the Washington Cascades, which resulted in this book. The picture of his mother is included herein.

Introduction

This book explores the history of skiing along the Snoqualmie Pass/I-90 corridor and surrounding areas from the 1910s to 1950, when it was one of the principal areas where skiing developed in Washington State. It discusses locations that are now "lost ski areas," which were important parts of early skiing in the Northwest, including The Mountaineers Snoqualmie Lodge, built in 1914; Cle Elum Ski Club, formed in 1921; Seattle Ski Club and its ski jump at Beaver Lake off of Snoqualmie Summit, built in 1929; the Seattle Park Board's Snoqualmie Ski Park, opened on Snoqualmie Summit in 1934; Northern Pacific's Martin Ski Dome at the eastern portal of its tunnel under Stampede Pass, opened in 1939; and the Milwaukee Ski Bowl at Hyak, opened in 1938. As Washington's first modern ski resort, the Ski Bowl transformed local skiing, and there the *Seattle Times* provided free ski lessons to Seattle high school students. The book also includes events that helped popularize alpine skiing in Washington, such as the Silver Skis Race on Mount Rainier begun in 1934; the National Championships/Olympic tryouts at Mount Rainier in 1935; the opening of the Sun Valley Ski Resort in 1936; and the 1936 and 1948 Olympic Games, in which a number of Washington skiers competed.

Initially, ski jumping was the most popular winter sport, led by the region's many Scandinavian immigrants. Jumpers toured the Northwest, competing in tournaments at Cle Elum, Snoqualmie Pass, Leavenworth, the Milwaukee Ski Bowl and elsewhere. Alpine skiing did not emerge en masse until the mid- to late 1930s. In the 1930s and 1940s, Washington was

nationally recognized as having some of the best skiing in the country. During the depths of the Great Depression, when people struggled with unemployment and poverty, thousands of northwesterners went to the mountains every winter weekend to ski. Equipment was crude, few lessons were available—so most of the skiing was self taught by trial and error—and there were no ski lifts so skiers had to climb up steep hills before sliding down. Getting to ski areas typically involved long, dangerous drives on narrow icy roads in old cars on bald tires. These factors limited the sport to the most adventurous, athletic and dedicated.

WASHINGTON'S CASCADES MOUNTAINS AND SNOQUALMIE PASS

The Cascades are the major mountain range on the Pacific coast, extending approximately seven hundred miles from British Columbia in the north to Northern California in the south, broken by the Columbia River Gorge, which is the border between Washington and Oregon. The range divides Washington into two different climate zones and has a major influence on weather, climate, agriculture, economics and settlement patterns.

Cascade peaks receive large amounts of annual snowfall because of west–east weather patterns. Freezing levels average about four thousand feet during the winter, and snowfall increases rapidly with small increases in elevation. Moisture-filled air from the Pacific Ocean hits the Cascades, cools down quickly and releases moisture in the form of snow. Mount Baker, in the northern Cascades, holds the record for the largest annual snowfall: 1,140 inches set in the winter of 1998–99.

Snoqualmie Pass, located approximately sixty miles east of Seattle, is the lowest-elevation pass through Washington's Cascades Mountains, peaking at 3,022 feet. It has historically been the major transportation corridor between western and eastern Washington.

Snoqualmie Pass was originally a Native American trail that linked tribes on both sides of the mountains and, later, was a rough wagon trail used by white settlers to transport agricultural products and trade goods. The Sunset Highway, a two-lane unpaved road, was completed over the pass in 1915, facilitating cross-state transportation. Beginning in 1923, the Washington Highway Department started a multi-year project to improve the highway, which included paving, removing switchbacks and blind curves, building new

bridges between North Bend and the Summit and relocating portions of the highway to follow the abandoned Milwaukee Road surface right of way. The Sunset Highway, also known as Primary State Route No. 2, became U.S. 10. These multiple names for the same road confused drivers for years.

In 1931, the road over the pass was kept open throughout the winter for the first time when new snow removal equipment became available, and it was paved from Seattle to the pass by 1934. In the 1950s, the road over Snoqualmie Pass became part of Interstate 90, which extends from Seattle to Boston. In 2009, the Washington Department of Transportation reported that 22,400 passenger and 4,600 freight vehicles crossed Snoqualmie Pass, in spite of its receiving a yearly average of 457 inches of snowfall.

Snoqualmie Pass was the route of the Chicago, Milwaukee, St. Paul and Pacific Railroad (known as the Milwaukee Road), the last of the transcontinental railroads to be built from the Midwest to the Northwest, which was completed in March 1909. Between 1912 and 1914, the Milwaukee Road constructed a 2.3-mile tunnel under Snoqualmie Pass to eliminate the snowbound route of its surface tracks, opening to traffic on January 24, 1915. Laconia, the Milwaukee Road stop at Snoqualmie Summit, was abandoned in 1915. It became the site of the Seattle Park Board's Snoqualmie Ski Park in 1934, later renamed the Snoqualmie Summit Ski Area; it is now known as Summit West. Rockdale was the western portal of the tunnel where The Mountaineers built a cabin in 1914. Hyak was the eastern portal of the tunnel that became the location of the Milwaukee Ski Bowl in 1938.

Milwaukee Railroad's operations west of Montana were abandoned in 1980, and its route through Snoqualmie Pass became the John Wayne Trail, a major recreational facility. Today, Snoqualmie Pass is a major year-round recreation corridor containing four ski areas; the southern boundary of the Alpine Lakes Wilderness area between Snoqualmie and Steven Pass; part of the Pacific Crest trail, which runs from Mexico to Canada; and numerous other trails used for recreation.

NEWSPAPERS, RAILROADS AND NEW DEAL PROGRAMS PROMOTED EARLY SKIING

Local newspapers, such as the *Seattle Times* and the *Seattle Post Intelligencer*, were major promoters of skiing in the sport's early days, publishing extensive articles by writers who were knowledgeable about the sport. Newspaper

coverage of skiing in the 1930s and 1940s demonstrates how important the sport was to the Northwest and gives a unique insight into skiing's early days. The *Seattle Times* has been scanned from 1900 on and is the source of much of the information in this book. Unless otherwise indicated, unattributed references in this book come from period sources such as the *Seattle Times*.

Railroads played an important role in early skiing in Washington. In 1884, the Northern Pacific Railroad was completed from Minnesota to Tacoma, going over Stampede Pass. It supported the Cle Elum Ski Club, providing land for its lodge and ski jumps and transportation to its tournaments. Northern Pacific also promoted skiing at Martin near Stampede Pass and considered opening a major new ski area there in 1939. The Great Northern Railroad was completed in 1893, connecting Seattle with Minnesota over Stevens Pass, and provided access to the ski jumping tournaments at Leavenworth after 1929. The Milwaukee Road provided transportation to ski tournaments on Snoqualmie Pass and opened its Ski Bowl at Hyak in 1938. A world-class ski jump was built at the Ski Bowl in the summer of 1939, and it was used for important tournaments for a decade.

During the 1930s, Franklin Roosevelt's New Deal programs provided valuable assistance to the ski industry by building roads, clearing hills for ski runs and trails and building warming huts or lodges. These include the Civilian Conservation Corps (CCC) and the Works Progress Administration (WPA), along with the Forest Service. Washington ski areas receiving such aid include Seattle's Snoqualmie Ski Park, Deer Park on the Olympic Peninsula, Stevens Pass, Mount Baker, Mount Rainier, Mount Spokane and others. The most significant New Deal ski facility built during the 1930s was Timberline Lodge on Mount Hood in Oregon, completed in 1938.

The ski industry has long been an important contributor to Washington's economy. By 1938, skiing was a $3 million industry, bringing 20,000 skiers to the mountains every weekend, and skiing has grown significantly ever since. According to the Pacific Northwest Ski Areas Association, each year from 2011 to 2014, there was an average of 2,102,488 visits to Washington ski resorts. In 2008, the ski industry contributed $282.8 million directly to Washington's economy and had $727.1 million of total impact. The same year, the ski industry supported 7,600 Washington jobs, generated $593.2 million in employee income and brought in $184.7 million in property and business taxes. According to a 2015 report prepared for the Washington State Department of Recreation and Conservation Office, in 2013, $840,706,347 was spent on alpine skiing in Washington and $110,327,122 on cross-country skiing, for a total of $951,033,346 spent by 1,956,469 participants.

Washington's ski industry is thriving today. There are nine alpine ski areas, six community ski areas, twenty-four Nordic ski centers and one helicopter and snowboarding center. Information about these areas and Washington's eighteen lost ski areas, as well as the state's thirty-nine Olympians (fifteen of them medalists), can be found at the Washington State Ski and Snowboard Museum.

However, the ski industry faces severe challenges from human-generated global climate change. In the last few decades, 272 ski areas have closed in the United States, more than one-third of the country's total, because they could no longer count on sufficient snow. Snow conditions that currently exist at 6,000 feet will likely rise to 7,000 feet by 2025. A two-degree Celsius temperature change means that ski resorts will have thirty-two fewer days each season for snowmaking at 7,400 feet. "Ski resorts are going to have to reconfigure their operations to get skiers and boarders higher than they currently go. Then they are going to have to figure out a way to get them back to the bottom—a bottom that may be more mud than snow in another thirty years. Some resorts may have to go to plastic grass that can be skied on year round," according to one environmental planner.[1]

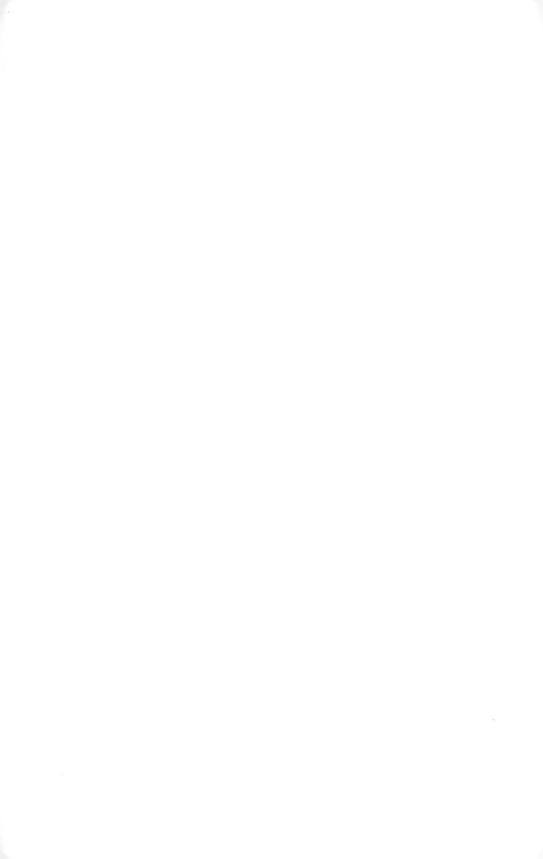

Jumping Dominates Early Northwest Skiing, 1916–1929

Norwegians Developed Ski Jumping

From the 1910s through the 1940s, ski jumping was the most popular winter sport in the Northwest due to the influence of Norwegian immigrants who learned to jump in the old country. Strong interest in alpine skiing did not appear until the mid- to late 1930s, as was generally true elsewhere. When the Winter Olympic Games started in 1924, skiing was limited to Nordic skiing (jumping and cross-country racing). Alpine skiing (downhill and slalom racing) first appeared in the 1936 Olympic Games.

Ski jumping originated in Norway, where it was a part of normal skiing. "Getting from one farm to another in Norway in winter often involves a climb on skis up one side of a hill, and ski jumping developed as a means of clearing obstacles when skiing down the other side." The sport involves athleticism, courage and grace, demonstrated by the fact that jumpers in tournaments receive points for both distance and form. Fridtjof Nansen, the famous Norwegian polar explorer, said, "To see how an expert ski jumper executes a jump is one of the most sublime sights the earth can offer us." Ski jumping in the United States was started by Norwegian immigrants who "once settled, some craved to get the feel of skis on their feet," according to Anson, in *Jumping Through Time*:

> *Ski jumping was introduced in North America by immigrants from Northern Europe. Between 1870 and 1910, more than 1,500,000 Scandinavians*

moved to the United States; a third were Norwegians. Many emigrated from Norway to find employment in the New World. A large number settled in the Northern Midwest, the Far West and the Northeast....The Norwegians brought to their new country a passion for skiing....They organized ski competitions to strengthen their ethnic ties, showcase their abilities, and generate a new sense of belonging to their new country.

By 1930, there were 1,100,098 people living in the United States who were either born in Norway or had Norwegian parents, and 47 percent of them lived in New York, Chicago, Minneapolis or Seattle. Ski jumping was an "ethnic forte" for them according to Helgerud in "Are Norwegian Americans 'Born with Skis?'"

Ski jumping was seen as adventurous, dangerous and exciting, more so than alpine skiing. For non-jumpers, the thought of climbing up a scaffold high above the ground, sliding down at a high speed and then soaring into the air and flying for several hundred feet is terrifying. The *Seattle Times* of February 5, 1937, described ski jumping as "the breath-taking pastime of risking life and limbs on skis." The well-known ski film maker Warren Miller said that "jumping takes great courage…or a low IQ." The famous Holmenkollen ski jump near Oslo, Norway, seen here, demonstrates the challenges a jumper faces.

The casual attitude of jumpers toward their sport was described by Torbjorn Yggeseth in an interview in the *Seattle Times* of February 28, 1960. Torbjorn was a Norwegian student at the University of Washington who was on Norway's Olympic jumping team at the 1960 Squaw Valley Olympics. Torbjorn said ski jumping in Norway is like football in the United States. He learned to jump at age six on a mound of snow his

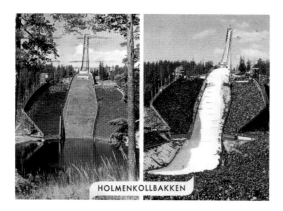

HOLMENKOLLBAKKEN

Postcard photo of the Holmenkollen ski jump outside of Oslo, Norway, one of the world's iconic ski jumps. *Author's collection.*

father made, first jumped competitively at age eleven and "sailed" 432 feet at Flying Week at Oberstorg, Germany, where the hill was engineered for jumps of 125 meters (about 410 feet). He scoffed at the idea of being afraid while flying the length of a football field over frozen terrain. "It's not really as dangerous as downhill skiing….You're only going about 60 miles an hour at top speed. As you follow the curve of the hill, you're never more than 20 feet high. And there are no trees to wrap yourself around. You land at 40 miles an hour. Some skiers land so gently they don't even leave a mark in the snow."

Norwegians have long dominated ski jumping. When Norway's Petter Hugsted won the Olympic gold medal in jumping in 1948 at St. Moritz, he said that winning in the Olympics was easier than winning Norway's Holmenkollen trophy, which is open to all comers. "In the Olympics you jump against four Norwegians, in the Holmenkollen you face fifty."

NORWEGIAN IMMIGRANTS HOLD JUMPING EVENTS IN SEATTLE AND MOUNT RAINIER, 1916–1924

As was true elsewhere, ski jumping in Washington was started by Norwegian immigrants who learned the sport in the old country. They organized events and tournaments here and dominated the competition.

The first organized local jumping event occurred in February 1916 on Seattle's Queen Anne hill following the heaviest snowfall in two decades. Snow began falling on January 31, and in three days, thirty-eight inches of heavy wet snow blanketed the city, piling into five-foot banks. The *Seattle Times* of February 1, 1916, announced, "Whole Northwest Paralyzed by Heavy Snow." The snow led to the collapse of the grandstand at the University of Washington's Denny Field, the dome of the St. James Cathedral in downtown and other damage throughout the area, as the city struggled to deal with "enormous quantities of snow without any adequate snow-fighting apparatus."

Seattle's emergency caused local Norwegian businessmen to come up with a novel idea. They built a ski jump on Queen Anne Avenue, one of the steepest hills in the city, and showed Seattle the "popular Scandinavian sport" of ski jumping, saying, "We believe that skiing is one of the most thrilling sports in existence both from the skier's and the spectator's standpoint." On February 6, 1916, the *Seattle Times* reported that three "Norwegian ski

experts" prepared the hill "into an ideal sliding incline. At the bottom of the incline a jump was built from which the ski jumpers will leap high into the air. Soft snow as a landing area was planted beneath the jump." The jumpers traveled three blocks on a forty-five-degree incline to reach jumping speed. "Reaching the bottom of the hill the jumpers will hurl themselves in the air landing many feet beyond." More than a dozen "crack jumpers" entered the exhibition, and a "ladies skiing event" was held, but they would not go off the jump. Reidar Gjolme had the longest jump of forty-five feet, L. Orvald was second with a jump of thirty-nine feet and J. Sather, O. Peterson and A. Flakstad tied for third with jumps of thirty-eight feet.

Based on the success of the exhibition and a tournament held at the scenic stop on the Great Northern line to Stevens Pass in 1917, "an event unprecedented in America was organized, a midsummer ski tournament." Between 1917 and 1924, summer ski jumping tournaments were held at Paradise Valley on Mount Rainier, since "[a]t an elevation of 5400 feet, Paradise often held snow into July." A cross-country race was added in 1922. A discussion of these early tournaments appears in Lowell Skoog's "A Far White Country," found on his website, alpenglow.org. Olga Bolstad, a twenty-two-year-old "girl ski jumper" from Norway who competed against the men and won, was one of the main attractions from 1917 to 1919. Olga was a sensation and a crowd pleaser. She won the jumping tournament on Mount Rainier in July 1917 and was called "champion of the Pacific coast on skis." When she failed to win the following year, the surprise result was reflected in the headline "Man Defeats Woman in Ski Tournament."

Getting to Paradise Valley was not easy. There was a long drive from Seattle or Tacoma to Narada Falls on Mount Rainier, where the road was closed because of remaining snow. Then the trip "to Paradise Valley is made by saddle horse or by foot. Distance is one and a half miles. Heavy walking shoes and other equipment may be rented at Narada Falls." This did not deter those interested in ski jumping. Some 50 spectators attended the 1917 tournament, over 500 made the difficult journey in 1919 and 1,500 came for the 1923 event. Virtually all the jumpers were Scandinavian immigrants, as were most of the spectators. Mount Rainier is "the second place in the world [after Finse, Norway] where the finest skiing may be obtained during the summer months." The event would be "similar in every detail to that practiced in Norway." Many of those competing on Rainier were "capable of returning to Norway at any time and putting up the stiffest fight for the honors among the men who are constantly on the famous Norwegian tracks."

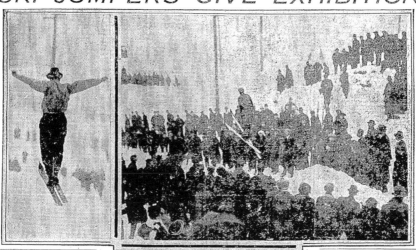

SKI JUMPERS GIVE EXHIBITION

GIL DOBIE WILL COME BACK FOR ONE MORE YEAR

Famous Football Coach, After Conference With President and Dean at Varsity, Consents to Work Again.

By ED R. HUGHES.

GILMOUR DOBIE will coach the University of Washington football team for the season of 1916, and thus fill out the unexpired term of his contract.

He made this decision today following a conference with President Suzzalio and Dean Priest of the University of Washington.

Ever since Dobie arrived in Seattle last week tremendous pressure has been brought to bear upon him to reconsider his resignation, and today he consented.

He will now fill out his contract and will work for the same money he got last season.

Dobie resigned after the game last Thanksgiving Day because he felt that he was going stale and he wanted a rest and a change. He was given the greatest send-off any coach ever got in this section of the country; he was banqueted until he nearly had the gout; the students gave him a gold watch and the alumni used up all the adjectives in the language telling how much they thought of him.

Joy Storm Impending.

All this warmed the cockles of old Dobie's heart and when he came back here last week and some of the biggest men in the city began to put the pressure on him to coach just one more year at Washington, he found it mighty hard to resist. He decided today to take another fling at it and when the students hear about it they will let out a whoop of joy that can be heard down town.

Dobie quit because he found interest in football waning at Washington, due, no doubt to the fact that Washington had won every game it played in the eight years he coached there. Since Dobie quit the Washington students have realized what a big man he is, and when he goes back there he will get an ovation.

Dobie had no intention of coaching at Washington again when he came to Seattle last week, but beginning last Saturday and continuing all day Sunday and this morning, influences were brought to bear upon him that caused him to withdraw his resignation.

It was because there was a chance to get Dobie back that no action was taken by the board of control last Saturday, when Manager Younger was ready to recommend a coach, but when

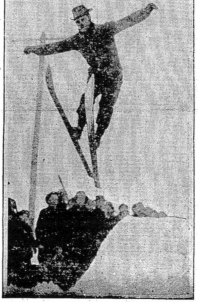

SEATTLE FOLK ENJOYING SCANDINAVIAN PASTIME.

Thawing weather conditions and a light fall of rain yesterday afternoon failed to keep ten masters of the skiing art from giving a scheduled exhibition of ski jumping on the north slope of Queen Anne Hill at Fourth Avenue North.

R. Gjolme, Pacific Coast general agent for the Norwegian American Line, with offices in Seattle, proved to be the best jumper of the day, his longest leap measuring 43 feet. L. Orvald was second with a jump of 38 feet, and J. Sather, O. Peterson and A. Flakstad tied for third place with jumps of 34 feet. The high temperature made the snow soft and adhesive and would not permit the wooden runners to gain a maximum speed.

Yesterday's skiing exhibition was arranged by John Sagdahl, L. Orvald and John Olsen. A "take-off" was built at the bottom of a four-block slide. The exhibition lasted nearly an hour and a half.

The upper left picture shows Flakstad making a jump of 34 feet. The right hand picture is of Gjolme jumping 43 feet and the lower view of Orvald leaving the takeoff.

OREGON RIVERS RAISED BY THAW TO FLOOD STAGE

Swollen Streams Pour Torrents Into Willamette and Columbia and Portland Prepares for High Water.

PORTLAND, Monday, Feb. 7.—Out of the foothills and the Cascade Mountains, swollen streams are pouring their flood waters into the Willamette and Columbia Rivers today and threatening to bring further damage in the wake of last week's snow and sleet storm. Salem and other Willamette Valley towns report small streams out of their banks.

Merchants in buildings near the banks of the Willamette in Portland are moving their goods from basements. Within twenty-four hours ending this morning the Willamette had risen 7.9 feet at Eugene. In Portland there was a rise of 1.8 feet, but the crest is not expected here until Thursday, when a flood stage of 16.5 feet is predicted by the weather bureau. This will inundate the lower floors of practically every dock in the upper harbor and water will seep into the basements on Front Street.

Last night 1.55 inches of rain fell at Eugene and 1.02 in Portland. Today spring weather prevailed here, the sun shining bright and the temperature rising to 51 degrees. Traffic was restored almost to normal.

BOY SNOW SHOVELER KILLED BY LONG FALL

VANCOUVER, B. C., Monday, Feb. 7.—The first Vancouver casualty as a result of the snow storm occurred this morning. Sidney Mills, 12 years old, was shoveling the snow off the roof of his father's home when he slipped and fell forty feet through the skylight. He died on his way to the hospital.

According to the official figures compiled today by Mr. Shearman, the weather observer, more snow has fallen already in February than in all of January. The January fall was 26.40 inches; that of February up to 10 o'clock this morning was 21.25 inches.

SNOW WRECKS ROOF OF EDGEWICK LUMBER CO.

NORTH BEND, Monday, Feb. 7.—Roofs of the dry sheds of the North Bend Lumber Co. at Edgewick have been crushed in by the weight of the snow, causing a considerable loss. The dancing pavilion at Taylor Park has

A *Seattle Times* article about the Northwest's first jumping event held on Queen Anne Hill in Seattle, during the giant snowstorm of 1916, *Seattle Times*, February 7, 1916. *Courtesy of the* Seattle Times *Historical Archives.*

The 1924 Rainier Tournament was scheduled for the same day Norway's Prince Olav reached his majority, a major celebration in the old country. Olav was an all-around sportsman, active in sailing and ski jumping, for which he won nearly fifty trophies. However, the tournament was canceled "owing to the absence of sufficient snow on the ski course."[2]

No more summer jumping tournaments were held at Mount Rainier, and the center of ski jumping shifted to Cle Elum.

CLE ELUM SKI CLUB BEGINS ORGANIZED SKIING IN 1921[3]

Cle Elum, located thirty miles east of Snoqualmie Pass on I-90, was formed when the Northern Pacific Railroad from Duluth, Minnesota, to Tacoma, Washington, was completed in August 1883. Its tracks went through the future town of Cle Elum and then over Stampede Pass into western Washington. A tunnel was completed under Stampede Pass in 1887. Coal was discovered by Northern Pacific engineers in 1886 in nearby Roslyn and in Cle Elum in 1894. Coal mines were developed by a subsidiary of the railroad, and the area became a major coal producing center. Roslyn was incorporated in 1889 and Cle Elum in 1902. Cle Elum's importance as a railroad town was enhanced when the Milwaukee Railroad tracks went by Cle Elum south of the Yakima River as the line was constructed in 1908, before going over Snoqualmie Pass to Seattle. A major Milwaukee Road depot was located in the newly formed South Cle Elum. The Sunset Highway over Snoqualmie Pass was opened to traffic in 1915, further linking Cle Elum to Western Washington.

In 1921, the Cle Elum Ski Club was formed by local residents John "Syke" Bresko, Russell Connell and John Koester to teach the area's youth how to ski and "promote the wonderland of sports that surrounds the community." Club members had to make their own skis as no local stores carried ski equipment. The club was originally called the Summit Ski Club, but its name was changed in 1928 when it incorporated.

The Cle Elum Ski Club has been called the first organized ski area west of Colorado and the "papa of all Northwest clubs." For over ten years, the club's ski area "was a skiers paradise," attracting one hundred to four hundred locals to its hills every weekend. In 1924, the *Cle Elum Miner-Echo* said "there are now hundreds of ski riders in this district." The ski club developed a

Cle Elum Ski Club's warming hut built in 1923 on a ridge between Cle Elum and the Teanaway Valley, two miles north of town, on land leased from Northern Pacific. *Courtesy of the Cecelia Maybo family and Central Washington Special Collections.*

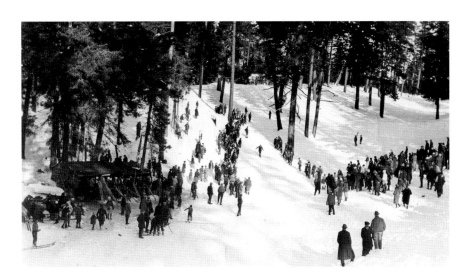

Spectators watching an an early jumping tournament on the Cle Elum Ski Club's Summit Course. The club's warming hut can be seen on the left-hand side. *Courtesy of the Cecelia Maybo family and Central Washington Special Collections.*

new summit course two miles north of town on the ridge overlooking the Teanaway Valley on forty acres of timberland leased from the Northern Pacific Railroad "at a nominal rate." The club built ski jumps, ski runs and a shelter on the site, as well as a two-story lodge in 1926.

Syke Bresko took particular pride teaching local kids to ski and jump, and females participated in all club activities, including ski jumping, as seen in the photos here.

From 1924 to 1933, the club held annual carnivals for its members and ski jumping tournaments that brought competitors in from all over the Northwest and several thousand spectators. Its events included an elected royal court with a queen, ski races, ski jumps, cross-country races, dances, banquets and trophy presentations. Cle Elum merchants donated money and merchandise for the competitions and financed the building of the jumps. The Northern Pacific Railroad provided primary access to the tournaments, from both east (Ellensburg and Yakima) and west of the

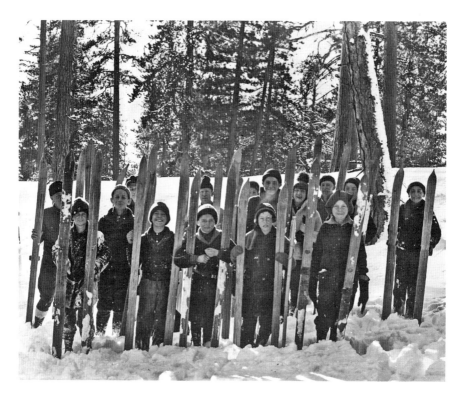

Cle Elum Ski Club kids holding jumping skis. *Courtesy of the Cecelia Maybo family.*

Cle Elum Ski Club, John Bresko and women skiers. *Courtesy of the Cecelia Maybo family and Central Washington Special Collections.*

mountains, since the road over Snoqualmie Pass was not kept open in the winter until 1931.

The club's carnivals included less serious events, including gliding races, costume races, obstacle courses on the club's ski runs (Rocky Run, Camel's Hump, Devil's Dive and Hell's Dive) and a "goose fashion glide." This caused some to accuse the Cle Elum Ski Club of conducting a "freak tournament." At one carnival, Tony Sandona, "the human tumbleweed," captured second place on the Hell's Dive course after remaining upright, "a performance judged by all to have been an accident." On February 19, 1926, the *Cle Elum Miner-Echo* gleefully reported that a local man entered the ladies' gliding course dressed as Mysterious Miss Hanson of Alaska, "fully ten feet tall, wearing yellow rolled stockings, bedaubed with cosmetics and

well gifted in the pursuits of flapperism, but all to no avail so far as the judges were concerned."

Club founder John "Syke" Bresko had grand visions about expanding local skiing. In 1924, Bresko attempted to purchase federal government land at Snoqualmie Pass Summit for a winter sports area. The land was priced at $2.85 an acre, but his bank wouldn't advance the money, claiming that lack of transportation would keep it from being profitable, although later four ski areas were developed on Snoqualmie Pass.

In the first of what would be a ten-year tradition, the Cle Elum Ski Club held a tournament on Lincoln's birthday, 1924. Eleven jumpers entered, and between 1,200 and 1,500 spectators were in attendance. Four professional jumpers from west of the mountains competed, although a high wind made long jumps impossible. Seattle's John Holden had the longest jump of the day, eighty-three feet, but Renton's Arthur Ronstad won the contest on points, since jumpers are graded on both form and distance. "The great crowd scattered about over the flat and over the hillside, witnessed a grand exhibition. Arthur Ronstad thrilled the spectators during one of his leaps

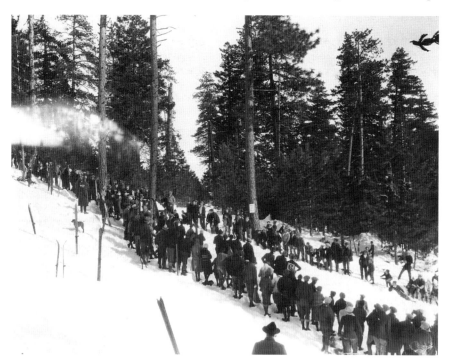

Crowd alongside the jumping hill at an early Cle Elum Ski Club tournament. *Courtesy of the Cecelia Maybo family.*

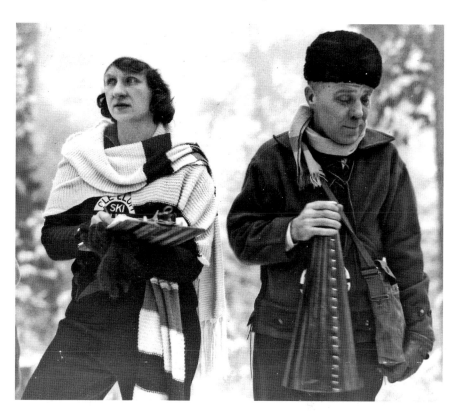

John "Syke" and Tilly Bresko, founders of the Cle Elum Ski Club. *Courtesy of the Cecelia Maybo family.*

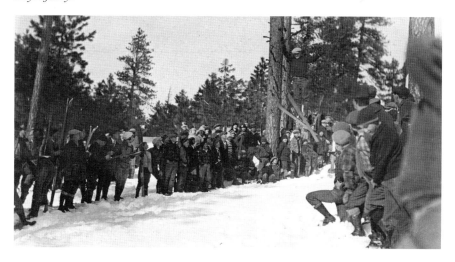

John Bresko jumping off a small jump at an early Cle Elum Ski Club tournament. *Courtesy of the Cecelia Maybo family and Central Washington Special Collections.*

when he struck the course sideways due to the wind and rode over a hundred feet on one foot, nearly straightening up, only to fall after a great effort. He was roundly applauded."

The 1926 tournament was publicized in Seattle at the Frederick and Nelson Department Store, and the *Seattle Times* discussed the tournament, although the paper's sense of geography was a bit off—"Ski Jumpers to Have a Big Day at Ellensburg," it announced. A crowd of one thousand was expected in Cle Elum to watch ten events "on its splendid course two miles south of the city, including three groups of Mountaineers from Seattle and Tacoma and a big delegation from Ellensburg." Cle Elum merchants donated thirty prizes for event winners. "Eighty-four spills were recorded during the events and the Rocky-Run and Hell's and Devil's Dive courses collected considerable skin, some tatters from overalls and shirts, besides administering a few blisters and bruises.…First-time visitors as usual freely expressed their surprises at the magnitude of the grounds and the individuality of the numerous courses." Rudolph Leonard of Bremerton won the expert jumping event with jumps of ninety-four and ninety-three feet.

Cle Elum Ski Club Builds a New Lodge and a New Jump

In the fall of 1926, the Cle Elum Ski Club built a new ski lodge on a ridge between Cle Elum and the Teanaway Valley—up a steep hill two miles north of town—to replace its small warming hut built in 1923, described in the *Cle Elum Miner-Echo* of December 17, 1926. The site was slightly over three thousand feet in elevation and covered with pine and fir trees, with the underbrush cleared to facilitate skiing:

> One of the most desirable things about it is the variety of the course. There are short, gentle slopes for the beginner, and then the courses range upward in length and steepness and difficulty to such an extent that even the most expert jumpers admit that they "get thrill aplenty" out of it. Two of the most difficult parts of the course are Hell's Dive which only those of great experience dare attempt.

A two-story, twenty-two- by forty-foot lodge was built of native pine logs. Eight-foot windows provided a commanding view of the ski course. The lower floor was one large room with a fireplace on one side and windows that took up most of the space on the other walls. The upstairs had dormitories

for men and women. Other rooms could be added without interfering with the beauty of the architecture. The club had 150 members, and "new recruits are being added rapidly." Skiing "is claimed to be one of most fascinating of sports," and the course at Cle Elum is "almost perfect in its possibilities."

> *The Cle Elum climate and nature of the land are both ideal for making skiing here a great attraction for the Northwest. Easily reached by auto or railroad, the only thing yet standing in the way is the matter of the steep climb to the skii* [sic] *course from town. This is expected to be taken care of in some way before another winter, however, and nothing would then be lacking in the way of preparation for a big Skii* [sic] *Tournament for the entire Pacific Northwest next year.*

The program for the Fifth Annual Cle Elum Ski Tournament in 1928 described the scoring system used. Competitors receive one point a foot for distance, twenty points for perfect form, fifteen points off for one hand touching, thirty points off for two hands touching, thirty points off for falls and two falls disqualified the jumper. "As a spectacle, ski jumping has few equals....Jumping from 100 to 120 feet and landing on the toes of Scandinavian snow shoes is a thrilling experience." Skiers got one trial jump and two jumps in the competition.

A crowd of four thousand attended the 1928 tournament, which "proved to be one of the biggest events of its kind ever staged in this part of the Northwest, and the hundreds who saw the program carried out were enthusiastic in their approval of the way in which it was handled." Two special train coaches were added by Northern Pacific Railroad to carry visitors from Yakima to Cle Elum. Carl Solberg and Sigurd Hansen both jumped seventy-six feet, but Hansen of Ione won the Class A event.

For Cle Elum's sixth annual Ski Carnival, in 1929, the club built a large new jump, which increased the level of competition and excitement. Norwegian ski expert Ingle Sneeva gave "useful hints on skiing and jumping." He leaped 100 feet off the new jump—which he would have doubled had the snow been in better condition—and said that "the jump is the best and largest he has seen in the United States." Three thousand spectators hiked one and a half miles up the snowy mountainside to the jump, which was "one of the few natural courses on the coast and what skiers and spectators alike acclaim will be the greatest ski course in the Pacific Northwest." Olaf Locken from Mount Vernon won the tournament, setting a distance record of 165 feet on the "gigantic runway."

On February 21, 1929, the *Cle Elum Miner-Echo* touted the event's success: "The consensus of opinion of all the jumpers was that the hill is excellent. After another year of work by the club the jump should be both sporting and fast. They all want to be back next year and plan to come a week or so early to practice." Three thousand spectators attended the tournament, and four extra coaches were needed on the westbound Northern Pacific train to accommodate the large Seattle crowd returning home.

On February 17, 1929, the *Seattle Times* published a story about the growing popularity of winter sports. Winter sports were being enjoyed at Lake Placid, Montreal, Quebec and St. Moritz in the East and at Mount Rainier, Mount Hood, Lake Tahoe, Banff and Lake Louise in the West, where tobogganing, skating and snow-shoeing have their devotees, but "skiing, which combines the swiftness of tobogganing, the balance of skating and the ability to get about in deep snow, has become king of winter sports."[4]

NEW CLUBS FORM TO PROMOTE SKI JUMPING

In the late 1920s and early 1930s, new ski clubs formed in Washington and Oregon centered on ski jumping. They built ski jumps and hosted tournaments that attracted competitors from all over the Northwest. Soon, ski jumpers had a circuit of tournaments in which they participated: at Cle Elum; the Seattle Ski Club's jump at Beaver Lake on Snoqualmie Summit; Leavenworth Winter Sports Club's jump at Leavenworth; and Cascade Ski Club's jump at Government Camp on Mount Hood, Oregon. New ski clubs at Ellensburg, Mount Baker, Mount Spokane and elsewhere also hosted tournaments and sponsored local skiing.

The Seattle Ski Club was formed by Norwegian immigrants in 1929, to promote ski jumping. In January 1930, Reidar Gjolme, president of the Seattle Ski Club, announced that the club had leased land at Snoqualmie Summit from the Northern Pacific Railroad Land Company for ten years, for "minimal consideration," by paying taxes assessed against the property. The club was incorporated on February 4, 1930, by R. Gjolme, C. Stang Andersen, P. H. Hostmark, Olce Hatlemark and Enoch Andersen. The club used an abandoned Milwaukee Road construction camp as its clubhouse and built a ski jump on Beaver Lake Hill, which became part of Snoqualmie Summit Ski Area (now Summit West).

Gjolme announced, "We have obtained one of the finest sites for the holding of a ski meet in the state....A beautiful hill is on the property, which should result in some new records being set on February 9 [1930, the date of the club's first tournament]." The road commissioners promised to keep the road open to the Snoqualmie Summit so spectators could drive to the event. The Seattle Ski Club had two hundred members, including former titleholders from other nations and women. The club planned to build a new lodge the following summer that would have "more than 50 bunks for men and will include special quarters for women. It will be the first lodge of its kind in this section" per the *Seattle Times* of January 12, 1930.

The Seattle Ski Club built a ski jump at Beaver Lake using the natural slope of the hill for both the inrun and outrun, unlike ski jumps at other locations where large scaffolds were built to gain elevation and slope that had to be ascended by skiers. The Beaver Lake jump was a hike uphill from Snoquamie Summit, described by different sources as being three-quarters of a mile, one and a half miles and/or two miles. Olav Ulland, a famous Norwegian ski jumper who moved to Seattle in December 1937, described the difficulty of getting from the highway to the Beaver Lake jump in a masterpiece of understatement: "It lays about 3/4 of a mile uphill from the Sunset Highway and the hike to the jumps is not one to encourage attendance."

Beaver Lake was the site of the Seattle Ski Club's jumping tournaments for over a decade, attracting international competitors along with tournaments held at Cle Elum and Leavenworth. The Milwaukee Road transported spectators to its Hyak stop east of the pass, and buses took them back to Snoqualmie Summit where skiers and spectators hiked up the hill to the Beaver Lake jump.

The Seattle Ski Club held its first annual Pacific Northwest Ski Championship, for amateurs only, on February 9, 1930, the "largest event of its kind ever held in this section." Hans-Otto Giese, "holder of a number of ski records in Germany as well as many local marks," made the first jump in preparation for the tournament. Giese, who immigrated to Seattle in the 1920s, was one of the few non-Scandinavian ski jumpers in the Northwest, although he became better known for his backcountry skiing and climbing. In the 1930s, he was president of the Seattle Ski Council, coordinated high school ski races and was "instrumental in systemizing high school ski competition." Beginning in 1935, a trophy named after him was given to the outstanding high school ski team. Giese was inducted into the Northwest Ski Hall of Fame in 1998.

In 1928, the Leavenworth Winter Sports Club was formed. Leavenworth was a stop on the Great Northern Railroad line east of Stevens Pass that connected Minneapolis and Seattle in 1893. In 1928, a ski jump and toboggan run were built on the northern outskirts of town by twenty-three volunteers who contributed $60.50 to buy materials and worked for twenty-seven days, using lumber donated by the Great Northern Lumber Company. By early January 1929, five hundred people were using the course. "Only a few dared to tackle the 'big ski course,' but many tried the amateur jumping course." The club's big jump was described by Roe in *Stevens Pass*:

> *The hill was 375 feet high from the top to bottom of the landing slope, as tall as a thirty-story building. Its slope was more than 53 percent, so steep that workers had to pack the snow to keep it from sliding off. Another 700 feet constituted the "runoff." A 240 foot trestle extended from the take-off point toward the starting point, crossing a deep ravine in the hillside. The supporting poles varied from sixteen to thirty-two feet and were dragged up the hill by men and tractors.*

The first Leavenworth Winter Sports Club tournament was held in February 1929, admission was twenty-five cents and one thousand spectators attended. The event attracted expert jumpers Sigurd Hansen of Ione, national champion in 1913; Walter Anderson of Leavenworth; and S.A. Anderson and Vic Anderson from Cle Elum. Hansen won with a jump of sixty-five feet, and Anderson finished second.

In 1930, the club opened a hill for downhill skiing. Its big ski jump on Bakke Hill was opened in 1933, built at a cost of $6,000 (mainly in contributions of labor and materials) and named after Hermod Bakke, a ski jumper from Hurum, Norway, who moved to Leavenworth in 1932. He designed its big jump and became an integral member of the Leavenworth Winter Sports Club. The jump's critical point of seventy-three meters made it one of the largest ski jumps in the country. It was easily accessible from the road and did not require a long uphill hike to reach like the Cle Elum jump and the Seattle Ski Club's jump at Snoqualmie Summit. This was emphasized by the club's ads for its tournaments, which said Bakke Hill was "the world's most perfect hill" where one could "drive all the way."

Leavenworth became one of the country's premier jumping sites, hosting a number of U.S. jumping championships, and was the site where multiple distance records were set. Leavenworth could be reached from Seattle

and Everett on Great Northern trains, which provided transportation to tournaments until World War II.

In 1928, the Cascade Ski Club of Portland was organized and secured the rights for a ski jump on Mount Hood at what was called Multopor Hill (a contraction of Multnomah, Oregon and Portland). A jump was built on a natural hill with a "cribbage of timbers used to sustain the takeoff geometry." The club's first tournament was held in 1929, involved jumpers from Oregon clubs and was watched by 3,600 spectators. In 1930, the Cascade Ski Club hosted the first jumping championship sanctioned by Pacific Northwestern Ski Association.

In April 1930, the Mount Baker Ski Club (which had formed in 1927 to take advantage of the newly opened Mount Baker Lodge and new highway into the area) held its first jumping tournament. In April 1931, the club held a meet featuring uphill, downhill and cross-country races. A fire destroyed the Mount Baker Lodge on August 5, 1931, setting back skiing for years. A two-day slalom tournament was held there in May 1935.

The Spokane Ski Club formed in 1929, and in 1932, it built a lodge on eighty acres of land on Mount Spokane with a 135-foot jump and a slalom hill. The club hosted ski tournaments in 1933, 1934 and 1950.[5]

Ski Jumping Tournaments Are Held at Multiple Sites, 1930–1936

*D*uring the 1930s, ski jumping was dominated by Norwegian immigrants who competed against one another in tournaments throughout the Northwest. These tough men drove on icy roads, often on successive weekends, to Cle Elum, Snoqualmie Pass, Leavenworth and Mount Hood to compete for the glory of the sport, as there were no monetary prizes. They were true amateurs, although some of the best jumpers had their travel expenses paid by tournament sponsors. Competitors often had to hike long distances up hills to reach the jumps. At places like Cle Elum, they had to climb up steep scaffolds to reach the take-off point. After each jump, they had to hike up the hill again and repeat the process. Local newspapers provided extensive coverage of ski jumping events in the Northwest, elsewhere in the country and in Europe, and the best ski jumpers were celebrities, much like professional football quarterbacks are today.

Tournaments attracted thousands of hardy spectators who traveled long distances by car or train, hiked up steep hills through the snow to reach the jumping sites and stood outdoors for hours, often in snowstorms, to watch the competitors fly off the jumps. Webb Moffett, who later owned and operated ski areas on Snoqualmie Pass, said, "Thousands of people used to hike up from the highway at Snoqualmie to Beaver Lake to watch those crazy Norwegians fly through the air at competitions put on by the Seattle Ski Club After the meet, it was always a thrill to watch the jumpers come down, straight-running Municipal Hill by leaping from hillock to hillock."[6]

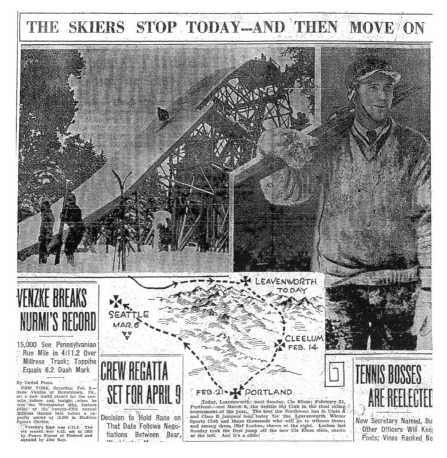

THE SKIERS STOP TODAY--AND THEN MOVE ON

VENZKE BREAKS NURMI'S RECORD

15,000 See Pennsylvanian Run Mile in 4:11.2 Over Millrose Track; Toppiho Equals 6.2 Dash Mark

By United Press.
NEW YORK, Saturday, Feb. 6.— Gene Venzke of Boyerstown, Pa., set a new world record for the one-mile indoor run tonight when he won the Wanamaker Mile, feature event of the twenty-fifth annual Millrose Games held before a capacity crowd of 15,000 in Madison Square Garden.
Venzke's time was 4:11.2. The old record was 4:12, set in 1925 by Paavo Nurmi of Finland and equaled by Joie Ray.

CREW REGATTA SET FOR APRIL 9

Decision to Hold Race on That Date Follows Negotiations Between Bear,

Today, Leavenworth; next Sunday, Cle Elum; February 21, Portland—and March 6, the Seattle Ski Club in the final skiing tournament of the year. The best the Northwest has in Class A and Class B jumpers leap today for the Leavenworth Winter Sports Club and those thousands who will go to witness them; and among them, Olaf Locken, shown at the right. Locken last Sunday took the first jump off the new Cle Elum slide, shown at the left. And it's a slide!

TENNIS BOSSES ARE REELECTEL

New Secretary Named, Bu Other Officers Will Kee Posts; Vines Ranked No

Map showing four ski areas holding ski jumping tournaments, *Seattle Times*, February 7, 1932. The jumper in the photo is Olav Lochen, jumping at Cle Elum. *Courtesy of the* Seattle Times *Historical Archives.*

From the 1920s on, most jumping clubs, including those in the Northwest, used a common rating system: Class A (elite), Class B (top status not yet earned), Class C (under eighteen years of age) and Veterans Class.

1930: THREE SKI CLUBS HOLD JUMPING TOURNAMENTS, PNSA IS FORMED TO OVERSEE COMPETITION

The Seattle Ski Club's first tournament held on Snoqualmie Pass in 1930 drew thirty-three entrants, including Ole Hegge of the Bardu Ski Club of

Norway, winner of the King's Cup in 1927. Entrants represented the Seattle Ski Club, Cascade Ski Club of Portland, The Mountaineers, University of Washington and Leavenworth Winter Sports Club. Buses carried spectators from Seattle to the Summit for three dollars to see "air-hoppers" compete, where admission was twenty-five cents. Reidar Gjolme, president of the Seattle Ski Club, said the hill was one of the longest in the United States, and "spectators will have a chance to see the most spectacular tournament ever staged in the west."

The day of the tournament, Snoqualmie Pass road was "thrown open" by the highway department, and no passes were necessary to continue beyond Camp Mason, which was a requirement for winter travel over the pass before it was kept open in 1931. Parking was a thirty-minute walk from the hill, and hundreds of spectators braved the snow. The tournament was won by Erling Thompson of the Seattle Ski Club, although E. Finsberg of Kent had the longest jump of 151 feet.

In 1930, the Cle Elum Ski Club featured "one of the steepest takeoffs in the world," its ski jump was "one of the most hazardous in the world, 6% steeper than any in Norway, which was the center of ski jumping," and the event helped to put the ski area on the map. Invitations had been sent to "internationally famous ski jumpers, and new records" were expected. Olaf Locken of Conway leaped 165 feet in a special exhibition, "the longest standing jump executed in the United States this year," thrilling three thousand "intrepid spectators who trudged up the snowy mountainside to the event." Ivan Finsberg of Cle Elum jumped 150 feet, but the event was won by Howard Dalsbo with a jump of 119 feet, as points are given in ski jumping on both distance and form. A picture of Dalsbo flying off the jump was published in the *Cle Elum Miner-Echo* of February 21, 1930, with the caption "Yippee! He's up in the air and going places!"

Leavenworth Winter Sports Club held its second annual Winter Sports Carnival on February 23, 1930. Twenty-six jumpers competed in a Class A event on a jump located half a mile out of town designed by Sigurd Hansen, a former world's champion. Nels Nelson, the champion jumper from Revelstoke, British Columbia, who held the world's record of 240 feet, won the tournament in front of a record crowd of 3,550. Fred Finkenhagen of Vancouver, who had the longest jump of the day of 108 feet, was second, and Sigurd Hansen came in third, according to the *Seattle Times*, February 24, 1930.

In 1930, the Pacific Northwestern Ski Association (PNSA) was organized by six ski clubs to sponsor regional jumping and cross-country

Northern Pacific ad for a 1930 Cle Elum Ski Club tournament, *Seattle Times*, February 19, 1930. *Courtesy of the* Seattle Times *Historical Archives.*

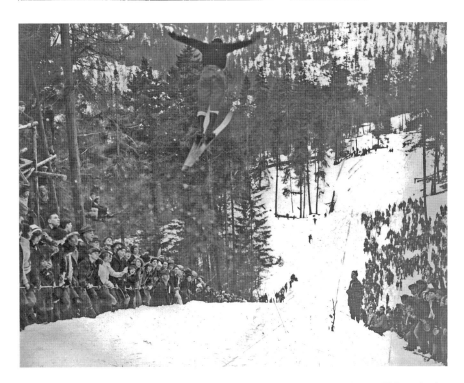

Howard Dalsbo jumping at a 1930 Cle Elum Ski Club tournament, "Yippee! He's up in the air and going places." *Courtesy of the Cecelia Maybo family.*

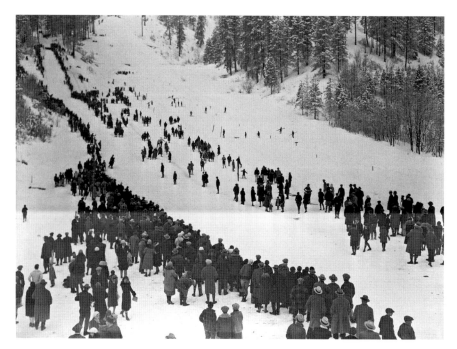

Above: Ski jump and crowd at the 1930 Leavenworth Winter Sports Club tournament.
Courtesy of the University of Washington Special Collections.

Below: Man posing on ski jump at the 1930 Leavenworth Winter Sports Club tournament.
Courtesy of the University of Washington Special Collections.

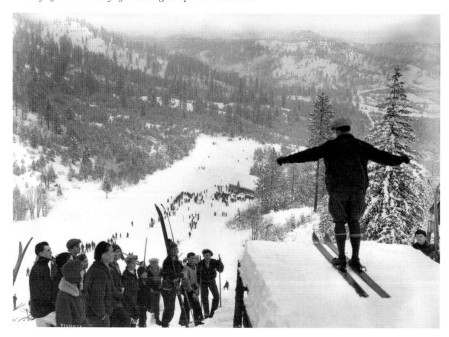

competitions, coordinate calendars and keep competition at a high quality. The clubs included Cle Elum Ski Club, Seattle Ski Club, Leavenworth Ski Club, Bend (Oregon) Skyliners, Hood River Ski Club and Cascade Ski Club of Portland. PNSA established standards for ski instructors, pioneered their testing and became the regional organization for the National Ski Association for sanctioned ski competitions in the Northwest. PNSA promoted competitive skiing, not recreational skiing. "Our interest centers on competitive skiing… Recreational skiing is something else. We encourage it, but competitive skiing is the reason for the existence of this association." The PNSA charter did not include alpine skiing until 1934.[7]

1931: RIDE THROUGH A COAL MINE AT CLE ELUM, REGIONAL TRYOUTS FOR THE U.S. OLYMPIC TEAM, NEW LODGE AT SNOQUALMIE SUMMIT

Newspaper articles show how skiing was growing in the Northwest. On January 25, 1931, the *Seattle Times* said that until recently, *Vogue* magazine carried pictures of St. Moritz in January and February:

> *Now Seattle and its slightly less pretentious friends, Portland and Vancouver, have discovered winter in seven or eight places; the western haut monde migrate every weekend in cars and gets its fill of skiing, of tobogganing, of unexpected falls.…And everyone skis.…*
>
> *Then there are the expert skiers, some of the most foremost in the world today, members of the Seattle Ski Club and nucleus of the decidedly thrilling winter meets. The headquarters of the Ski Club are almost as picturesque as the members. They are in an abandoned construction camp in Snoqualmie Pass where the members, including almost the whole Norwegian community, have built a timber jump with one of the steepest landings in the world—a hill three or four degrees steeper than the famous Holmenkollen Hill in Norway. And the tournaments—pageantry and color—with expert ski jumpers and lovers of winter sports coming from Canada, from the East, and even from abroad. The meet at Leavenworth, in the Stevens Pass this weekend; the winter sport tournament at Banff and Lake Louise in February; and the annual meet in Snoqualmie Pass in March. Each one with its following of two or three thousand people, and the bracing thrill of the cleanest of sports.*

At the third annual Leavenworth tournament in January 1931, "The skiing talent of the Northwest assembled for the first of a rapidly increasing series of ski meets." Entrants from Washington, Oregon and British Columbia competed for thirty prizes. Women jumpers participated in tournament, as pictured here. The "Three Musketeers" of Hollyburn, British Columbia, dominated the Class A competition: Nordal Kaldahl, Tom Mobraaten and Henry Solvedt. They were born in Kongsberg, Norway, and immigrated to Vancouver, where they joined the Hollyburn Pacific Ski Club and competed all over the Northwest for years. Kaldahl won the 1931 Leavenworth tournament with a leap of 116 feet in a blinding snowstorm.

For 1931, the Cle Elum Ski Club increased the height of its ski jump tower by twenty feet. In addition, the club designed a unique method to provide better access to its jumping site, located two miles up the hill from town: a ride through coal mines operated by a Northern Pacific company, according to Litchfield, *When the World Came to Cle Elum*:

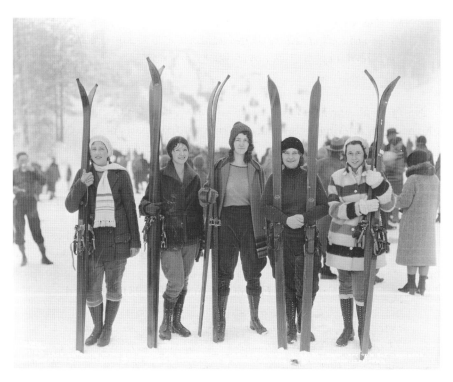

Women ski jumpers at the 1931 Leavenworth Winter Sports Club tournament. *Courtesy of the University of Washington Special Collections.*

Working with General Superintendent of the Mines, Thomas Murphy, they crafted a route through [Roslyn Coal Mine] No. 7's one and three-quarter mile mine tunnel up the mountainside. Spectators would load into the mine cars and then onto tractor-pulled sleds for the last half mile up to the hill. There was an obvious risk pulling civilians through the low clearance mine tunnel, so the club purchased a $100 insurance policy (just in case) and billed the tournament as a two-for-one event. "Here's your chance to ride through a real mine and see world class ski jumping," they said, and the hype worked.

The official invitation to the tournament described the unique attraction:

The transportation which is called Two in One—a ride on the electric tramway through two long-tunnels of the coal mine. This will bring you to within one-half hours walk of the Ski Course or Lodge. You will be able to see the coal on both sides of the tramway through the tunnels. There is no gas or loose rock through this mine. The transportation will be $1.00 from the Railroad station—round trip. 50 cents admission to Ski tournament. Those who walk up will be charged admission of 50 cents—children 25 cents. There are various other events besides jumping—something you don't get on other ski courses.

Northern Pacific advertised a special train to the eighth annual Cle Elum tournament, offering a "spectacular ride through parts of two coal mines to ski course by electric tram." The train left Seattle at 7:30 a.m., arrived in Cle Elum at 10:45 a.m. and left at 5:30 p.m., costing $3.50 round trip. A tractor provided by local merchant M.C. Miller Lumber Company hauled a sled with spectators from the end of the coal mine up the hill to near the site of the jump.

John Elvrum of Portland jumped 128 feet to win the Class A event in a blinding snowstorm that obscured the runway, landing in heavy wet snow on the end-run. Olaf Locken of Leavenworth was second with a jump of 118 feet. The *Cle Elum Miner-Echo* of February 20, 1931, reported:

Over 5,000 spectators converged for Cle Elum's 8th Annual Ski Tournament. Seven passenger trains filled with ski fans arrived from Seattle and another came from Yakima. Some drove over Snoqualmie Pass—the first time ever the pass had been opened for winter travel. And for the first time ever, downtown Cle Elum had a winter traffic jam with the Autorest,

Ski Tournament
WINTER CARNIVAL
Cle Elum ▾ Sunday ▾ February 15
Eighth Annual Tournament — Cle Elum Ski Club

Spectacular ride through parts of
two coal mines to ski course by electric tram.

Special Northern Pacific Train to Cle Elum —
Lv. Seattle 7:30 a. m. Ar. Cle Elum 10:45 a. m.
Lv. Cle Elum 5:30 p. m.

ROUND TRIP FARE $3.50
From King Street Station

Reserve Your Tickets Now at any Northern Pacific office

Northern Pacific Railway

Left: Northern Pacific ad for the 1931 Cle Elum Ski Club tournament, *Seattle Times*, February 2, 1931. *Courtesy of the* Seattle Times *Historical Archives.*

Below: A tractor-pulled sled taking spectators the last half mile up the hill after riding through the coal mine during the 1931 Cle Elum Ski Club tournament. *Courtesy of the Cecelia Maybo family and Central Washington Special Collections.*

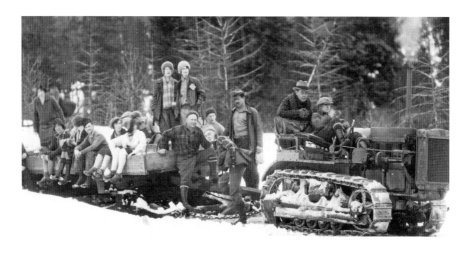

Liberty and Ritz Cafes trying to keep up with the crowds. They were a sight to behold, "gaudily dressed in the bright colors of winter sports garb…and wearing high topped hiking boots…form[ing] a picturesque crowd of merrymakers."

The Seattle Ski Club's 1931 tournament at Snoqualmie Summit was the regional tryout for the U.S. Ski Team for the 1932 Olympic games at Lake Placid, New York, and included jumping and cross-country skiing. The *Seattle Times* of February 19, 1931, had a picture of three women members of the Seattle Ski Club holding jumping skis, "casting a critical eye at the Snoqualmie Pass ski trajectory where the Olympic Games ski tryouts will be held March 1, and finding it excellent." The headline read "Brushing Up Their Technique, They'll Take the Big Jump Soon," indicating that women members were joining their male colleagues in ski jumping. The *Seattle Times* of February 22, 1931, reported:

Northwest ski enthusiasts are particularly fortunate in having in their midst an organization such as the Seattle Ski Club for the purpose of furthering ski jumping. Conceived and originated here by a small band of Norwegian experts, many of whom before coming to Seattle had hung up enviable records in Europe, and joined by many native skiers, the club has fostered the idea of developing a permanent and annual exhibition at Snoqualmie Pass.

The Milwaukee Road provided a special train to its Hyak stop for an expected crowd of eight to ten thousand, with buses taking spectators back to Snoqualmie Summit. It was a "short hike from the Summit to the jump of less than a mile, and although the trail was not difficult or steep, attendees were warned against wearing low shoes or oxfords." Thirty-one Class A jumpers competed on a hill "so steep none but the best will attempt it." Canada was sending a "good sized delegation," including the country's champion and twenty others. The grueling ten-mile cross-country race, "studded with bumps, jolts, cliffs and red flags," stretched "from the Summit at Snoqualmie to the vicinity of Source Lake, and return. Over a broken track, winding through woods and open stretches under snow-laden trees and cliffs, the participants will race to select the Northwest representative in Olympic competitors next winter." Scandinavians made up most of the eighteen who entered the cross-country event.

John Elvrum of Portland won the jumping event. "Elvrum's winning leaps were brilliant, finely finished products of a master jumper" as he

Brushing Up Their Technique
*** *** *** ***
They'll Take Big Jump, Soon

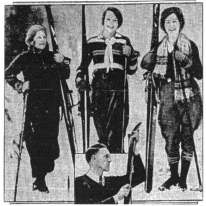

Women jumpers getting ready for 1931 Seattle Ski Club tournament, *Seattle Times*, February 19, 1931. *Courtesy of the* Seattle Times *Historical Archives.*

landed on the "graded surface of the clifflike jump." However, Elvrum was not a U.S. citizen, so he could not compete for the United States. "That counted him out of the Olympic tryouts," although he was on track to get his citizenship two months after the 1932 Olympics. Nordal Kaldahl of Vancouver, British Columbia, was second, but he was a Canadian. "The only American jumpers in the tournament were one or two in the Class B, whose performances were not particularly hot....There never was so successful a ski tournament in the Northwest, or one in which so many brilliant jumpers took the great leap over a forbidding hill," but the tournament failed to yield "a solitary candidate for next winter's Olympic games." The headline in the *Seattle Times* read, "N.W. Fails in Olympic Ski Trials." The tournament was "amazingly successful," with a crowd of ten thousand on hand for the cross-country race and five thousand paying spectators for the jumping event, but it "was not an Olympic test for American jumping."

Seattle Ski Club Builds a New Lodge and Improves Its Jumping Hill

In the spring of 1931, the Seattle Ski Club appropriated $7,000 to improve its facility on Snoqualmie Pass, with $6,000 to construct a new clubhouse on land leased from Northern Pacific that would have sleeping quarters, lockers, showers and an assembly room for members and guests. The rest of the money would be used to expand the club's jumping hill, refurbish its takeoff, correct its pitch, lengthen its run, remove stumps and regrade the landing. The ski jump was designed to take advantage of the natural slope of the hill for both its inrun and outrun, features that can be seen in pictures of the facility.

The club completed its new lodge in the fall of 1931, a three-story structure with a pitched roof, "sheer enough to edge off the heavy winter snow." The first floor had a large lounge with "the customary mountain fireplace." The second floor had a big lounge, convertible to a dining room, with a kitchen in the back that was "large enough to cook food for all the regiments of mountain men who work up appetites on the cross-country loop and the jumping hills." The third floor had a sleeping lounge for two hundred.

In December 1931, Seattle Ski Club inaugurated its "Big Hill," where $1,000 had been spent the prior summer to make its jump "one of the best in the United States....The Big Hill has the sheerest pitch of any in America. All summer long, a diligent crew graded and regraded, took out stumps, smoothed those occasional bumps even the best trained course will develop." Before, the take-off gate had been too sharply accentuated, so that only one 199-foot jump was made. "This year the ground's the limit, and the ground stretches exceedingly far." Ken Binns, the *Seattle Times* ski writer, later described the jump:

> *The architects who packed the course with stiff banks of snow weren't interested in degrees horizontal. They chose the most violent pitch on the*

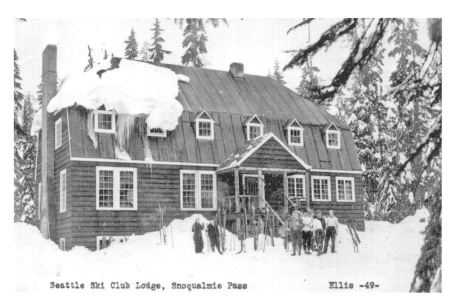

Seattle Ski Club Lodge, early 1940s. *Courtesy of Jack Leeper.*

mountain-side at Summit, built a log take-off, then began the more delicate process of anticipating where a good skier should land. Having discovered that point, a some-what crucial point if you please, they fooled him. They stepped back about ten paces and built another precipice.

When a jumper reached the point of "the trickery of the architects" while flying off the jump, "[r]ight where he begins to drop they have thoughtfully removed the earth. In the case of Snoqualmie, nature assisted materially by providing another hill. So the skier continues to drop. It is this drop which materially adds yards to the ultimate distance the jumper acquires in his medal-seeking." Binns said the Big Hill at Snoqualmie was "surpassed in declivity pitch only by that 43 per cent scaffold at Cle Elum after Cle Elum built its new jump."

1932: Winter Olympics at Lake Placid, Jumping Feud Between Kaldhal and Elvrum, U.S. Jumping Champions Compete in the Northwest, Giant New Ski Jump Is Built at Cle Elum

The Winter Olympics in Lake Placid, New York, were the backdrop to the local jumping tournaments held in 1932. The *Seattle Times* of January 15, 1932, compared quality of the jumpers and the local snow conditions at the upcoming Seattle Ski Club tournament with those at Lake Placid:

Fifty skiers, all able, some brilliant, is an amazing field. And the fifty and more assured of jumping will represent the greatest array of skiers you probably could find in any one section of the United States, which is not at all ballyhoo, as folks will learn Saturday when they see them jump. They seem to flock to the Washington country. They were indulging in sardonic chuckles at the expense of Lake Placid, New York, scene of the Winter Olympic games, if they get any snow. "Why don't they come out here" the skiers demanded. Here they know they can have snow within easy riding distance of Seattle.

During the 1932 season, there was a heated rivalry between Norwegians Nordal Kaldhal of the Hollyburn Ski Club of Vancouver, British Columbia, and John Elvrum of the Cascade Ski Club of Portland,

Oregon, who had split winning honors in 1931. Their competition resulted in Elvrum getting hurt by "overjumping" hills at several tournaments in an attempt to gain more distance. Ken Binns described their "ski feud" in the *Seattle Times* of February 8, 1932:

SKI FEUD. This Kaldahl-Elvrum ski jumping feud promised to last until John Elvrum, the smooth Portlander, either beats Nordal Kaldahl, the British Columbia ace, or jumps off the edge of the world. Elvrum is down to Kaldahl this year, and he's tumbled himself into a hospital once and almost a second time with his daring leaps in an effort to beat his rival. Such do-or-die rivalry really deserves success, but Kaldahl is a hard lad to beat with his smooth consistency on the tiny ribbons of wood that catapult him to championships.

At the Seattle Ski Club's Northwest Invitational Tournament at Snoqualmie Pass, Nordal Kaldahl beat John Elvrum in a blinding snowstorm on the "precipitous slope" of the Snoqualmie Summit's big hill in front of two thousand spectators. Both might go to the national ski tournament the following month at Lake Tahoe, where they could finish first and second, barring accidents.

For the 1932 season, Leavenworth erected a sixty-five-foot tower with three starting platforms and a "well-pitched landing," making "a majestic hill." For the second year in a row, Nordal Kaldahl won the tournament, beating John Elvrum and two former national champions: Sigurd Hansen of Ione (1914) and Carl Solberg of Ellensberg (1915).

Even though the Cle Elum Ski Club had increased the height of its ski jump tower by 20 feet for its 1931 tournament, club president John Bresko vowed to make the jump bigger and better for 1932. Ski jumps later built at Mount Spokane and the Milwaukee Ski Bowl were patterned after the Cle Elum jump. According to Lichfield's "When the World Came to Cle Elum," in the fall of 1931, Cle Elum Ski Club members worked on the ski hill to "make it the most stupendous incline of the Cascades and possibly the entire world" for the Pacific Northwest National Ski Tournament in 1932. Dynamite was used to blast away a huge amount of rock on the course, and a new 75-foot tower was erected with 292 feet of vertical drop and a forty-six-degree ramp. The upper portion of the landing was on an elevated scaffolding using timber from the site and was contoured to match the flight of the jumpers. The jump was on the ridge north of town, with its incline dropping into the Teanaway Valley. The new jump and re-

contoured ski hill cost $5,000, which was donated by Cle Elum merchants. The result was a huge new ski jump that impressed sportswriters, spectators and the jumpers themselves:

In late November of 1931, Bresko led a group of men up the ridge behind downtown Cle Elum. With two feet of snow on the level and four on the hill, they may have snowshoed up the steep road at the end of Columbia Ave., heading some two or so miles to the top of the ridge. The group finally arrived at a huge bowl-shaped skiing area, mostly shaped by nature and fine-tuned by men. That summer a crew and a team of horses had blasted away rock and smoothed and leveled out the lower part of the course. Towering above the bowl—a giant ski jump tower and landing stretching 600 feet down the hill. Bresko's guests from the Northwestern Pacific National Ski Association were speechless. What had been a mediocre ski jump hill was now so perfect they struggled to find words to describe it. For a few short years, this jump was the biggest and baddest in the west and maybe even the whole world, and the much of the credit goes to one man—John Bresko.

Ken Binns described Cle Elum's "stupendous jumping hill" and the first jump taken on it in his article about the 1932 Pacific Northwest Skiing Championships held at Cle Elum:

You never saw such a hill. They took the old hill and buried it under a convincing mass of lumber. They shafted a jumping tower far into the stratosphere, at an almost inconceivable pitch. The tower jerked up into the heavens at a 46 degree angle, 117½ feet above the comparative level of the takeoff. The landing dropped at a 46 degree pitch, 194½ feet from the takeoff to the flat.

It exceeded in ferocity even the Seattle Ski Club's precipice. It was covered with loose snow. But Olaf Locken, member of the Cle Elum club, tested it. He tried it from the tower at first, but the snow impeded him. He failed to clear the nose of the landing and spilled. Then he went to the very peak of the great tower. He sifted down like a galloping ghost, left the takeoff with the singing whine of a diving plane, cleared the nose, but spilled again, though comfortably. His was the premier jump—the first. It showed a condition soon to be remedied, the takeoff, for all its speed, needed 16 more feet of nose. "That," said Olaf when the test was over, "was the fastest takeoff speed I ever made. With 16 feet more on the nose of the takeoff, a 200-foot jump won't be at all impossible."

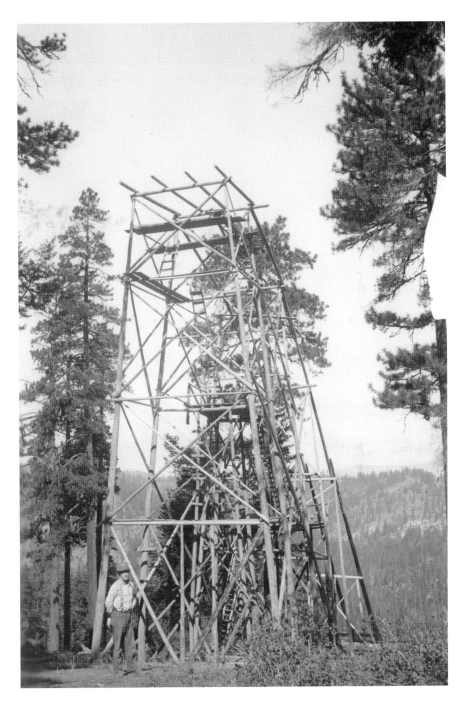

Cle Elum Ski Club's giant new ski jump under construction in fall 1930, with "one of the steepest takeoffs in the world." *Courtesy of the Cecelia Maybo family and Central Washington Special Collections.*

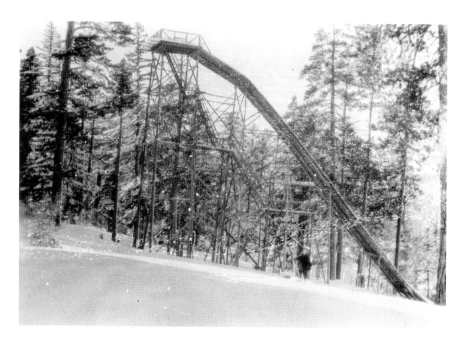

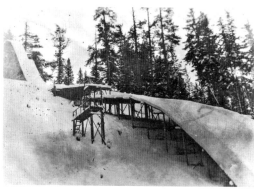

Above: Cle Elum Ski Club's giant new ski jump was called "the biggest and baddest in the west and maybe even the whole world." *Courtesy of the Cecelia Maybo family and Central Washington Special Collections.*

Left: In 1931, the *Seattle Times* said Cle Elum Ski Club's giant new ski jump was "one of the most hazardous in the world, 6% steeper than any in Norway." *Courtesy of the Cecelia Maybo family.*

The tournament featured cross-country and jumping, with awards given to the best jumper, the best cross-country skier and best combined skier. Three-quarters of the five-mile cross-country course were visible to spectators, who were urged to carry binoculars "to bring the runners smart into your eye." The 1931 system of transporting spectators through a Roslyn coal mine was not used. Instead, trucks transported people "to within a forty minutes walk to the ski course," according to the invitation sent out by the Cle Elum Ski Club. Northern Pacific offered a special train to the Cle Elum Ski Tournament—round-trip fare from Seattle was

$3.50. The train left Seattle at 7:30 a.m., and Northern Pacific "parked a diner in the string of cars, calculating increased appetites en route. That always happens." The train was expected to bring five hundred spectators to the tournament.

Forty-one contestants competed at Cle Elum's 1932 tournament in front of 3,500 spectators. John Elvrum of Portland made the longest jump of 202 feet, setting a new Northwest record, but fell on the landing and lost the jumping title to Ole Tverdal of Seattle. Hjalmar Hvam of Portland won the Pacific Northwest combined jumping and cross-country championship.

In 1932, Northwest skiers got to a chance to compete against the country's best Nordic skiers for the first time at home. National competitors came west to the National Jumping Championships held in Lake Tahoe in late February and entered tournaments in Washington and Oregon afterward. Before the National Jumping Championships, "Northwest skiing received small recognition in the East." However, "then came John Elvrum from Portland, Oregon," at the National Tournament, where he

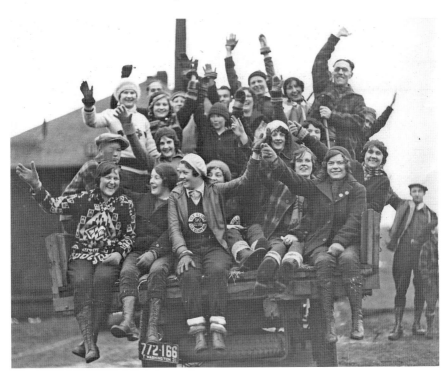

A truck carrying people uphill to near the club's ski jumps at the 1932 Cle Elum Ski Club tournament. *Courtesy of the Cecelia Maybo family.*

Dorothea Vogt posing in a publicity photo for the 1932 Cle Elum Ski Club tournament. *Courtesy of the Cecelia Maybo family.*

beat Magnus Satre in the eighteen-kilometer cross-country race by fifty seconds. For three years, Satre had been the undefeated national cross-country champion. Hjalmar Hvam also won the Class B jumping event and the national combined championship, putting Northwest skiing on the map. In the Class A tournament, John Elvrum made the event's longest jump of 198 feet but finished behind Anton Lekang of the Norway Ski Club, New York.

The eastern ski stars entered the Seattle Ski Club tournament at Beaver Lake in early March. Magnus Satre came to race John Elvrum, who had beaten him at Tahoe. There would be a three-way jumping competition between Anton Lekang, national jumping champion; Casper Oimoen, who could not compete at Tahoe; and John Elvrum, who finished second to Lekang at Tahoe. "There never was such a brilliant display of jumping talent," including six men internationally famous as jumpers and cross-country skiers, all of Norwegian descent. Casper Oimoen and Roy Mikkelson were members of the 1932 U.S. Olympic Jumping team and would compete against the best of the local jumpers.

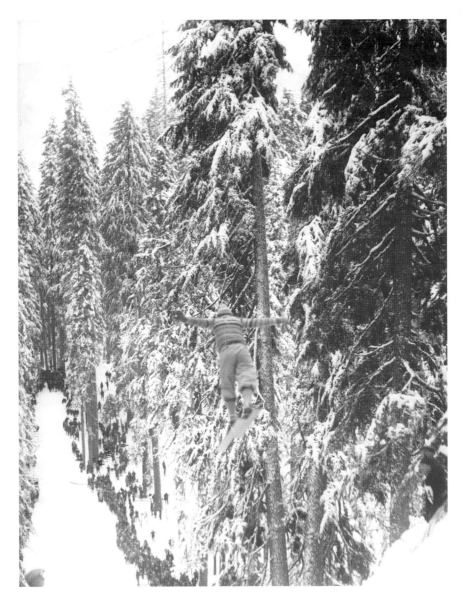

A skier going off the Beaver Lake jump at the Seattle Ski Club's 1932 tournament. *Courtesy of the Museum of History and Industry.*

Magnus Satre, "Satre the Magnificent," won the seventeen-kilometer cross-country race with a twenty-five-man field in an "astonishing time" of eighty-four minutes, eight seconds. John Elvrum finished second, Al Johansen of Vancouver was third, Guttorm Paulsen of the Norge Ski Club of Chicago was fourth and Hjalmar Hvam of Portland was fifth. Roy Mikkelson of Chicago won the jumping event, beating Anton Lekang of New York, the national champion, who came in fifth, in an event where "the nation's best skiers competed with the Northwest's best." Guttorm Paulsen of Chicago was second, Kaldahl third and Elvrum fourth. John Elvrum won the combined championship for Northwest bragging rights. Guttorm Paulsen was second and Magnus Satre third in the combined.

After their West Coast tour, praise from the eastern skiers about the ski conditions and skiers in the West appeared in the *Seattle Times*. Roy Mikkelson of Chicago wrote, "I also want to tell you that after the trip out in the West, I don't like Chicago. I didn't like it before. But now I can understand why it is so bad." Anton Lekang, said the Pacific Northwest

> *in the near future will be the center of the ski sport in America, owing to excellent hills where most wonderful ski courses can be developed, to the abundance of snow in the mountains, good roads to them, and the favorable temperature for enjoying ski sport. Already now the Pacific Northwest seems to be more ski-minded than any part of the country I have visited while participating in tournaments from coast to coast. The most amazing experience on the whole trip west was the great number of excellent skiers in the states of Oregon and Washington.*

Lekang said that John Elvrum of Portland "ranks with the best in America. He has marvelous form. He usually makes the longest jumps at their meets in the Northwest. But the whole Northwest is alive with skiers who are just as good as any, east or west." At the end of the year, it was announced that Portland's John Elvrum and Hjalmar Hvam would compete in the National Ski Association meet in Salisbury, Connecticut, in January 1933. This would deprive the Northwest Ski Association's championship meet at Snoqualmie of two brilliant performers, but other Northwest talent would mean the event would not suffer. Seattle was not sending a competitor, since it lacked a skier with enough finesse to compete with the nation's skiing elite.

1933: LEAVENWORTH'S BAKKE HILL
IS INTRODUCED, CLE ELUM TOURNAMENTS END,
FEMALE SKI JUMPER APPEARS

In January 1933, the Seattle Ski Club's third annual Pacific Northwest Championship Tournament at Snoqualmie Summit featured cross-country racing and ski jumping. The competitors were "making the skiing world eye the tournament with amazement....Nowhere, it seems, this side of Norway, are there so many able skiers, not even in the northern Middle-Western states." The editor of a local Norwegian newspaper was quoted: "Nowhere in the Unites States could 27 other men be found who, in team competition, and basing their competition on total points, could approach this field of jumpers." Of the fifty-four Northwest entrants, four "rank high in the national yearbook." Spectators were told that "heavy clothing and boots are recommended. French heels on feminine shoes are discouraged, and dancing pumps aren't at all successful." Snoqualmie Summit was a two-hour drive from Seattle under normal conditions, and the jumping venue was "a trifle less than a mile from the Summit, up a well packed trail. Salamanders, those happy creations of cast iron to warm chilled hands and feet, will be placed about the bottom of the hill in sufficient profusion to keep folks warm." The Three Musketeers of Hollyburn finished in the first three places in the jumping event, which was won by Nordal Kaldahl, the "iron-muscled" jumper who showed "nearly perfect form" in front of four thousand spectators. Tom Mobraaten was second, followed by Henry Solvedt. Hjalmar Hvam won the cross-country event followed by Mobraaten, who won the combined jumping and cross-country title.

The 1933 Leavenworth tournament showed off the new Bakke Hill, named after Hemod Bakke, the Norwegian immigrant who designed it. The Winter Sports Club had "discarded its old hill [and] built a new one" after four successful tournaments. The entry list included "practically every Class A and B jumper in the Northwest...which gives Leavenworth the finest field of jumpers in America." Leavenworth was a three-and-a-half-hour drive from Seattle, and chains were advisable on Snoqualmie and Blewett Passes. Tom Mobraaten of Vancouver jumped in perfect form and "defeated a magnificent crowd on a magnificent Sunday" in front of five thousand spectators, beating forty-two competitors. John Elvrum of Portland outdistanced Mobraaten by jumping 201 feet but lost, as Mobraaten showed superior form.

Prospects for the Cle Elum tournament of 1933 looked bright. The hill—built by the Northwest's oldest ski club—was lauded as the the "steepest in America." The Class A event featured "five youths whose jumping this year have been a source of wonder even to those who have seen many national tournaments come and go." The competitors included John Elvrum and Hjalmar Hvan from Portland and the Three Musketeers from Vancouver, Tom Mobraaten, Henry Solvedt and Nordal Kaldahl, the "electrically-muscled bit of skiing dynamite whose duels with Elvrum have been epic in Northwest history."

A road would be open to within less than a half a mile of the jump, and trucks could drive the rest of the way for those who do not care to walk. The Cle Elum Ski Club would select a queen, with her coronation to take place at Saturday's skiing ball. Everyone was invited to bring their skis, as "this is ideal terrain for the inexperienced as well as the veterans." Northern Pacific lowered its rate for the tournament to $2.90 for a round trip from Seattle.

Unfortunately, Cle Elum's 1933 tournament was marred by high winds, as described by the *Seattle Times* of February 20, 1933: "The biggest ski hill in the United States drew only 2,500 spectators in near blizzard conditions." The big take-off was too dangerous because of the wind and snow, so a makeshift take-off was constructed on the hillside:

> *The skiers broke the nose of the high scaffold, stuffed snow into the chinks, reassembled a 3-foot take-off instead of a 20-foot take-off, and jumped for form. Even the lower take-off was perilous, for the wind whipped to the velocity of a gale, was annoyingly inconsistent. It blasted one place, paused idly in another. So then the field, as though to prove its high callipered excellence, amazed with brilliant jumping performances.*

The 1933 Cle Elum tournament was the club's last. Competition increased as new ski areas were opened. Cle Elum, with its more remote location and difficult-to-access ski hill, could not compete with the other areas that offered skiing and jumping hills that were easier to reach. The difficulty in getting from Cle Elum to the Summit course, located two miles north of town, turned out to be an insurmountable obstacle. The solution used in 1931, consisting of a ride on the electric tramway through two long tunnels of the coal mine, only brought spectators to within a half an hour's walk to the ski course. In other years, trucks or snow cats transported spectators to within a forty-minute walk to the ski course, which was still

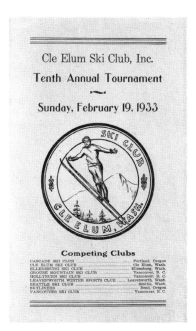

Cle Elum Ski Club, Inc.

Tenth Annual Tournament

Sunday, February 19, 1933

Competing Clubs

CASCADE SKI CLUB	Portland, Oregon
CLE ELUM SKI CLUB	Cle Elum, Wash.
ELLENSBURG SKI CLUB	Ellensburg, Wash.
GROUSE MOUNTAIN SKI CLUB	Vancouver, B. C.
HOLLYBURN SKI CLUB	Vancouver, B. C.
LEAVENWORTH WINTER SPORTS CLUB	Leavenworth, Wash.
SEATTLE SKI CLUB	Seattle, Wash.
SKYLINERS	Bend, Oregon
VANCOUVER SKI CLUB	Vancouver, B. C.

Left: Program for the 1933 Cle Elum Ski Club tournament. *Courtesy of the Cecelia Maybo family and Central Washington Special Collections.*

Below: Spectators hiking up the hill two miles to reach the ski jump for the Cle Elum Ski Club tournament in a storm, 1933. *Courtesy of the Cecelia Maybo family.*

59

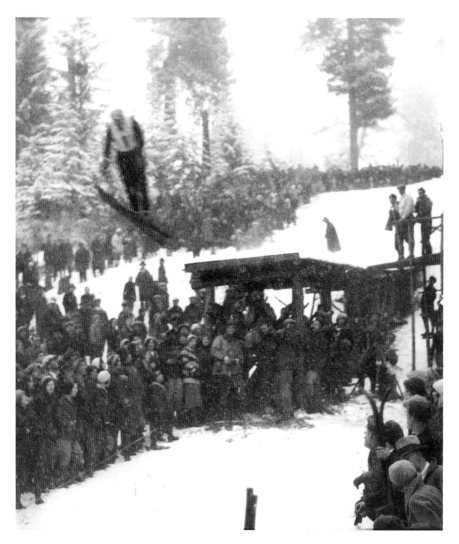

Jumping off a modified ski jump during a snowstorm at the 1933 Cle Elum Ski Club tournament. *Courtesy of the Cecelia Maybo family.*

an arduous uphill climb. "The unwillingness of spectators to make the hard trek to the summit was the reason the ski club abandoned the hill" according to Litchfield. Cle Elum Ski Club members continued to jump on their hill, compete in Northwest ski events and participate in the Pacific Northwest Ski Association.

In 1944, a fire burned the ridge between Cle Elum and Teanaway where the ski jump was located, turning the ski hill into a version "of

[Jumping Score Card]

SEATTLE SKI CLUB

PACIFIC NORTHWEST
THIRD ANNUAL
CHAMPIONSHIP
SKI
TOURNAMENT

SNOQUALMIE SUMMIT
JANUARY 28-29, 1933

CLUBS REPRESENTED

Auburn Ski Club, Auburn, Cal.
Cascade Ski Club, Portland, Oregon
Cle Elum Ski Club, Cle Elum, Wash.
Ellensburg Ski Club, Ellensburg, Wash.
Grouse Mountain Ski Club, Vancouver, B. C.
Hollyburn-Pacific Ski Club, Vancouver, B. C.
Leavenworth Ski Club, Leavenworth, Wash.
Seattle Ski Club, Seattle Wash.
Skyliners, Bend, Oregon
Three Rivers Ski Club, Canada
Vancouver Ski Club, Vancouver, B. C.

TOURNAMENT JUDGES

Peter Hostmark, Seattle
H. A. Lee, Portland Reidar Gjolme, Seattle

TOURNAMENT PHYSICIANS

Dr. Roderick Jansen Dr. Ivar W. Birkeland

Left: Program for the Seattle Ski Club tournament, 1933. *Courtesy of the Cecelia Maybo family.*

Middle: Cars parked on the highway and a sign for Seattle Ski Club's Beaver Lake tournament, early 1930s. *Courtesy of the Washington State Archives.*

Bottom: Seattle Ski Club's Beaver Lake jump in the early 1930s, described as "one of the steepest landings in the world a hill three or four degrees steeper than the famous Holmenkollen Hill in Norway." *Courtesy of the Washington State Archives.*

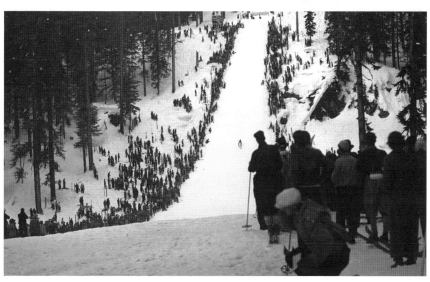

Stalin's...scorched earth." Skiing continued on Silver Dollar Ski Bowl on the old Cassassa Ranch for a few years, but eventually, Snoqualmie Pass offered a broader variety of skiing and Cle Elum skiers ended up going there for their winter recreation. The days when Cle Elum was the "Ski Capital of the West" became a memory but left a grand tradition, most of which has been long since forgotten.

A female ski jumper made her appearance in 1933. Johanna Kolstad, a nineteen-year-old "Norway ski girl" who was "the holder of numerous women's ski-jumping titles," had "performed creditably against men in Norway, but banning of mixed contests there caused her to come to the United States for competition." At Chicago's 1933 Norge Ski Tournament, she made exhibition jumps of 125, 136 and 128 feet. The Pacific Northwestern Ski Association decided to permit female ski jumpers to compete at the Pacific Northwest Championships and invited Kolstad, according to the *Seattle Times* of March 12, 1933:

> *Male skiers step aside for the fairer sex. Johanna Kolstad exhibits jumping prowess off Summit's Big Hill, and they do say she knows how. The Norwegian girl, foremost ski-jumper of her sex in the world, is the guest star of the Seattle Ski Club's annual home tournament, which starts with jumping events today....It was sheer fortune which permitted Miss Kolstad to be announced as today's headliner in Snoqualmie Pass.*

Kolstad made an exhibition jump at the tournament, which was won by Ole Tverdal of Seattle, who beat Tom Mobraaten of Vancouver and Nordal Kaldahl of Hollyburn, British Columbia.

1934–1935: SKI JUMPING TOURNAMENTS CONTINUE AT SNOQUALMIE SUMMIT AND LEAVENWORTH

Although ski jumping had a large following in the Northwest, the Midwest was where the sport began in this country, and it had far more history and support there. In late January 1934, thirty thousand spectators were expected at the National Ski Jumping Championship at Fox River, Illinois, where thirty thousand cubic feet of snow had been moved on the Norge Ski Club slide. Every American Olympic team member would compete.

The Seattle Ski Club's tournaments at Snoqualmie Summit for 1934 and 1935 featured a new event: slalom racing. The 1934 event featured the first slalom race sanctioned by the Pacific Northwestern Ski Association, held along with jumping and a cross-country race. There were over one hundred entrants despite efforts to limit the field: "We do not need inexperienced jumpers." Motorists stopped by traffic on the pass should "park their machines, purchase tickets from the ticket sellers who follow traffic down the highway, and get free transportation to the Summit in the buses the ski club has retained for the tournament." Competitors from Vancouver, British Columbia, swept the event. First and second places in the jumping competition were won by Henry Solvedt with jumps of 163 and 161 feet, with Nordal Kaldahl second. Tom Mobraaten, the "sandy-haired needle of jumping poise," won the combined racing and jumping championship. Hamish Davidson won the slalom race, which featured thirty-eight competitors and was "a test of racing skill which proved to be unexpectedly strenuous and spectacular." Attendance was huge, and spectators left five thousand cars parked on the highway.

In 1935, there were reserved seats for the jumping and the slalom events at the Snoqualmie course. "Wear boots and two pair of woolen socks" warned the *Seattle Times*. Slalom races held on Tverdal Hill with parallel courses for men and women would be "a conditioner for prospective entries in the upcoming National Downhill and Slalom Championships at Rainier National Park" in April 1935. In the jumping event, two thousand spectators watched Portland's Hjalmar Hvam win the Class A competition, beating twenty competitors. "The brilliant Hermod Bakke of Leavenworth, who doubtless will be sent by the Leavenworth Winter Sports Club to the Olympic jumping trials at Salt Lake March 3, took second." In the slalom race, which had forty-eight entrants, Darroch Crookes of the Washington Ski Club won, despite facing a time handicap because he missed a set of flags.

The Fourth Annual Pacific Northwest Jumping Championship was held in February 1934 on Leavenworth's "long and steep and dangerous" jumping hill, said to be "the world's most perfect hill," where one could "drive all the way." Snow was scarce, but trucks hauled in snow that was "passed from person to person in apple boxes to be dumped on the jumping hill." John Elvrum of Portland won with jumps of 200 and 208 feet. Tom Mobraaten of British Columbia won the cross-country race in front of five thousand spectators and won the combined title in the first Apple Box Tournament, which was called the "finest competitively and best managed the Northwest has ever seen."

The 1935 Leavenworth tournament was the PNSA Championship in jumping and cross-country skiing and the sectional Olympic trials. The entire town turned out to make the meet successful. Spectators could drive their cars to the event and walk one hundred yards to watch the competition. Federal funds were used to hire twenty-seven men to work on the hill for twenty-three days, who "perfected the runout at the bottom of the hill. They smoothed it perfectly. We planted ten pounds of dandelion seed on the hill…. Our jumpers can jump on four inches of snow, now." Washington Ski Club's team included several candidates for the National Olympic cross-country trials: Don Fraser, Alf Moystad, Hans-Otto Giese and Darroch Crookes.

Leavenworth's Hermod Bakke won the tournament with jumps of 200 and 201 feet in a wind that "twisted him from side to side in the air," on a course "where 1,500 pounds of rock salt had broken the ice into a shifting, treacherous bed, and the least sideslope sent jumpers tumbling." The win earned him the right to represent the PNSA at the Olympic Games tryouts in Salt Lake on March 3. Five thousand spectators saw the event, with five hundred coming on a Great Northern special ten-car ski train, the largest in history—"jammed to the roof." Henry Sotvedt of Vancouver, British Columbia, won the eleven-mile cross-country race and placed fourth in the jumping event, winning the combined title. Don Fraser finished a disappointing tenth in the event's "historic langlauf," or cross-country race, an event in which he hoped to qualify for America's Olympic team. Fraser said the "Norwegian lads…passed me as though I was standing still" with their "amazing shoulder strength."

At the U.S. Olympic jumping finals at Salt Lake City on March 3, 1935, the top four finishers included Sverre Fredheim of Minneapolis; Roy Mikkelsen of Auburn, California; Casper Oimoen of Anaconda, Montana; and Einer Fredbo of Salt Lake City. Northwest jumpers finished out of the money. Helge Sather and Hermod Bakke of Leavenworth finished tenth and eleventh. Spokane jumpers Arnt Ofstadt and John Ring were twelfth and twentieth. Hjalmar Hvam of Portland fell on both of his jumps.

3

Alpine Skiing Emerges as a Winter Sport, 1920–1934

1914: THE MOUNTAINEERS BUILD FIRST LODGE ON SNOQUALMIE PASS

Skiing on Snoqualmie Pass dates back to the early 1920s and revolved around private ski clubs.

The Mountaineers club was founded in 1906, dedicated to outdoor activities, mountaineering and climbing. The club's biography, *The Mountaineers: A History*, describes the organization through the years. "[O]rganized skiing in Western Washington can be traced back to 1912, when Olive Rand brought a pair of skis on a Mountaineers trip to Mount Rainier, and was the first person to reach Longmire from the park boundary on a pair of 'wooden boards.'" Beginning in 1916, members brought skis to the club's trips to the newly constructed Paradise Lodge on Mount Rainier, which the club rented for five days each winter. The club held annual winter outings in Rainier National Park for many years, although getting there involved a significant trip. Seattle skiers took a ferry to Tacoma, boarded a steam train to Ashford and then hiked ten miles to Longmire, where they spent the night. The second day, they hiked to Paradise.

In 1914, The Mountaineers built a lodge just west of Snoqualmie Summit, about halfway between Snoqualmie Pass and Milwaukee Road's Rockdale stop at the west end of its tunnel under the pass, on land leased from the Forest Service, a quarter of a mile southwest of Lodge Lake. Architect and

The Mountaineers' Snoqualmie Pass Lodge designed by Seattle architect Carl Gould, built in 1914, located near Milwaukee Road's Rockdale stop at the west end of its tunnel under the pass on land leased from the Forest Service, a quarter of a mile southwest of Lodge Lake. *Courtesy of The Mountaineers.*

club member Carl Gould designed a lodge made mostly of materials found on site, which was built primarily by club volunteer labor. Lack of electricity and plumbing were not seen as problems. On the first floor, there was a main room thirty by forty feet, an adjacent kitchen and a women's dorm. A men's dorm was on the second floor. It was a year-round lodge, held seventy people and had a cook and caretaker. Until the early 1920s, it was used primarily as a climbers' lodge to access surrounding peaks and a social center for members. "Climb or hike all day and dance all night. The wind-up Victrola horn got plenty of use." In the 1920s, the lodge "became a development center for skiing."

Getting to The Mountaineers' lodge was a challenge. Members could ride Milwaukee Road trains from Seattle to the Rockdale stop and hike one and a half miles up the hill to reach the lodge in the winter. In the summer, the lodge could be reached by a steep one-and-a-quarter-mile

hike from the Denny Creek Ranger station after a long drive from Seattle on primitive roads.

Although most skiing in the teens and 1920s centered on jumping, The Mountaineers were primarily interested in climbing and mountaineering. The club's interest in skiing involved trips to the surrounding mountains "using turning and braking techniques for the descent....Technique in the early 1920s generally consisted of pointing the skis downhill and shoving off—straight back down to where you started. If you managed to stay on your feet, your technique was adequate." Ski lessons were nonexistent, and advanced skiers helped beginners obtain the necessary skills. Beginning in 1923, The Mountaineers marked many miles of cross-country ski trails around the pass and sponsored cross-country skiing events and contests. The club's 1923 annual report said, "Each year the ski gains in popularity. The festive ski-runner now flits scornfully by the deliberate snowshoer. The sight-seeing columns of snowshoers retort that they enjoy more of the beauties of nature, and have even been heard to allude to our old friends the hare and the tortoise."

The Mountaineers began holding ski events in 1922, when a trophy for a women's competition was awarded. In 1923, the club began awarding the Harper Novice Cup for beginning male skiers able to negotiate a race course. By the end of the 1920s, The Mountaineers were awarding trophies in eight ski events. In 1929, the club began giving ski lessons and adopted tests based on those used in Europe to classify skiers and implement systematic learning techniques. To win a third-class rating, one had to demonstrate beginner skills such as proper kick turns, level running using ski poles, ascent of a fairly steep slope by sideslipping and herring-boning, two continuous stem turns and telemark turns, both right and left, and come to a stop from a descent at a slow speed. In addition, one had to climb five hundred vertical feet in at least an hour and return within fifteen minutes and complete a cross-country trip of four miles. To win a first-class rating, one had to demonstrate four continuous stem christies on a steep slope at a high speed, four successive jump turns at a fair speed, a two-thousand-foot vertical climb in ninety minutes, returning in twenty-five minutes, and an eighteen-mile cross-country trip.

Ski equipment was difficult to obtain in the sport's early days, although Piper & Taft, a Seattle retailer, advertised skis for sale in The Mountaineers' annual publication beginning in 1912. In 1920, Tacoma's Kimball Gun Store advertised skis in the club's annual, and in 1922, Seattle Tent and Awning opened its OutDoor Store selling Northland

skis "in 6 ft. to 8 ft. lengths, in pine, ash and hickory." By 1928, Eddie Bauer's store in Seattle stocked "a full line of skis imported from Europe," according to The Mountaineers' history.

1928: THE MOUNTAINEERS BUILD MEANY SKI HUT AT MARTIN NEAR STAMPEDE PASS, BEGIN PATROL RACES

By 1926–27, skiing had become so popular that The Mountaineers' Snoqualmie lodge "was bursting with skiers throughout the winter and more facilities were needed." The club located a site for a new lodge at Martin, a stop on the Northern Pacific Railroad at the east portal of its tunnel under Stampede Pass. A fire near Stampede Pass left large areas clear of trees for "open slope skiing." Although Martin was at a lower elevation than Snoqualmie Pass, it was on the eastern slopes of the Cascades, and the snow there was drier than at the Pass and the skiing better.

The Mountaineers' first organized outing to Martin was in February 1928. Members traveled by railroad, stayed in railroad cars near the Stampede Pass tunnel and were enthusiastic about the favorable terrain and accessibility by train. It offered open areas around the weather station, the power line hill and open timber slopes that were "ideally suited for ski touring that dominated the sport." "The skiing was declared the best ever—indeed, the slopes rivaled those of Paradise Valley."

In 1928, The Mountaineers approved $1,700 to build a "plain ski shelter without luxurious embellishments" at Martin. Professor Edmund S. Meany, the club's president for twenty-seven years, bought sixty-four acres of land for $125, which he donated to the club. In the fall of 1928, club members built Meany Ski Hut, located five minutes from the Martin stop. Materials were brought in by train and taken three hundred yards to the site uphill by hand, including a 1,700-pound kitchen stove that had to be hauled with a block and tackle. It took two months of volunteer labor to build a twenty- by fifty-foot hut that accommodated fifty-two people to be used just for skiing. Round-trip train fare to Martin was $1.80 on Northern Pacific trains. Members could also hike into Martin from the Sunset Highway over Snoqualmie Pass. Train service to the Ski Hut continued until 1960, when Burlington Northern (Northern Pacific's successor) canceled its stop at Martin, and The Mountaineers bought a snow tractor to bring its members from the highway.

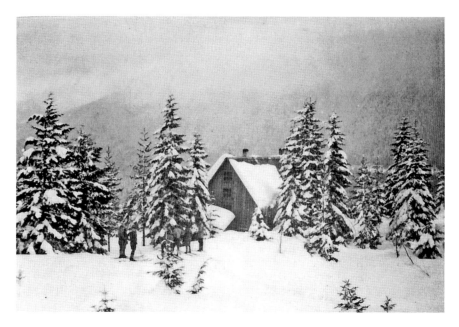

The Mountaineers' Meany Ski Hut, built in 1929, located three hundred yards uphill from the Northern Pacific stop at Martin, the eastern portal of its tunnel under Stampede Pass. *Courtesy of The Mountaineers.*

In 1930, under the leadership of Wolf Bauer, an immigrant from Germany, The Mountaineers began annual downhill and slalom races said by the *Seattle Times* to be the start of this kind of racing in the Pacific Northwest. Wolf Bauer won the first slalom race in 1930, Hans-Otto Giese was second and Hans Grage was third. Grage won the downhill, Giese was second and Bauer third. All three had emigrated from Europe.

The club marked a twenty-mile trail along the crest of the Cascades between its Snoqualmie Lodge and Meany Ski Hut. Beginning in 1930, Club Patrol Races were held that went between its two lodges. The event, in which three-man patrol teams competed, was based on military patrol races common in Europe, such as Norwegian army maneuvers in which a three-man unit, often a machine gun team, was sent to a specific point. Each team member carried a piece of the equipment, and they all had to arrive together at a specific location to assemble the gun. This was the only patrol race in the Northwest and probably the only one in the country. Teams left ten minutes apart, and all three members had to arrive at Meany Ski Hut within one minute of one another. Each team had to carry required equipment, which included an axe, a compass, first-aid equipment, candles, a contour map,

fifty feet of quarter-inch rope, emergency rations, a flashlight, matches, snow glasses and specified clothing. Each team member had to carry a ten-pound pack, although the packs typically weighed fifteen to twenty pounds as they contained additional equipment such as food, ski wax, extra ski tips and repair parts for bindings. It took around seventy-five Mountaineers to run the race, which included operating the Snoqualmie Lodge and Meany Ski Hut, marking and preparing the trail and having starters and finishers, often for just fifteen racers.

Patrol races began at the Snoqualmie Lodge at 3,200 feet, climbed up Olallie Meadows to 4,500 feet on the northeast side of Tinkham Peak, went down to Mirror Lake at 4,200 feet, down Meadow Lake to the junction of Dandy Creek at 3,000 feet, back up to Dandy Pass at 3,700 feet and down to Meany Hut at 2,900 feet. The finish of the race was spectacular. "To watch the men at the end of an 18-mile race over the roughest kind of terrain, their legs all numb from fatigue try to run down the steep lane at Meany and cross the finish line in some kind of an upright position filled the audience with suspense, sympathy and admiration," according to the *Seattle Times*.

Winners of The Mountaineers 1930 Patrol Race, Hans-Otto Giese, Andy Anderson and Fred Ball. *Courtesy of The Mountaineers.*

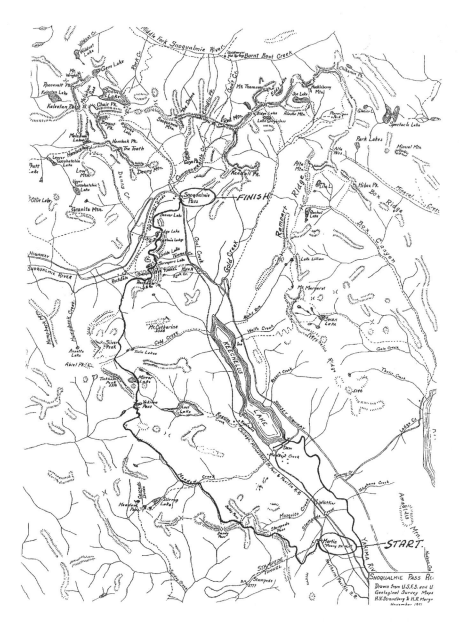

A map of The Mountaineers' Patrol Race from its Snoqualmie lodge to Martin Ski Hut, "an eighteen mile grind along the crest of the Cascades." *Courtesy of The Mountaineers.*

Before the first patrol race was run in 1930, a *Seattle Times* article, "Women Can Ski Expertly as Men," featured Mrs. Stewart Walsh, a Mountaineer who was "a firm believer in the future of Puget Sound as a national winter resort." She complained that "women have neglected skiing terribly." Eight years before, only 5 women showed up for a Mountaineers ski meet, although by 1930, there were 150 women who skied and could "do it well." They could do everything that men could do—except ski jump, which they could do but it "isn't generally recommended." Northwest women should be as expert on "wooden runners" as their Scandinavian and Swiss sisters. To prove her point, Mrs. Walsh "made the difficult twenty-miles between the Snoqualmie Lodge of The Mountaineers Club and the Meany Ski Hut at Martin—the first woman to perform a feat that has been equaled by only six men."

Four patrol teams entered the first Club Patrol Race on March 23, 1930, facing unfavorable conditions due to several days of fresh snow. The team of Hans-Otto Giese, Andy Anderson and Fred Ball won the race in a time of seven and a half hours. No races were held in 1931 and 1934. In 1932, the race was won by the team of Norval W. Grigg, Fred W. Ball and Hans-Otto Giese. The 1933 Patrol Race was won by "the hard-running team of Art Wilson, Herbert Standberg and Dan Blair" in a record-breaking time of five hours and thirty-two minutes. Patrol Races were held until 1941, and The Mountaineers reran the race in 2014.[8]

EARLY 1930S: SNOQUALMIE PASS IS KEPT OPEN IN THE WINTER, NEW SKI FACILITIES ARE BUILT

During the 1920s, permits from the state highway department in North Bend were required to cross Snoqualmie Pass in the winter. The number of travelers was telephoned to the other side, and search parties were dispatched when a car failed to arrive. Travelers without permits were fined "a hefty $250." Those driving to Snoqualmie Pass before 1931 parked at Denny Creek and climbed on skis for several hours to the summit. In the late 1920s, Seattle's Garfield High School counselor Harry B. Cunningham began taking students on snowshoe expeditions to Snoqualmie Pass, either to Rockdale, the west portal of the Milwaukee Road tunnel, or Hyak, the east portal. When Cunningham found that a majority of the expedition participants were skiers, he began taking them

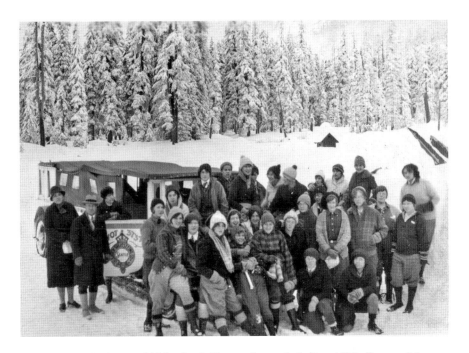

Harry B. Cunningham and high school skiers on Snoqualmie Pass, 1929. *Courtesy of the Moffett family.*

on ski trips. Cunningham later became the Garfield Ski Club advisor and operated a store in his garage selling and renting ski equipment in Seattle's Montlake neighborhood.[9]

In the winter of 1931, the Washington State Highway Department kept Snoqualmie Pass open for the first time throughout the winter, allowing access by car for skiers. By 1934, the highway had been paved from Seattle to Snoqualmie Pass. This created "unprecedented access" and greatly expanded skiing opportunities around the pass, and the sport became more accessible and popular.

The 1933 Mountaineers' annual said, "Snoqualmie Pass a few years ago was almost as remote and mysterious in winter as Little America [Antarctica] is today. It was not only an event but an actual achievement for anyone outside of the initiated to visit the summit in winter months." Driving to the pass before the highway was paved was a four-hour ordeal. Drivers had to go through the Seattle suburbs of Lake City, Lake Forest Park, Juanita, Kirkland and Redmond. Then narrow country roads went to Snoqualmie Falls and North Bend, where a narrow unpaved track wound its way up to

the pass. "A winter trip meant tire chains and the ever-present danger of sliding into a ditch."

In the early 1930s, interest in alpine skiing grew, private ski lodges were built and ski clubs formed on Snoqualmie Pass and elsewhere. Skiing was initially centered on private clubs and their ski hills, which were narrow runs cut through trees. The new sport of slalom racing appeared, quickly becoming popular, and ski clubs began having regular competitions against one another. Per the *Seattle Times* of Dember 8, 1935, "[I]t was in Snoqualmie Pass that modern skiing in the Northwest, or at least in Washington, was really born and raised."

The *Seattle Times* of January 17, 1932, announced that "the whole world seems suddenly to have gone skiing." A few years before, skiers at Snoqualmie Pass had the hills to themselves, but then along came Ben Thompson, "and skiing began to rise in importance." Ben and his mates at the Seattle Ski Club built facilities and gathered jumpers, and "crowds began to grow where no crowds ever were before, that is, before the advent of skiing." Now, those crowds "plunge into the mountains Sunday after Sunday in quest of snow." A few years before, it was hard to find ski equipment to buy, but in 1932, one Seattle store sold two thousand pairs of skis in one month, and another store stocked thousands of dollars of skis, straps, mountain clothing and so on. The Mountaineers' Snoqualmie Lodge was the oldest at the pass, and the club had another lodge at Martin built in 1928, the Meany Ski Hut, "where one goes up on the train and where skiing is best of all."

On January 18, 1933, the *Seattle Times* described the large number of skiers who traveled to the mountains every weekend, saying, "Thousands Hit Snow Trails":

> *Spread along Snoqualmie Pass from North Bend to Cle Elum were automobiles Sunday and Saturday—and from those machines, etched in the snow, criss-crossed and twisted, were thousands of parallel grooves, mute testimony to a Washington yen for skiing. "You never saw anything like it."…Crowds have been anywhere from 2,000 to 4,000 every week-end since the first snow fell—and they grow larger every Sunday. And that was only one sector of the skiing front.*

Six or seven years earlier, skiing was limited to "those from the old country who had skiing as a heritage, but the idea caught on. Once propped on a pair of skis, the enthusiast couldn't let go. He couldn't

even keep quiet about it. He insisted on others trying it." The turnout at Snoqualmie Pass, Paradise Valley, Stampede Pass on the Northern Pacific Line and Mount Baker "was tremendous."

Kendall Peak Lodge was built in 1930 near Snoqualmie Summit by several Seattle families who were winter sports enthusiasts. It had two and a half stories and accommodated twenty persons. On January 28, 1934, the *Seattle Times* published pictures of members skiing through a forest, saying they were "all excellent skiers who enjoy many week-ends at their lodge, at the Summit of the Cascades."

In 1931, the Sahalie Ski Club (originally called Commonwealth Ski Club) built a lodge on forty-five acres of land purchased from the Northern Pacific Railroad on what later became Alpental Road off Snoqualmie Pass. Washington Alpine Club built its Guye Cabin near the Commonwealth Lodge in 1932 and used boxcars near Northern Pacific's Martin stop in addition to its "grand new lodge."

Sahalie's Ski Lodge, designed by Seattle architect Arthur Loveless, was "three stories in height with a full basement, built in the form of two L's, with a three flue chimney thrust through the center" and slept forty. In 1933, it was called "very imposing, to the left as one approaches the Summit. It has the added comfort of steam heat." The club offered "serious instructions for its membership" in the winter of 1934, some of the first ski lessons available in the Northwest according to historical materials on the club's website:

> *Commonwealth Ski Club began offering ski lessons for its members in the 1933/34 season. This was a major step forward, since early skiing was mostly cross-country, and when new skiers tried to go downhill, there were a lot of injuries. "Controlled" skiing using turns was a relatively new concept being pushed by ski promoters. Commonwealth employed some of the best skiers available: the initial teachers were Ben Thompson, Hans Grage and Don Fraser, all huge names in early Northwest skiing. Skiers learned "to do level running, execute kick turns, exhibit proper handling of ski poles and descend a slight slope in various fundamental positions."*

In the fall of 1933, Seattle's Helen Bush School built a log ski lodge on Snoqualmie Pass designed by architect Carl F. Gould on three acres of woodland, with a ski run on the meadow below. It had a balcony overlooking Snoqualmie and Guye Peaks, built-in bunks, cedar slab tables and a large cobblestone fireplace. "This cabin is one of the prides of the Bush School students" and was available to pupils and their friends. By the winter of 1934,

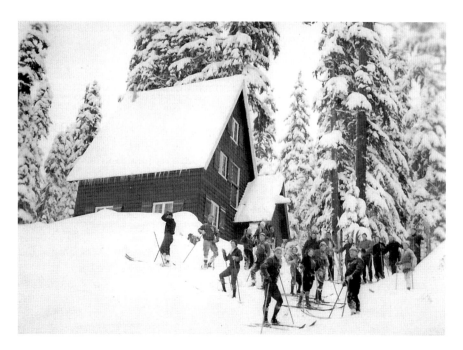

Sahalie Ski Club lodge, designed by Seattle architect Arthur Loveless off Snoqualmie Pass, 1931. *Courtesy of the Sahalie Ski Club.*

there were several private homes near Snoqualmie Pass: one on Surveyors Lake, Phil Bailey's cabin at the summit designed after a Swiss chalet and Tony Talbot's ski cabin below the summit, which "will shortly be filled with happy weekend guests." Talbot was the manager of the Washington Athletic Club (WAC) sport shop and often hosted WAC ski parties at his cabin. The College Club lodge, built above Lake Keechelus by club members, was renamed the Roaring Creek Lodge.

Private ski clubs formed the backbone of Northwest skiing during the 1930s, and they promoted alpine skiing by sponsoring slalom and downhill competitions. Ski racing was a major activity for the ski clubs, and races against other clubs were held on many weekends, with newspapers reporting the results of the ski competitions. Ski races were held at Sahalie Ski Club beginning in January 1934, and annual competitions were held against Snoqualmie's other three ski clubs during the 1930s (Mountaineers, Seattle Ski Club and Washington Alpine), sometimes including four-way events involving downhill, slalom, cross-country and jumping.

SLALOM RACING APPEARS AND BECOMES POPULAR

Slalom racing was first done by The Mountaineers in 1930, but the sport was introduced to the public in April 1933 at the Seattle Junior Chamber of Commerce spring sports carnival at Mount Rainier. It had been brought to the Northwest by Ben Thompson, "manager of Paradise Lodge and one of the Northwest's foremost cross-country and mountain skiers." According to the *Seattle Times* of April 1, 1933, the race course is one thousand feet long, but racers travel two thousand feet before they finish and "there are frequent and tremendous spills."

> *It is a pell-mell, downhill of muscle over mind. But not in a straight manner. It has twists and turns, flags to round, moments in which to gather speed for a nerve-shaking stop, and finally, a triumphant flash across the finish line. There is nothing sane about it. The racers gallop against time.... They round the flags, leap frantically, striving to maintain balance through the maze of flags the rules require must be rounded.*

In the fall of 1933, the Seattle Ski Club broke new ground by including slalom events in the Pacific Northwestern Ski Association winter racing schedule. Until then, PNSA's sanctioned tournaments had been limited to Nordic events, either jumping or cross-country. Slalom skiing, "which calls for the highest sort of skill," had been introduced by Ben Thompson, who was in charge of winter sports at Rainier National Park, and it "caught on by wildfire." The *Seattle Times* of November 10, 1933, described the new sport of slalom, which was

> *a sport for swift skills and certain nerves. You start at the top of a 2,000 foot slide. There are flags placed at intervals along the 2,000 feet and you steer dexterously in and out of this path of flags. Fine, if you know how to do it! The skiers in their bright colored clothes, winding in and out of the flags, darting like flamingo winged birds to the bottom of the slide, reminded one somewhat of the highly colored balls in a pushball game being released from their grooves. It's decidedly a sport for the young and adventurous, is this slalom.*

Washington skiers got a chance to see what their future would hold in late January 1934, when the *Seattle Post Intelligencer* ran an article about the first motorized ski tow in the country, which opened on January 29, 1934,

at Woodstock, Vermont: "The device consists of an endless rope which runs over a pulley at the top of the hill over a motor at the foot of the incline. It takes skiers up 900 feet in one minute." However, Washington skiers would have to wait until the late 1930s before ski tows arrived in their state.

By the beginning of 1934, alpine skiing had grown in popularity, creating speculation that it might displace ski jumping as the primary winter sport. There was a "growing interest in winter sports," as 2,500 skiers were in local ski clubs, 3,000 to 5,000 spectators attended ski jumping events at Snoqualmie Pass, 400 cabin reservations had been made at Paradise Valley and 10,000 persons "participate in some form of winter sports every weekend."

Since alpine skiing was new in the 1930s, the *Seattle Times* published seven ski lessons written by Ben Thompson, "a former winter sports director and chief guide at Mount Rainier, one of the Northwest's best students of skiing." Thompson explained "how to learn, how to develop, how to master the fundamental turns on which all skiing success is built." Lessons were published on Sundays from December 17, 1933, to January 28, 1934, and pictures of Thompson and other local skiers were used to demonstrate the lesson of the week.

During the winter of 1934, weekly slalom races were held at Paradise Valley on Mount Rainier, and the University Book Store awarded medals to the winners in the spring. Many of the best local skiers came out of those races on Mount Rainier, including Don Fraser, Darroch Crookes, Grace Carter, the Smith sisters, Gretchen Kunigk and Don Amick, who became members of U.S. Olympic ski teams. Soon, annual alpine races were held at Snoqualmie Pass, Mount Baker, Mount Spokane and Mount Hood and later at Stevens Pass.

By the early 1930s, equipment had improved and could be obtained from a number of outlets, making skiing more accessible. In 1932, the University Book Store in Seattle sold a full array of ski equipment, described in *The Mountaineers: A History*: "Boots were $6, skis were $3.50, ski jackets $3.95, bindings $3.50 to $4.50, Norwegian bamboo poles $2.25, and wax 35 cents.…By 1933, skiers could purchase the latest downhill cable bindings, which allowed for both touring and downhill skiing. Metal edges were become popular in Europe, but most skiers in the Northwest considered them for experts only since they required delicate skill in edging."

In 1934, Ray Anderson and Ben Thomson formed a partnership to make ski equipment in Seattle, producing A&T laminated skis—for which Anderson received a patent in May 1933—which were stronger than skis made from a single piece of wood. In 1934, A&T began producing the

first steel ski pole, stronger than the bamboo then used, and the first cable binding in the United States, an improvement over leather heel straps. The company became one of the largest manufacturers and distributors of ski equipment. Climbing boots were used for skiing initially, but by 1935, actual ski boots were available "with rugged soles, grooved and square toes." Also in 1935, the first Kandahar cable binding, which held the skier's heel to the ski, was introduced.

In 1934, ads in the *Seattle Times* show that A&T sold its laminated skis for $12.00 (which was much more expensive than other skis), bindings for $5.75, poles for $1.50 to $2.00, Swiss boots for $16.50 and ski parkas with a hood for $8.50. Eddie Bauer sold skis ranging from $1.75 for Mountain King skis to $1.75 for Tubbs Ash skis, $3.85 for Winner Hickory skis, $4.45 for Strand Hickory skis and Canadian ski shoes for $5.45.[10]

1934: SEATTLE PARK BOARD OPENS SNOQUALMIE SKI PARK AT SUMMIT

In spite of the growth of interest in skiing in the early 1930s, there were few ski areas open to the general public on Snoqualmie Pass. A Seattle Park Board report highlighted the problem. "Before the development of the municipal ski course, various clubs and outdoor groups maintained camps and cabins there but there were no facilities for the general public, and only a small number of persons could be accommodated." Seattle's Snoqualmie Ski Park was opened in 1934 to address that issue.

The Ski Park was one of the earliest ski areas created using New Deal programs begun by President Franklin Roosevelt designed to put unemployed people back to work, and it represented a step forward for alpine skiing. These New Deal programs are discussed in a recent book, *Rightful Heritage: Franklin D. Roosevelt and the Land of America*, by Douglas Brinkley.

In December 1933, the Seattle Park Board obtained a permit from the U.S. Forest Service to establish a ski hill at Snoqualmie Summit. A Civilian Conservation Corps crew cleared the hill for skiing in December 1933 and built a warming hut the size of a two-car garage. The area was operated by the Seattle Park Board as a city park, even though it was over sixty miles from the city. A large lodge was designed for the park but was never built. The park board's Snoqualmie Ski Park was "unique in American skiing, since it is owned and operated by a city."

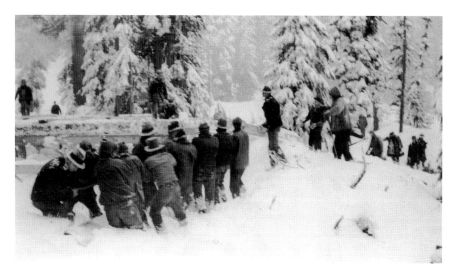

A large WPA crew working on the foundation of the warming hut at Seattle Municipal Ski Park, December 1933. *Courtesy of the Seattle Municipal Archives.*

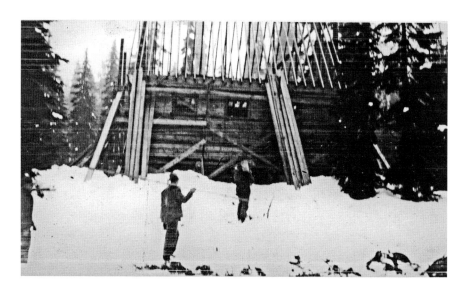

Foundation of Seattle Municipal Ski Park warming hut, December 1933. *Courtesy of the Seattle Municipal Archives.*

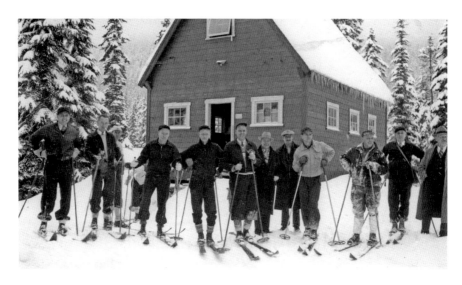

Warming hut and skiers at Seattle Municipal Ski Park, January 1934. *Courtesy of the Seattle Municipal Archives.*

On January 21, 1934, the Snoqualmie Ski Park (also known as the Municipal Ski Park) opened on Snoqualmie Summit. The *Seattle Times* of January 22 announced, "Snoqualmie Ski Park at Summit, Snoqualmie Pass, becomes a unit in Seattle's rapidly expanding ski plan," and described a gala opening ceremony. Marguerite Strizek of the Seattle Ski Club was chosen Ski Queen after a skiing competition was held between female skiers from the seven Snoqualmie Pass clubs. Then came an obstacle event, a flag race, formation skiing, a ski jump on a modified hill by junior members of the Seattle Ski Club and the opening of the ski hill. The thirty-five-piece North Bend Community Band entertained the crowd. Junior jumpers gave an exhibition on a miniature hill, twenty skiers raced down a "quickly devised slalom course, and the dedication broke up in a general rush of skiers to the hill."

Following the opening of "the country's first municipal ski park," the Seattle Park Department provided free ski lessons at the Westlake Skating Rink in downtown Seattle. Six ski classes a day were offered, and lessons lasted a week. Lectures were given on equipment and first aid, and training was provided on ski walking, sliding and various turns. Final instruction was given the following Sunday on the "snowy slopes of the municipal park." Newspapers from all over the country took notice. The *Sarasota Herald-Tribune* said ski enthusiasts were "learning the art of the telemark, christiana,

Above: Mayor Dore and Queen Margerite Strizek at the opening day of Seattle Municipal Ski Park, January 1934. *Courtesy of the Seattle Municipal Archives.*

Opposite, top: The North Bend High School Band at opening day of Seattle Municipal Ski Park, January 1934. *Courtesy of the Seattle Municipal Archives.*

Opposite, bottom: Indoor ski lessons at Seattle Skating arena were part of the Seattle Park Board's plan to encourage skiing, January 1934. *Courtesy of the Seattle Municipal Archives.*

gelandesprung, double stem and such ski turns on a soap-covered floor far from the icy slopes and chilling snow of the mountains." According to the *Christian Science Monitor*, Seattle began the first "indoor ski school" in the country, run by the park board, offering free ski lessons. "The soap-polished floor makes it possible for the people to manipulate their skis."[11]

Opening the ski park in the middle of the Great Depression was especially daring, as funds for any recreational activity were scarce, the city was slashing its budgets and unemployment was high. Yet Seattle opened a new recreation area sixty miles from the city, accessible in the winter by a several-hour car trip over a two-lane snow-covered road. The *Seattle Times* called the ski park "an unprecedented enterprise…It marks the first known time in America a city has ventured into the recreational skiing field in such a first-class manner."

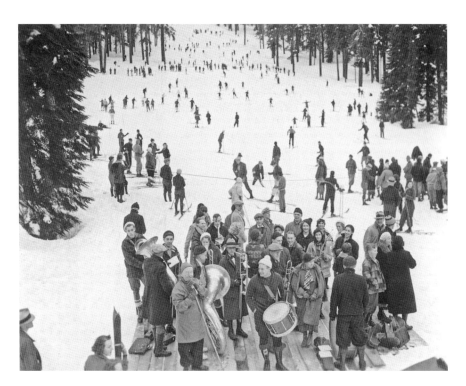

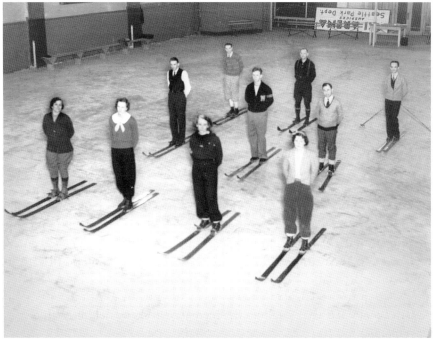

Ski Me Some Time?

Queen Marguerite Strizek, who reigns at the Winter Sports Week luncheon at the Washington Athletic Club tomorrow noon—it's open to the public—invites Alfred H. Lundin, president of the Seattle Chamber of Commerce, to the luncheon and the Seattle Ski Club tournament Sunday at Snoqualmie Pass.

Three Queens at Ski Luncheon
Seattle Honors Portland Visitors

Ski Queen Margaret Strizek and Alfred Lundin promoting Seattle's Winter Ski Week, *Seattle Times*, February 2, 1934. *Courtesy of the* Seattle Times *Historical Archives.*

Seattle's Snoqualmie Ski Park opened a new era for skiing. It provided the public a place to try the new sport, and skiing thrived, as it was no longer dependent on access to private ski lodges. Thousands braved the cold and sense of danger to get out of the city into the mountains. This was the first public ski area on Snoqualmie Pass, and one of the first in the state, but it was little more than a narrow run cut through a dense forest. There were no tows, so skiers had to hike up the hill to be able to slide down with little sense of control. The equipment was rudimentary, and there were often no lessons available, so it was trial and error. According to Joy Lucas, "Little was known about downhill skiing and skiers learned the hard way—on their own.... Reading 'How to Ski' books was the only way to learn the sport." Skiing was so unusual that large numbers of spectators showed up on weekends to watch the adventurous athletes slide down the hill.

The first week of February 1934 was Winter Sports Week in Seattle, celebrating the opening of the Ski Park and promoting the upcoming Seattle Ski Club tournament at Beaver Lake. A Seattle Chamber of Commerce lunch honoring Portland ski officials was attended by the mayors of Portland and Seattle and three Ski Queens, including Marguerite Strizek, who reigned at the opening of Seattle's Ski Park. There were over fifty thousand skiers in the Northwest, so civic organizations got behind the idea of a Winter Sports Week, pointing out "the perfect opportunities for skiing abundant in this region" and "thumping home the message that Seattle has the best skiing in the United States." The *Seattle Times* ran a picture of Queen Marguerite and Alfred Lundin, the president of the Seattle Chamber of Commerce (and the author's uncle), promoting Winter Sports Week.

In February 1934, the Seattle Ski Club's Snoqualmie Summit tournament featured the first Pacific Northwestern Ski Association–sanctioned slalom

race, along with jumping and cross-country events. Ten thousand spectators were expected to attend the event, and transportation and parking were a concern.

The slalom race was "a test of racing skill which proved unexpectedly strenuous and spectacular." Conditions on the hill showed the advantage of newly developed steel-edged skis, as it was "almost a solid sheet of ice." The event drew a huge crowd, and "tournament officials were pondering a crowd phenomenon," as there were five thousand cars parked on the highway. "We have made skiing perhaps too successful," said the PNSA president. The fourteen-flag slalom course set by Ben Thompson "called for every whit of skiing skill and nerve." Forty-three skiers entered the race and twenty qualified for the two race finals, but only nine completed their two final runs. The slalom was won by Hamish Davidson of Vancouver, followed by Alf Moystad of Seattle. Davidson and the entire Vancouver delegation used laminated steel-edged slalom skis that he produced, whose edges held on the icy course. "Those without the steel edges were helpless. They slipped and fell." The advantage of the skis was demonstrated by the fact that some of the Northwest's best alpine skiers fell, including Don Fraser, Darroch Crookes, Hans-Otto Giese, Wolf Bauer and others. Ironically, Davidson's prize was a pair of laminated skis manufactured in Seattle. Henry Sotvedt won the jumping competition, and Nordal Kaldahl finished second. Tom Mobraaten of Vancouver won the combined cross-country and jumping championship. The hill was as challenging for the jumpers as it was for the slalom racers, as the icy course had to be "broken by men with axes."

A Seattle Park Board report described the first year's operations at the Ski Park:

Each winter skiing becomes more popular, and people of all ages seem to derive extreme pleasure from this unusual and health-giving pastime. We feel that the operation of the ski site at Snoqualmie Pass was a very timely thought, and the people of Seattle and the territory from which this ski site may be reached owe a vote of thanks to the government for the permission granted to the Park Department to use the ground for this purpose, as well as to the Board of Park Commissioners for their interest in the matter. The site consists of a 45 acre tract turned over to the City of Seattle by the U.S. Forestry Service on a five-year lease grant for recreational purposes. C.W.A. labor constructed a building for the use of the people who frequent the ski course, and Park Department employees with the assistance of other

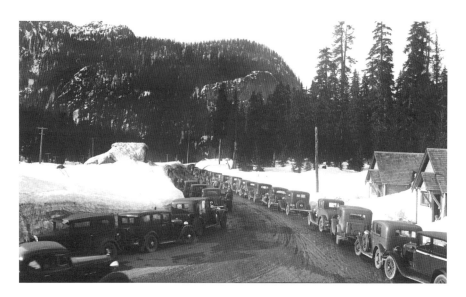

Cars parked on the highway for Seattle Ski Club jumping tournament at Beaver Lake, early 1930s. *Courtesy of the Washington State Archives.*

interested citizens of Seattle donated spare time in clearing the ground for use, preparatory to the work which was done by the C.W.A. workers.

The first edition of *Ski* magazine, published in January 1936, praised the Seattle Ski Park:

High school boys and girls are the skiers of today and tomorrow. They cannot afford trips to distant places and to expensive hotels, but they must have physical activity to develop fully and to satisfy their love of adventure. The exhilaration of swift running skis, the purity of mountain air, the achievement of skill and the approbation of their companions, the feats of daring on skiis [sic]…all these give to young America an outlet of exuberant spirits. It is a youth movement worth while. It teaches them teamwork, self control, good sportsmanship, ability to overcome obstacles, to endure and enjoy a mountain storm and to really know the outdoors in all its varying beauties and vicissitudes. Let us then work ceaselessly for the further development of skiing in Snoqualmie Pass.[12]

1934: SEARCH FOR NEW SKI AREA SITE, SILVER SKIS RACE ON MOUNT RAINIER BEGINS

Even though the Cle Elum Ski Club held its last tournament in 1933, John Bresko had plans to develop a new ski area at a more accessible location. In 1934, Bresko obtained forty acres of land on the Cle Elum River above the Bull Frog Bridge west of the city and planned a ski jump, tower and runway close to the highway. The project received a $10,000 grant from FDR's Works Progress Administration.

The *Cle Elum Miner-Echo* reported on December 14, 1934, that work on the new ski hill would begin soon. Bresko said the new hill would be the largest jumping course in the Northwest and would make jumps of 250 feet possible. The following week, an eighteen-man crew would "erect a 50-foot tower and a take-off and will grade the hill to the correct contour. Spectators will be able to drive within 100 feet of the jump and may watch the events from their automobiles." The old course, on which skiers leaped 200 feet, measured 360 feet. The new hill would be 460 feet from the takeoff to the bottom of the hill, giving plenty of reserve after a long jump. Bresko planned to install an aerial tram, and Northern Pacific Railroad's land subsidiary expressed interest in installing the tram and developing the ski area. However, due to lack of funds, Bresko's dream never became a reality, and the plan was dropped.[13]

In the spring of 1934, the first Silver Skis race on Mount Rainier was held, which became the iconic Northwest race and helped to popularize alpine skiing. Hans-Otto Giese, a German immigrant who became an important figure in Northwest skiing, convinced *Seattle Post Intelligencer* reporter Royal Brougham that the race would show the rest of the country that the Northwest had great skiing, and the newspaper agreed to sponsor it. Brougham described the race as the "Kandahar of the Northwest" and the "Kentucky Derby of downhill racing." Competitors had to hike from Paradise Lodge at 5,400 feet up the mountain to Camp Muir at 10,000 feet using skins on their skis before skiing down glaciers and snow fields to finish at Edith Creek Basin near Paradise Lodge, a distance of nearly four miles. Racers dropped 1,424 feet in every mile they skied, 1 foot in 5. The pitch gave racers maximum speed of "slightly better than sixty miles an hour" before they traveled 300 yards. Snow conditions could range from sheer ice to slush.

Otto Lang, a famous Austrian ski instructor who later taught in the Northwest, described the race in his autobiography:

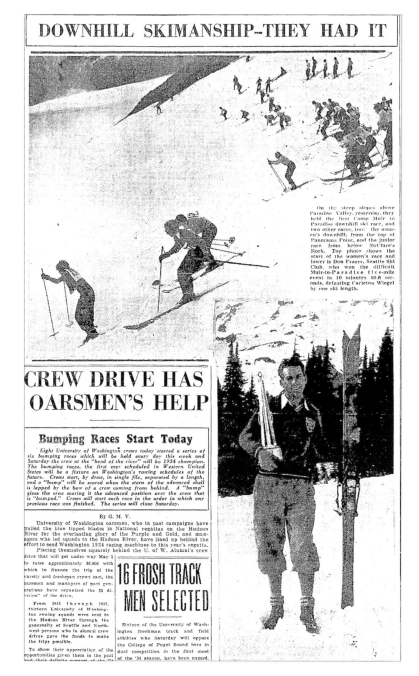

The first Silver Skis Race on Mount Rainier from Camp Muir to Paradise Lodge, described as the "Kandahar of the Northwest" and the "Kentucky Derby of downhill racing." Pictured here are the women's mass start and winner Don Fraser, *Seattle Times*, April 23, 1934. *Courtesy of the* Seattle Times *Historical Archives.*

For racers, the climb to the starting point, a matter of two or three hours, was laborious and exhausting…The course was in its natural condition, whether there was a heavy layer of freshly fallen snow, an icy crust, windblown moguls, or treacherous gullies….The weather could be a factor, with a sudden bank of dense fog rolling in and obliterating the course…. The terrain was varied and undulating, interspersed with long, moderately pitched, straight runs. A punishing, steep schuss led to the finish line above the finish line above the main lodge, Paradise Inn, at 5,200 feet. With a vertical drop of 4,800 feet and a total length of 3.25 miles, it was not technically demanding but a leg killer nevertheless because of the sheer distance covered and the terrain, where one either had to go straight at high speed or make a lot of tiring, time-consuming turns.

The first race featured a mass start, with all the competitors starting at the same time, and the first one to the finish line won. Sixty-six racers started the race, forty-four finished and four were hurt in the first half mile of the race, with 2,726 spectators watching. Don Fraser of the Paradise Ski Club won the men's race (and won again in 1938), with a time of 10 minutes, 19.6 seconds, and Marguerite Strizek won the women's race. "Fraser Wins the 5-Mile Ski Dash" declared the *Seattle Times* of April 23, 1934. "Most unique starter of all was Martin Tverdal, Seattle Ski Club jumper. He took to the starting line heavy jumping skis, no ski poles. His speed was high—but he needed the poles. He went tumbling, parallel with the rock island below Anvil." Fraser said Tverdal "was whirling end over end like a top." The mass start was abandoned after 1934. The race was held from 1934 to 1942, and after the war in 1947 and 1948, and it became one of the Northwest's iconic ski races, one that helped to popularize alpine skiing.[14]

4

Alpine Skiing Grows in Popularity as New Ski Areas Open, Nationally Important Races Are Held and Ski Lifts Inc. Installs Rope Tows, 1935–1937

*I*n the middle 1930s, alpine skiing began to challenge ski jumping in popularity as new clubs formed, new ski areas opened, alpine races were held and the movement to bring ski lifts to Washington ski areas came to fruition. Interest in alpine skiing received a huge boost from several major events. First was the National Downhill and Slalom Championship Tournament and Olympic team tryout, held on Mount Rainier in 1935, which resulted in the selection of five local skiers to go to Europe for the 1936 Olympic Games in Germany. The 1936 Olympic Games themselves were the second. Third was the opening of Sun Valley Ski Resort in December 1936, which had a huge impact on skiing in the Northwest and the entire country. These events received extensive publicity and generated new interest in alpine skiing that resulted in the development of new ski resorts in Washington, including the Milwaukee Ski Bowl on Snoqualmie Pass, and the installation of rope tows in a number of local ski areas.

Several new ski clubs were organized in 1934. The Washington Ski Club formed with seventy-five members to focus on competitive alpine ski racing. Membership was open to any person over eighteen, "white, and a citizen of the United States of America." The club sponsored most of the major alpine races in the Northwest until World War II. The University of Washington Ski Club and ski team were also started, and the university's ski team began competing in collegiate tournaments against other schools, becoming one

of the best on the West Coast. Ski team members were typically four-way competitors who participated in alpine events (downhill and slalom), cross-country and jumping.

Alpine skiing began to challenge ski jumping as the region's most popular winter sport. The Seattle Ski Club, the senior club of the district, and the Washington Ski Club, the youngest, "are bending serious efforts to the acquisition of new material—be it downhill racing material, or jumpers." The Pacific Northwestern Ski Association warned that "unless juniors eager to learn ski jumping of the better variety are located, groomed and developed, ski jumping two or three years from now will go into serious decline":

> *It has become increasingly apparent with the development of slalom and downhill racing that jumping—a fine and daring ski sport, safe only for the most adept—would inevitably decline unless a program were sharply defined to build it up. The bulk of Class A jumping rests with those Norwegian youths comparatively fresh from the old country. Class B has seen casual development among the American born, but not enough.*

The PNSA said it would encourage slalom and downhill racing, and member clubs would construct courses where they have never been before. The Cle Elum Ski Club was planning to open a new hill close to the Sunset Highway with a slalom course "pouring practically onto the apron of the jumping hill." The Leavenworth Winter Sports Club "sized up a precipitous hillside directly contacting its jump, and doubtless will construct a slalom course on it."

In October 1934, the Pacific Northwestern Ski Association authorized the Washington Ski Club to make a bid to hold the National Championship Tournament and Olympic trials in 1935 at Paradise Valley on Mount Rainier, since the Northwest "possessed of admittedly the finest ski terrain in America." The move recognized the "tremendous growth in the popularity of slalom and downhill racing....Slalom and downhill racing are entitled to equal recognition with jumping and cross-country, and this organization cannot be caught napping." PNSA's bylaws and constitution were amended to recognize alpine events, which would be added to the Pacific Northwest championships, and a four-way championship would start the following year, with equal weight given to each branch of competition.

In December 1934, the National Championship and Olympic selection tournament was awarded to the Washington Ski Club by the American

Olympic Games Committee. This was a major step forward for alpine skiing in Washington and the entire country.

On January 28, 1935, the *Seattle Times* reported that the Washington Ski Club won a combined downhill and slalom tournament in Oregon, and Oregon skiers were "licking their wounds." There was more than just the tournament victory—"the sport is catching on and Washington skiers are leading the way."

1935: NATIONAL CHAMPIONSHIP TOURNAMENT AND OLYMPIC TRYOUTS ARE HELD ON MOUNT RAINIER

Alpine skiing in Washington got a major boost as the best skiers in the country competed on Mount Rainier on April 13 and 14, 1935, at the National Downhill and Slalom Championships and Olympic tryouts, hosted by the Washington Ski Club. The first National Alpine tournament took place in 1933 at Mount Moosilauke, New Hampshire, an event that received no local publicity. The Mount Rainier tournament was one of the early significant alpine races in the country.

There were fifty-nine entrants in the tournament: eight from the East; one from the Midwest; thirteen from the Rocky Mountains; twelve from California; fourteen from the Pacific Northwest; ten from Canada; and one from Austria. Northwest racers included Hjalmar Hvam of the Cascade Ski Club of Portland; Washington Ski Club members Don Fraser, Carleton Wiegel, Ken Syverson, Hans Grage and Darroch Crookes; John Woodward of the UW Ski Team; and Emil Cahen of the Seattle Ski Club. The 2.19-mile-long downhill course had 2,750 feet of vertical drop from Sugar Loaf at 8,500 feet above sea level down to Panorama Point and Edith Creek basin on a 35 percent slope. The 1,500-foot slalom course had twenty turns on a course along Alta Vista.

The *Seattle Times* had extensive coverage of the tournament between April 14 and 18, 1935. More than seven thousand spectators hiked two and a half miles from Narada Falls to Paradise and another two miles to the slalom course. Hannes Schroll, an Austrian teaching at Badger Pass at Yosemite, won the slalom, downhill and combined events, beating favorite Dick Durrance of the Dartmouth Ski Team. Schroll was known as "the madman of the Alps" and the "tornado on skis; a whooping, yodeling, hat-throwing, rip-snorting fool who doesn't respect fog ice, precipices,

avalanches or tradition." The downhill course was shrouded in fog for over a mile and covered by an avalanche near the finish line before it was cleared. "Schroll didn't fall. He went leaping from snow terrace to snow terrace, and sometimes as far as 60 feet, landed on one ski, [fighting] wildly for balance and recovered," reaching seventy-five miles per hour in the mist and fog, surprising the spectators as he came out of the fog yodeling and waving his hat. "That Amazing Schroll…who stole the ski meet, is as great a piece of coordinated athletic machinery as this writer has ever seen in action," used a European skiing technique that "beats American methods all to pieces," according to a *Seattle Times* sportswriter. The event's three best U.S. skiers, who were "almost certain to be selected to the Olympic squad," included Dick Durrance of Dartmouth College, who was first of all U.S. competitors (and second in the combined); E.D. Hunter Jr. of Dartmouth College; and Robert Livermore Jr. of Boston's Hochgebirge Ski Club.

Two sisters from Tacoma won national titles, "skiing off with major awards in the initial running of the women's national championships in downhill and slalom." Ellis-Ayr Smith, who had only been skiing a couple seasons, "made a thrilling run down the side of Panorama to Edith Creek Basis in the remarkable time of 1:57.6 to best a field of 14 competitors," winning the women's national downhill title, beating Seattle's Grace Carter by thirty-six seconds, "falling only once. Most of her competitors were somersaulting 5 to 15 times in their do-or-die races against time." Ethelynne "Skit" Smith won the women's national slalom title, beating Grace Carter by three seconds. Ellis-Ayr finished fourth in the slalom, and "the big thrill of the day" came when it was announced that she won the combined National Championship title. Grace Carter finished second in the combined and Skit Smith sixth. The *Seattle Times* published a picture of the Smith sisters on April 18, with the accolade "Tacoma's Great Ski Champions," and the *American Ski Annual* called them the Tacoma Ski Queens. A teenage girl named Gretchen Kunigk from Tacoma, who would later make her mark in ski racing, was "watching in awe from the sidelines."[15]

On October 3, 1935, the *Seattle Times* announced that Seattle and Tacoma would send five men and women to the Olympic Winter Games in Garmisch-Partenkirchen, Germany. "Those are Don Fraser and Darroch Crookes, both of Seattle, for the men's U.S. Olympic team, and Ellis-Ayr and Ethelynne Smith of Tacoma and Grace Carter of Seattle for the women's Olympic team." The Tacoma and Seattle sections of the Washington Olympic Ski Committee guaranteed the funds for the skiers' costs:

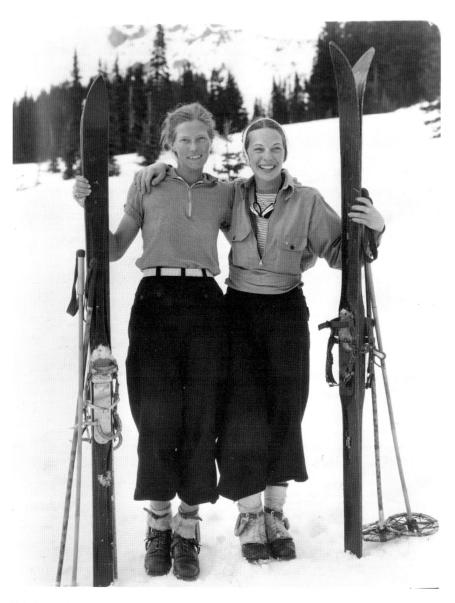

Ethelynne "Skit" Smith and Ellis Ayr Smith from Tacoma, the 1935 national slalom and national combined champions at Mount Rainier in 1934 and members of the 1936 U.S. Olympic team. They were called the Tacoma Ski Queens. *Courtesy of the Tacoma Public Library.*

Don Fraser never competed in the National Championships or U.S. Olympic trials. Four days before they were held, boring at high speed down the series of snowbanked terraces high above Paradise, he leaped a bank…80, 90 feet. In fact, he overleaped it, landing on an uphill slope, in skiing, you can't do that. The speed is too severe. He ripped ligaments in his leg, and was carried out in a toboggan. But Eastern skiers, who had seen him pass them, said he ought to go. He was chosen for the team on reputation and past record. Darroch Crookes of Seattle had no 1933–1934 competitive record. He was working. He went back into competition that winter, placed high in the Nationals. On the strength of his showing and the knowledge that he had fine powers, he was chosen. Ellis-Ayr Smith won the national women's downhill race. Her sister Ethelynne—"Skit" to her intimates—won the national women's slalom race.

Olympic athletes were not treated the same in those days as they are now. Don's future wife, Gretchen Kunigk Fraser, said that he worked his way to Europe on board a Norwegian freighter, chipping rust and painting the decks for thirty-one days, earning one dollars per day. Don also got seventy-five dollars plus free room and board for two weeks once he reached the Olympic site, along with a fifty-dollar overcoat, cap and sweater.[16]

The 1936 National Ski Year Book described how influential the 1935 National Championships and Olympic Tryout tournament were in Seattle, summarized in the *Seattle Times* of December 8, 1935:

The widespread general public interest in the National Downhill and Slalom Ski Championships was most surprising. In the East, only those "in the know" would have been talking freely and venturing opinions. In Seattle, however, the championships seemed as general a subject of public conversation as baseball games are in Boston.

Upgrades to skiing facilities for the upcoming ski season show the growth of the sport. Seattle Ski Club improved its ski hill close to the highway near Snoqualmie Summit with $25,000 worth of labor from its members. The Forest Service spent $35,000 on two projects. First, a warming hut was built close to Leavenworth's big jump with comfort facilities, shower baths, a lunch stand, a large lounge with a nine-foot fireplace, caretaker's facilities and conveniences. Second, at Mount Baker, a large stone shelter was erected on the site of the race course where competitors could warm up and eat. A shelter was built at McClure's Rock in Paradise Valley on Mount Rainier, "a

welcome protection for high altitude skiers," and major improvements were made at the Paradise Inn. In addition, the Forest Service cleared a large area at Leavenworth, opening the hillside for skiing with both gentle and steep slopes. The club offered two warming huts and several jumping hills of all sizes, from little eighteen-inch ones up to the "famous big A hill," which had been rebuilt by the CCC.

1936: MAJOR EVENTS POPULARIZE ALPINE AND NORDIC SKIING

A series of events in 1936 increased interest in both alpine and Nordic skiing in the Northwest.

Winter Olympic Games in Germany

The 1936 Olympic Games were held in Garmisch-Partenkirchen, Germany, in February. Demonstrating the strength of Northwest skiing, five Washington skiers went to Europe for the 1936 Olympic Games, and their experiences were carefully followed by local newspapers. These Olympics featured alpine skiing for the first time, with a combined downhill and slalom event, along with the traditional Nordic events. Men and women competed in the alpine events, but only men were allowed in Nordic events. In Europe, eight men and eight women racers would compete for four men's and four women's slots on the U.S. team, who would race in the Olympic Games. All of the Northwest skiers except for Skit Smith made the eight-person teams, but none was selected to race in the games, although all were considered to be members of the 1936 U.S. Olympic team.

On January 29, 1936, the *Seattle Times* said Don Fraser hit a tree and hurt his hip in practice and wasn't responding to treatment very fast, but he still hoped to race on the downhill squad and on the cross-country team. The injury took Fraser out of the alpine events, but he had been a successful cross-country racer so he attempted to become one of the four U.S. cross-country entrants for the eighteen-kilometer races. He was selected as an alternate but did not race, although he was said to have been a member of both the alpine and Nordic U.S. Olympic teams. Crookes took fifth in the downhill trials, just missing the cut to race in the games. Grace Carter was number five on the women's team and the first substitute.

In the Olympic downhill, Americans Dick Durrance finished eleventh, Tony Page took seventeenth, Bob Livermore took twenty-eight and Link Washburn took thirty-fourth. Durrance said his poor finish was the result of using the wrong wax. He did better in the slalom and finish tenth in the combined, the highest American skier. German skiers won gold and silver in the combined, and Emile Allais of France won bronze. In the women's combined, Germans won gold and silver, and a Norwegian won bronze. Durrance went on to have a distinguished skiing career, was inducted into the U.S. Ski and Snowboard Hall of Fame in 1958 and, in 2011, was named the "skier of the decade" for the 1930s in the seventy-fifth-anniversary edition of *Ski* magazine.

In the jumping competition, watched by 100,000 spectators, Norway's Birger Ruud won the gold medal, Reidar Andersen took the bronze and Sweden's Sven Eriksson won silver. Sverre Fredheim of St. Paul, Minnesota, was the highest U.S. jumper, finishing eleventh. Ruud nearly achieved an unprecedented double Olympic win. In the combined downhill/slalom event, he won the downhill by 4.4 seconds but missed a gate in the slalom and placed fourth, just out of medal contention. Both Ruud and Andersen later competed in the Northwest.

After the Olympics, the Northwest skiers, along with many other U.S. ski team members, stayed in Europe and entered other tournaments to improve their skiing, competing at the FIS race at Innsbruck and the Kandahar race at St. Anton, Austria. By this time, Grace Carter had worked her way from number five on the women's team up to number two. None of the northwestern skiers did well against tough European competition, but they gained valuable experience. In 1937, Grace Carter married Alfred Lindley, who was a member of the 1936 U.S. Olympic team, and they moved to his hometown, Minneapolis. They both played a major role in Sun Valley over the next decade.[17]

Ski Magazine Promotes Northwest Skiing

The premiere issue of *Ski* magazine, published in January 1936, lauded Northwest skiing, saying it was "the Switzerland of America" with perfect conditions for skiing. "With a mild climate and close proximity to population centers, golf may be played in the lowlands while skiing takes place among the mountain tops." Snoqualmie Pass was Seattle's closest skiing area, "a mecca for thousands who have but a day to spend." At Leavenworth, a

government grant paid for the clearing of trees and stumps from a forty-acre skiing area by the Forest Service and CCC. The club had several jumping hills and a variety of slopes and trails. Stevens Pass was comparable to the best ski terrain found in the Northwest, and a clearing and building project was being considered by the Forest Service for 1936, similar to the work done at Leavenworth. The Mountaineers, Washington Alpine Club, Washington Ski Club and Seattle Ski Club were organizations that "blazed the trail" for local skiing. The University Book Store offered a two-hour bus service from Seattle to Snoqualmie Pass on Sundays for $1.50 and rented ski equipment. The Northwest offered "one of the longest ski seasons in the world. Spring and midsummer skiing starts around March and continues as late as June or July. At these dates, we turn to the vast sun-lit expanses of ski ground that lie between glaciers."

Seattle's Snoqualmie Ski Park was "unique in American skiing, since it is owned and operated by a city and is undergoing somewhat of a spiritual transformation." The area was "a long descending triangle of cleared hillside, spreading out at the bottom like a delta. But its popularity the past two years has grown to such a degree that skiing was actually dangerous."

Skiers at the Seattle Municipal Ski Park in 1936. *Courtesy of the Seattle Municipal Archives.*

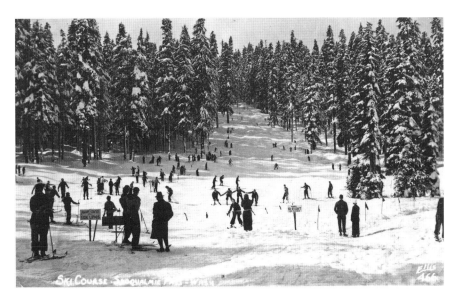

Seattle Municipal Ski Park before a rope tow was installed, showing how skiing was regulated with signs, 1937. *Courtesy of the Moffett family.*

A Seattle Park Department employee was appointed as the ski director or traffic cop for the Ski Park, and skiing was becoming "more or less controlled." He said, "No more of this stuff of skiers climbing up in the middle and getting knocked down by someone who hasn't learned to make a turn....We're trying to educate them to go up the sides and then ski down the middle. The upper half of the slope is for the better skiers, who perhaps are learning to turn to a stop. My megaphone helps. I stand in the middle and direct traffic." The city hoped to persuade the Forest Service to widen the ski area by cutting trees. Floodlight skiing would begin soon, using three huge searchlights placed at the bottom of the hill.

The Mountaineers Join PNSA and Open Its Patrol Race to Other Club Members

In 1936, The Mountaineers joined the Pacific Northwestern Ski Association and opened its twenty-mile Club Patrol Race from its Snoqualmie Lodge to Meany Ski Hut at Stampede Pass to other PNSA-affiliated ski clubs.

Five three-man ski patrol teams entered the 1936 race, which was "an eighteen-mile grind along the crest of the Cascades" and the

"nation's longest and hardest ski race." The Seattle Ski Club team of Roy Nerland, Howard Dalsbo and Ole Tierdal won, finishing in four hours, fifty minutes and thirty-seven seconds, beating the second-place College of Puget Sound team by four hours. Dalsbo pulled a tendon in his knee ten miles from the finish but "gamely finished." It was thought the College of Puget Sound team turned back, but the skiers arrived at Martin nine hours after leaving the Snoqualmie Lodge and were the only other competitors that finished the race intact. The Washington Ski Club team was disqualified when a member broke a ski and borrowed an emergency ski tip from another team, since competitors may not accept assistance from another team.

The Mountaineers' 1937 Open Patrol Race was "a grueling haul designed only for the best cross-country racers of each club." Teams started at five-minute intervals beginning at 9:00 a.m., and all teams not past the halfway mark by 2:00 p.m. would be turned back. The race was won by the team of Sigurd Hall, Bill Degenhardt and Scott Edson in five hours, twelve minutes and five seconds. "Condition of the long Cascade Range course, crusty."

Seven patrol teams entered in the 1938 race, which consisted of "twenty miles of ice." The *Seattle Times* of February 28, 1938, described the difficulty they faced:

> *No audience will watch them, for their course doesn't run past any grandstand; but a small group at the finish will cheer six three-man ski teams…at Martin, far up in the Cascades, when they cross the line in the third annual Northwest Patrol Race championships. They'll have earned it. To reach Martin, twenty miles from their start at Snoqualmie Lodge of The Mountaineers, they must climb several times, to heights of 1,000 to 3,000 feet. They'll be downhill trails, of course…eleven miles in all. But they come dearly, when the teams are slugging their way along as fast as wind and muscle will permit.*

The race was won by The Mountaineers' team of Sigurd Hall, Scott Edson and Arthur Wilson in four hours, fifty-seven minutes and forty-five seconds. "It wasn't the record, or even close to it, but it was for the sort of skiing conditions encountered."[18]

WPA Plans Major Improvements to the Jumping Facilities at Seattle's Snoqualmie Ski Park

The Seattle Park Department's Report for 1936 said the Snoqualmie Ski Park operated between January 27 and April 20, 1936, from Fridays to Sundays. Total attendance was 16,480, with 400 to 500 people on the hill on several Sundays. The hill was divided by ropes to allow more people to use the hill at once with less danger, providing a regular uphill route separated from the area on the left for those coming down. Lights allowed skiers to enjoy night skiing. Ski races were not encouraged due to the lack of space, although the Annual High School Meet was held there. Special buses brought kids to the Ski Park. Regular bus service was provided by the University Book Store. "With skiing's popularity growing every year, it seems advisable that the skiing area be enlarged for safety and really enjoyable skiing by the many who use the ski hill during the winter."

The WPA announced plans to make major improvements at Seattle's Snoqualmie Ski Park in late 1935 as part of its program to put the unemployed to work, although the project dragged on for several years and was never built due to cutbacks in federal funding.

On December 8, 1935, the *Seattle Times* announced that $50,000 in WPA projects had been approved for Seattle's Snoqualmie Ski Park. A new jumping hill was to be built, "the most modern one this side of the huge Olympic take-off at Lake Placid, New York," along with "a comfortable cabin for skiers who frequent the Seattle Park Department's big ski sector." Snoqualmie Summit

> *probably has more skiers to the square inch during the winter season than any area, due to its easy availability and also due to the fact that it was at Snoqualmie Pass that modern skiing was really born and raised. It is the home of Seattle Ski Club, the Mountaineers, Washington Alpine Club, and now one of the leased Washington Ski Club Lodges. It is the hub of more ski tours than can even be imagined; it is the home of the annual Seattle Ski Club tournaments, and next February is the host to the Pacific Northwestern Ski Association jumping and cross-country championships and to the Pacific Northwestern Junior championships in jumping, cross-country, downhill and slalom racing. Its high altitude length is dotted with private cabins of winter sports enthusiasts.*

WPA's plans were discussed by the *Seattle Times* throughout 1936. A grant of $18,520 would create a "new skiing paradise," to include a 200-foot jumping hill, new trails and a large warming shed. Land would be cleared for a new ten-acre park, and improvements made on the existing five-acre park. The existing 20- by 20-foot warming hut would be supplemented by a 60- by 30-foot structure with a large rock fireplace. It was noted that there were 100,000 skiers in the United States, of which 25,000 to 30,000 were in the Northwest. A 225-foot-capacity jump designed by Peter Hostmark would give the West a hill comparable to the magnificent ones in Norway. The runout would be lined with a grandstand, and the hill would be a model of engineering perfection open to all Washington skiers, although the Seattle Ski Club would maintain it.

Unfortunately, WPA funds were "slashed in 1936 and 1937, its work force in Washington was curtailed," and the Snoqualmie Pass project never came to fruition. In the fall of 1937, the Pacific Northwestern Ski Association considered transferring the Northwest Jumping Championships from the Seattle Ski Club to another club "since the Works Progress Administration failed to construct a promised new jumping hill at the summit of Snoqualmie Pass."

On December 27, 1936, the *Seattle Times* discussed highlights of the ski year. The top highlight was Washington Ski Club's sending its five best competitors to Europe as members of the American skiing team. Second was the "avalanche of interest" in skiing, which department stores, sports goods stores, hardware stores and apparel stores saw and were stocked to meet. "The mountain passes were choked each week with ski-jammed cars. There was no place in America where skiing was as good or so convenient. The snow was deep as usual."

Sun Valley Opens, Transforming Skiing in the United States

In December 1936, Union Pacific Railroad opened its Sun Valley Ski Resort in Ketchum, Idaho, with a luxurious lodge and chairlifts developed by railroad engineers to carry skiers up the mountains, transforming skiing in this country. The *Seattle Times* of November 18, 1936, described the new resort:

> *Sun Valley was born—a fashionable ski resort costing Harriman and the Union Pacific something more than $1,000,000; offering a luxurious,*

ultra-modern hotel with accommodations for some 200 guests; sun-bathing
in roofless ice igloos; mid-winter swimming in outdoor swimming pools fed
by natural hot springs; ski-tows to raise skiers 1,470 feet in elevation on a
6,500-foot-long hoist; the other which gives the skier 650 feet of elevation
above the valley level.

Sun Valley was the country's first destination ski resort and attracted skiers from all over the world, including members of the New York Social Register, people from Chicago's north shore suburbs, Hollywood movie stars, eastern businessmen and Seattle residents. Skiers went there to ski on the huge mountains served by chairlifts, to learn how to ski from a staff of European experts who gave the area a colorful and international flavor and to socialize with like-minded people.

It is hard to envision now the impact that Sun Valley had on Washington's skiing community. Skiing in Washington was done in private ski clubs or on local mountains, which involved climbing up the hills as there were no ski tows. Ski gear was rudimentary, and there were limited ski lessons available at best.

Sun Valley could be reached from Seattle by Union Pacific trains in comfort and safely. "Sun Valley was 26 hours from Seattle by train, and 20 hours by car, but it might as well be in Seattle's back yard," according to the *Seattle Times*. Seattle newspapers regularly reported on ski races in Sun Valley and on the local skiers and socialites who traveled there to enjoy its year-round attractions in both its sports and society sections. Sun Valley was mentioned in the *Seattle Times* 227 times in 1937 and 234 times in 1938. "Washington ski areas are certain to feel direct benefits from the creation of Sun Valley Lodge," the country's most ambitious ski resort.

1937: Ski Schools are Opened, Rope Tows are Installed at Three Ski Areas

Otto Lang Opens Ski Schools and Seattle's Snoqualmie Ski Park Continues Its Success

In the winter of 1937, noted Austrian ski instructor Otto Lang started the first Hannes Schneider Ski School in the country, bringing the latest European Arlberg ski technique to the Northwest, "revolutionizing a sport

that had no chair lifts, no groomed runs and long, tough-turning skis." A *Seattle Times* headline on January 13, 1937, proclaimed "Lang's Work Is Reviewed, Young Austrian Instructor Has Changed Skiing." Hannes Schneider from St. Anton am Arlberg, Austria, founded the first modern ski school, helping to develop skiing as a recreational sport and creating the Arlberg style considered to be the basis of modern skiing. Lang explored the Northeast, the Rockies, California and Canada looking for a place for his school. "Then he chose Rainier and Baker—an alternating series of instructions at each place is his plan." Lang said, "This is the place. You have the slopes, the finest in America. You have the potential skiers, and the enthusiasm."

Lang ran ski schools at Rainier and Baker in the winters of 1937 and 1938, and a ski school at Mount Hood in 1938, to take advantage of the newly opened Timberline Lodge built by the federal government, before he moved to Sun Valley for the winter of 1939. A number of ski instructors who worked for Lang played significant roles in ski schools elsewhere, including Ken Syverson, who headed the Seattle Times Ski School at the Milwaukee Ski Bowl after it opened in 1938.

Lang's best-known student was Gretchen Kunigk (later Fraser), whom he coached on Mount Rainier when she was sixteen years old. She began winning races on a regular basis in 1937, skiing for the Washington Ski Club and battling the Smith sisters and Grace Carter from the 1936 Olympic ski team:

> *She was petite and muscular, well proportioned, and blond, and radiated charm. She enrolled in the school, and in only a short time I could tell that this young lady had the determination to go far in the skiing world. She grasped important technical points quickly and improved rapidly. At the time I had not even the slightest inkling of what the future might hold for her. Her well-balanced personality and poise, for one so young, impressed me. Furthermore, her infectious sense of humor made her a delightful companion.*

Lang covered the 1948 Olympics for the *Seattle Post Intelligencer*, and there he saw Gretchen win two medals in skiing. He was inducted into the U.S. Ski and Snowboard Hall of Fame in 1978.[19]

The Seattle Park Board's Ski Report for winter 1937 described another successful year. The Ski Park opened on Sunday, December 20, 1936, and closed Sunday, May 2, 1937, operating from Friday to Sunday. Total

attendance was 19,865, with 2,800 being the largest single day. Buses carried high school students and special groups to the area. Local sporting goods stores sent at least one special busload of skiers every Sunday in January and February. A one-thousand-watt floodlight on the hill made night skiing more popular than daytime skiing. "It must be said that from the crowded condition of the hill and the falls some of the skiers took it is really a miracle that there were no broken arms, legs or bodies." A larger cleared area was necessary to accommodate the hundreds of skiers who overcrowded the hill each week.

Seattle's Ski Park was small and jammed too many beginners into a small area, according to the *Seattle Times* of November 11, 1937. This situation was somewhat relieved by the extension of its trails back into the timber on the top side,

> *but it is somewhat hazardous to come down any but in a generally straight line. Those who try to curb speed by traversing become the target for those, who, with more courage that ski-savvy, click skis together in the military manner and shaft straight down, completely out of control, they fall, bounce, start cart-wheeling, and wind up with the half-dozen unfortunates they have knocked down.*

Seattle's lack of funds to bring the Ski Park up to the condition that the Forest Service desired was discussed in a Forest Service letter to the city dated July 16, 1937:

> [T]*he City of Seattle has done very little as yet toward carrying out the original plan for development which I understand was to be put into effect as rapidly as possible by the Park Department. For example, the warming house and the latrines are makeshift structures which were approved by the Forest Service representatives only until such time as it was demonstrated that the public use of the area required permanent structures. Our experience over a period of three years has indicated that the buildings and the existing ski runs are inadequate and that the increasing public use will make it imperative that additional and better facilities be installed not only for skiing but also for the comfort of the skiers. Sanitary facilities always have been inadequate.*
>
> *I realize that limitations of funds and the difficulty of using relief labor have made it difficult for the City to carry out all of the plans which were originally contemplated. On the other hand, the project has been started by*

the City, the public has made use of the area and undoubtedly will continue using it to such an extent that both the Park Department and the Forest Service will be subject to just criticism if no further action is taken to meet the public's needs.[20]

Ski Lifts Inc. Installs Rope Tows at Three Ski Areas[21]

The success of the chairlifts at Sun Valley and publicity about rope tows installed at eastern resorts motivated Northwest skiers to work on getting tows installed in local ski areas.

Seattle's Junior Chamber of Commerce lobbied for ski lifts to be installed at Northwest areas at its Spring Carnival at Paradise in 1937: "Skiing needs more uphill lift than downhill drag. Ergo, build ski lifts…'A ski lift on every mountain' might well be the slogan. The Junior Chamber of Commerce is serious about this. It wants them at Mount Rainier, Mount Baker, Chinook, Pass, Yakima, Mount Spokane…but why go on?" National Park and Forest Service officials were unhappy since they "want their lands kept clear of encumbrances such as overhead trams and chair lifts, to maintain pristine beauty untouched by the hand of man. Plans for lifts at Rainier, Baker and Snoqualmie Pass will likely be resisted right up to the President of the United States.…The necessity of funiculars in the development of great ski areas brooks no argument." Skiers are not made by climbing hills—they develop proficiency by coming downhill. Skiers at Rainier get in around four thousand vertical feet of skiing a day. At Sun Valley, with its chairlifts, a skier can get in thirty-seven thousand feet a day. The Junior Chamber of Commerce planned meetings with National Park and Forest Service officials, and by next year, the members wanted their plan to be in full swing.

During the summer of 1937, private individuals talked to the official in charge of Seattle's Snoqualmie Ski Park about installing a Sun Valley–type tram or chairlift there on a commercial basis for the next winter. Initially, it was thought that such a lift would put too many skiers on an already congested hill. The area "has never been large enough to handle the crowds." However, a ski tow might thin out the "downhill running crowd" and make skiing safer.

In August 1937, James Parker and Chauncey Griggs formed Ski Lifts Inc. to build and operate ski lifts in the Northwest, combining their financial resources and PR talents. Griggs came from a wealthy Tacoma family whose fortune was made in real estate and timber. Parker had been a ski coach in

the Northeast, where he helped to build two rope tows, and an assistant to Otto Lang at his Mount Rainier ski school. Their work would help transform skiing in the Northwest.

In the summer of 1937, Ski Lifts Inc. sought permission to install rope tows at Seattle's Snoqualmie Ski Park, Mount Baker and Mount Rainier. On June 5, 1937, Parker wrote the Seattle Park Board proposing to install a ski tow at the Snoqualmie Ski Park, which would lead "this area to its greatest possibilities as a popular ski center." Parker discussed the benefits of ski tows based on experience from eastern ski areas:

SAFETY: In a congested area a ski tow eliminated the most frequent of accidents: collision between person ascending and person descending, by concentrating uphill traffic along the tow line and leaving the slope free for downhill skiers....PROFICIENCY: The eastern skier has developed faster with the introduction of the ski tow....The western skier has no hope of competing with the eastern product unless he is given the opportunity of more downhill practice. ENJOYMENT: Five times as much downhill skiing is possible with a ski tow. The skier arrives at the top fresh for the down run.

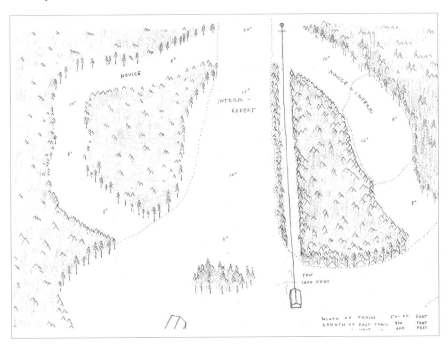

Ski Lifts Inc.'s drawing of the Seattle Municipal Ski Park with a plan for a rope tow. *Courtesy of the Seattle Municipal Archives.*

INCREASED CAPACITY: In a limited area a tow makes it possible for many more skiers to use a hill satisfactorily....ADVANCEMENT OF SKIING: The added enjoyment of skiing with a tow will bring more people from the cities into the out-of-doors during the winter months. A ski tow at Snoqualmie would make it the most popular ski center in this area.

Seattle's Board of Park Commissioners gave permission to Ski Lifts Inc. to install a ski lift at Seattle's Snoqualmie Ski Park, as reported in the *Seattle Times* on August 27 and 28, 1937:

Designed to save skiers the long, weary uphill trek before the exhilarating downhill trip may be accomplished, the lift will go in operation on or about December 1....Seattle ski experts felt that with the added inducement of the lift at Snoqualmie, hundreds of additional lovers of the sport would flock to the area and that the Forest Service would be asked for further space to handle winter sports....Skiers need lifts. And from the civic standpoint, lifts are essential if ski-tourists are to be attracted here. Throughout Europe, the ski lift is institutional: in fact, it is essential if a resort is to survive. And the lack of ski lifts is the only thing that is preventing Washington ski areas from dominating those in Europe.

By the fall of 1937, rope tows at three ski areas had been approved. Work had begun to install the "endless ropes" powered by gasoline motors at Baker and Snoqualmie Summit, "where heavy poles the size of telephone poles had been erected in a straight line up the ski hills where the forest service authorized the removal of trees....The Northwest will have made the first step toward catching up with Europe in the matter of ski equipment."

David Hellyer was involved with Ski Lifts Inc., and he described the difficulty of building and operating rope tows.

But who...was going to spend time at the two sites in the off-seasons, live in a tent or shack with a work crew while designing and constructing the buildings, setting poles, figuring out the tightening devices for the ropes, supervising the machining of the sheaves, devising safety gates, and making it all come together? And when this was done, who was to stand in the cold and collect the dimes? Or climb frozen poles with the weight of a wet rope on one shoulder replacing it in the pulleys when it jumped out in response to the bouncing and tugging of some high spirited customer? And worst of all,

who was to weave a long splice in a broken tow rope while the lift stood idle and the dimes remained in pockets?…

 The principles of a rope tow are fairly simple, but in practice, when one is dealing with snow depths that fluctuate from a few inches to twelve or more feet, not counting drifts of twenty feet or more, and when the length of the tow is so great that the stretch and contraction of the rope may be more than thirty feet, ingenuity is called for, and I spent much time trying to solve these problems.[22]

In October and November 1937, the *Seattle Times* described the progress that Ski Lift Inc. was making in installing its new tows. The rope tow at Snoqualmie Summit would be 1,000 feet long and lift skiers up 450 feet. This "should be the solution to the area's weekly traffic jam," as it would keep uphill skiers riding the tow on the right side, with the downhill-bound skiers on the other side. "The added opportunity of getting downhill training instead of long uphill climbs and sudden, weary-legged returns will work wonders in developing turning technique." At Mount Baker, Parker and Griggs built a dam to furnish power and water to the buildings and installed a rope tow from the dam to Panorama Point. The tow ran 800 feet up the hill from the dam, with 250 feet of elevation gain, and was powered by a 1934 Ford engine. The charge would be $1.00 for an all-day ticket on Saturday and $1.50 on Sunday, to take "you to the top of the run without effort!" The tow at Paradise Valley ran 1,000 feet from the Guide House to the saddle on Alta Vista, gaining 300 vertical feet. Rates would be "$1 per day per person, for as many rides as he wishes." The rope tow was responsible for the record crowd of 2,328 skiers at Mount Rainier's opening day in late 1937, "the greatest early season skiing crowd that ever jammed a highway, packed a ski slope, or did a sitzmark." Jim Parker said, "You can really get a lot of downhill skiing on a tow….At Sugar Hill, Vermont, two years ago, one chap I knew got in sixty rides on a tow with 500 feet vertical lift. That's 30,000 downhill feet of skiing."

Webb Moffett was hired by Ski Lifts Inc. to run its operation at Snoqualmie Pass. Beginning in the winter of 1938, Webb and his wife, Virginia, managed the rope tow and concession stand at the Snoqualmie Ski Park, earning $10.00 per weekend plus 10 percent of the gross revenue, sleeping in the equipment room. His first paycheck for January 1938 was $74.75. Rates were $0.10 for a single ride and $1.00 for a day pass. Moffett became the godfather of skiing on Snoqualmie Pass and ended up owning Ski Lifts Inc. and operating all four ski areas on Snoqualmie Pass. He was

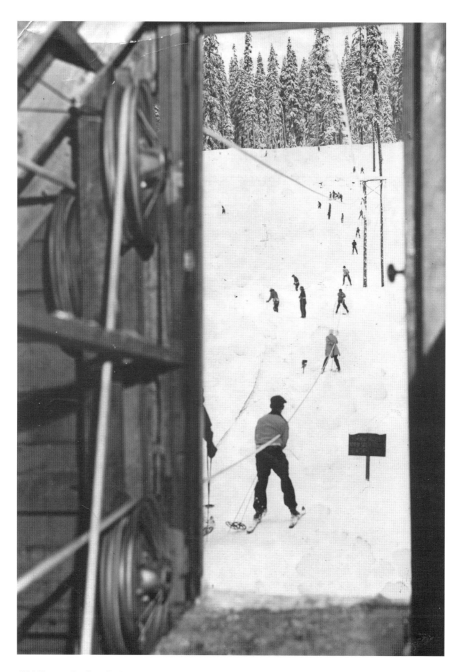

Old Betsy, the first Ski Lifts Inc. rope tow at Seattle Municipal Ski Park. *Courtesy of the Moffett family.*

Left: Ski Lifts Inc. ad in the *Seattle Times*, November 17, 1937. *Courtesy of the* Seattle Times Historical Archives.

Below: Ski Lifts Inc.'s Chauncey Griggs riding the rope tow at Mount Rainier, 1939. *Courtesy of the Tacoma Public Library*.

inducted into the Northwest Hall of Fame in 1992 and the U.S. Ski and Snowboard Hall of Fame in 1999.

Although the new rope tows were immediately popular and were a vast improvement over hiking up the ski hills, they presented challenges of their own, as described by Otto Lang:

> *A skier had to grab the often icy or, at other times, wet and slippery rope, which raced through a gloved hand until friction tightened the hold, similar to the clutch in an automobile. Then the skier either began to move slowly*

Webb Moffett (first employee of Ski Lifts Inc.) and rope tow at Seattle Municipal Ski Park. *Courtesy of the Moffett family.*

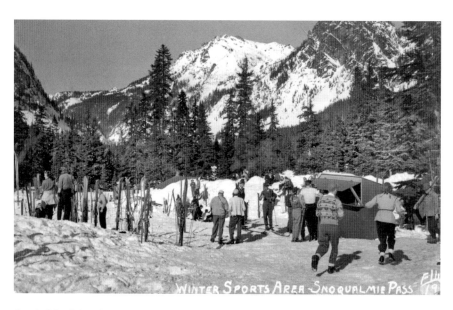

Seattle Municipal Ski Park concession stand manned by Virginia Moffett when she and her husband, Webb, operated the area's concessions beginning in the winter of 1938. *Courtesy of the Moffett family.*

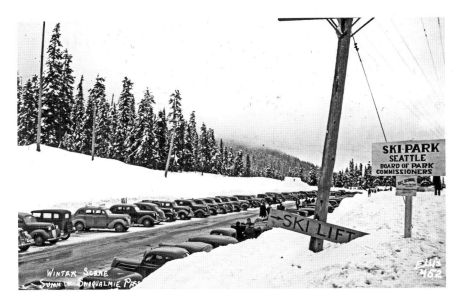

Snoqualmie Pass highway with a sign for the Ski Park and ski tow. *Courtesy of the Seattle Municipal Archives.*

or, if he grabbed the rope too firmly, shot forward, as if launched from a cannon, to fall flat on his face. This would obstruct the next skier's progress, who fell on top of the one already prostrate, entangling his skis and struggling to get out of the way. There was an infinite variety of prat and pitfalls, like devious traps, along the journey and it was always a relief to arrive at the top. At the terminus a skier would let go of the rope, his fingers cramped and shoulders stiffened from the long haul up the hill. As primitive as this conveyance was, it was still preferable to laboriously climbing up the hill.

In *The Ancient Skiers of the Pacific Northwest,* skiers who learned to ski riding rope tows shared their memories of the never-to-be-forgotten experience:

Riding rope tows became an art. When light, young gals rode the steep slopes, they would be lifted off the snow a couple of feet unless they rode right in front of a strong man who could hold the rope down. Then, when you got to the top, you had to let go fast, swing the skis sideways, dig the edges and pray that you wouldn't slip! You could smell the gloves burning, the ropes went so fast. Some skiers had hinged grippers tied to a belt, that grabbed the rope, and you leaned back against the belt to pull you up. You

had to quickly flip it open at the top to release it so you were free. This was a real boon as our arms got so tired trying to hang on all day long. When a rope wore out and broke, everyone fell off and the lift would be down for an hour or so while it was spliced together.

Riding rope tows in the spring was a mess. The ropes would drip constantly and leave a white residue on your clothing. Some skiers wore a rubber apron to protect their ski clothes. Girls with long hair had to be careful because the twisting rope would grab their hair and lift them off the ground toward the wheel. Many was the time when an instructor would have to talk the rider down to ease her fear while the tow was stopped and backed down so she could get loose.[23]

Number of Skier Visits Show an Outstanding Ski Season

In November 1937, the Forest Service reported that 186,000 persons visited National Forests in Washington and Oregon that year. Mount Hood had the highest number of winter visitors, 58,888. Snoqualmie National Forest was second with 46,070. Mount Baker Forest was third with 34,850, and the Wenatchee National Forest had 18,535. Ski developments at Snoqualmie Summit, Heather Meadows at Mount Baker and Leavenworth caused much of the attendance in Washington National Forests. Some 20,000 skiers visited Snoqualmie Ski Park, and 2,800 was the largest single day.

5

Ski Jumping Continues to Be a Major Part of Northwest Winter Sports, 1936–1939

1936 AND 1937: SKI JUMPING TOURNAMENTS
CONTINUE, SKI JUMPS ARE IMPROVED, INTERNATIONAL
COMPETITORS ENTER LOCAL TOURNAMENTS, NORWEGIAN
SKI JUMPING STAR OLAV ULLAND MOVES TO SEATTLE

While the Northwest's best alpine skiers were competing in Europe in the winter of 1936, the normal series of ski tournaments were held at home. Major jumping tournaments were planned for Leavenworth and at Beaver Lake at Snoqualmie Summit, and "[a]s usual, the cream of the Northwest and Canadian jumping talent will be on hand." "With Leavenworth, the ski jumping is so institutionalized that the only change each year is one of improvement bettering the hill; making things better for the public; easing the parking problems; and encouraging Seattleites to 'come over' on the big ski special operated by the Great Northern."

The 1936 Leavenworth tournament was won by Ivind Nelson of Revelstoke, British Columbia, and watched by 5,500 spectators who braved extreme weather. The Great Northern special train, which included a diner and parlor car, surpassed all records with fourteen cars "jammed to the doors." The jumps at the tournament were the longest made in any American event that year.

The Northwestern Ski Jumping Championships at the Seattle Ski Club's Big Hill at Snoqualmie Summit on February 22, 1936, included both ski jumping and cross-country skiing and was expected to be dominated "by

lads of Norwegian descent." However, it was postponed after a major snow slide buried over a mile of the Sunset Highway west of the summit at Airplane Curve (the site of a plane crash in 1931), killing three, including two men trapped in a truck; burying twenty-three passengers in a bus; and requiring the rescue of fifty people. "Two Die in Snoqualmie Slide! Man Buried Alive Seven Hours Rescued," announced the *Seattle Times*. A truck driver was rescued after being buried for seven hours. Rescuers used long rods to probe the snow and dug down from five to thirty feet to rescue the occupants of a buried car. A Milwaukee Railroad train was derailed when the slide tipped over three freight cars, injuring the engineer and a brakeman. Four hundred cars carrying skiers were stopped, and North Bend was packed after the highway was closed. It took thirty-three hours for snowplows to clear the highway. When the jumping tournament was held later in March, Howard Dalsbo completed "the perfect circle of Northwest Championships" by winning the jumping event, and Hermod Bakke of Leavenworth won the combined jumping and cross-country title.

In 1937, local jumping tournaments were more successful than ever, attracting the best national and international skiers, with jumpers from Kongsberg, Norway, dominating the events. Famous jumping champions Sigmund Ruud, Alf Engen, Reidar Anderson and others competed in the Northwest for the first time.

Leavenworth's "already tremendous ski jump" had been improved for 1937 and offered a larger maximum capacity while becoming safer. A new trestle was built for the takeoff, 14 feet back from the crown of the landing slope, raising it 8 feet and increasing the maximum jump from 250 feet to 265 feet. To open up the hill for both spectators and jumpers, 4 feet were cut off on the jump. A new judge's stand was built higher than the old one. The Class B tower as well as the inrun and takeoff were "entirely new, built all in one scaffold" of logs and more substantial than the old ones. "The curve is such that the jumper is making speed from the very start to the takeoff without any loss such as we had before." With a retarded takeoff and an 8-foot higher start, "the smack of the wind and the jump of the skier will be practically instantaneous, and much more comfortable to the competitor's peace of mind."

The 1937 Leavenworth tournament in early February featured Caspar Oimoen of Anaconda, Montana, five-time national champion who placed thirteenth in the 1936 Olympic Games and held the American amateur jumping record of 257 feet; Tom Mobraaten, Northwest champion two years before, who represented Canada at the 1936 Olympic games; and

Leavenworth's Hermod Bakke, defending Northwest champion. However, "despite a blinding snowstorm," Arnt Ofstad of Spokane won the Northwest Ski Jumping Championship with jumps of 192 and 186 feet, followed by Einar Fredbo and Helge Sather, who made the longest jump of 194 feet. The event was watched by 7,000 spectators, including 2,000 from Seattle, 1,800 of whom traveled on three special Great Northern trains. The railroad had been swamped by the last-minute rush of people wanting to ride the ski trains, and Great Northern had to send a second train, which arrived so late the passengers missed the Class B jumps.

The date for Seattle Ski Club's 1937 tournament on its jump at Beaver Lake was changed from late February to late March to allow Sigmund Ruud to compete. Sigmund was one of the famous Ruud brothers from Kongsberg, Norway, who won a silver medal in the 1928 Olympic Games. He was "one of the two great riders in the world" and "one of Norway's ski immortals." The tournament attracted international competitors, the best of whom came from the small town of Kongsberg. The 1937 Beaver Lake tournament was the most important one held in the Northwest.

Sigmund Ruud had recently competed in an alpine tournament in Sun Valley, and Averell Harriman asked Ruud and Alf Engen to locate a site for a ski jump at the resort. They chose a hill between Proctor and Dollar Mountains where a ski jump and lift were installed in the summer of 1937, named Ruud Mountain in his honor, which became the resort's site for jumping events and slalom competitions.

The upcoming tournament was to be "a gathering of skiing greats" who would "wage such a duel as Norway would enjoy." Entrants included Alf Engen, a national ski jumping champion "who broke more records in America than any other skier" and had jumped 287 feet; Sigmund Ruud, one of the greatest jumpers in the world, who "is to skiing what Bing Crosby is to crooning, and the Dionne quintuplets are to Canada," who had jumped 334 feet; Tom Mobraaten from Vancouver, British Columbia; Portland's Hjalmar Hvam, former national combined champion; Sverre Kolterud, "the greatest four-way combined skier in the world"; Corey Gustafsson; and Nordal Kaldahl from Wells, British Columbia. "The Ruud-Engen-Hvam-Kalahjl-Svere-Kolterud rivalry will live long," since they all came from Kongsberg, Norway. "The Kongsberg jumping style—grand form plus great distance—has been made famous through two generations. It is particularly distinctive. It calls for pronounced forward lean, a distinctive arching of the body from the hips…aerodynamic jumping, the technicians call it…something like a glider leaving a hill, to soar."

DOUBLE JUMP---AND DISASTER

Sverre Kolterud (left) and Sigmund Ruud, two of Norway's greatest skiers, did a double jump yesterday as the exhibition feature of the Seattle Ski Club's big ski tournament at Summit, Snoqualmie Pass. They landed on the 217-foot mark—but Ruud was headed for the crowd. He threw himself, smashed into a woman spectator where the mark is indicated, and sustained, possibly, a broken ankle bone.

"Double Jump then Disaster." Sigmund Ruud and Sverre Kolterud executing a double jump at Seattle Ski Club's Beaver Lake before running into the crowd, *Seattle Times*, March 29, 1937. *Courtesy of the* Seattle Times *Historical Archives.*

Engen and Ruud had "fought it out furiously" at the National Ski-Jumping Championships held in Utah the third week of February, where four of the best Northwest jumpers also competed (Arnt Ofstad of Spokane, Ole Tverdal of the Seattle Ski Club and Helge Sather and Hermod Bakke of Leavenworth). In what was called "the greatest ski jumping duel in American history," Engen defeated Ruud at the National Championships "by the extremely thin margin of 226.3 points to 224.6. He had to set a new American competitive record of 245 feet to do it," breaking the 242-foot record set by John Elvrum of Portland in 1934. The margin between Ruud and Engen was in distance, as Ruud outscored Engen on form.

The Ruud/Engen competition continued at the Seattle Ski Club tournament, the "greatest ski jumping tournament the Seattle Ski Club has ever held....The Ruud-Engen rivalry is epic." Three thousand spectators watched Engen make the longest jumps and set a new record for the Big Hill of 210 feet, but Ruud won the competition, beating Engen on form points and earning "a measure of revenge" for his loss at Salt Lake. Norway's Sverre Kolterud finished second, followed by Engen and Ole Tverdal.

After the tournament, "exhibition double jumps gave the crowd more of a thrill than it wished," said the *Seattle Times*, which published a picture of Sigmund Ruud and Sverre Kolterud doing a spectacular double exhibition jump of 217 feet. Ruud was hurt when he ran into a female spectator on the runoff. Ruud's speed "was tremendous," and when he landed, he "threw himself flat on the snow, skidding, ski-first into a woman spectator" who had the wind knocked out of her but recovered. X-rays showed that Ruud did not break his ankle but had torn ligaments. Hjalmar Hvam was also hurt doing a double jump with Tom Mobraaten when he "fell hard, hit his face with his ski and suffered cuts on his forehead and nose."

Ironically, in August 1937, the National Ski Association announced that a study of distance sheets from the National Ski Jumping Championships at Salt Lake in February turned up an error, and Sigmund Ruud of Kongberg, Norway, was the national champion instead of Alf Engen of Salt Lake.

Olav Ulland Moves to Seattle to Coach Ski Jumping

Norwegian ski jumping star Olav Ulland moved to Seattle in December 1937. Ulland was a famous ski jumper from Kongsberg, Norway, the ski jumping capital of the world. Ulland began jumping by age four and

competed for Norway from 1929 to 1936, placing high in a number of events at the famous Holmenkollen jump, where he set a hill record of 50.5 meters in 1930. He was on the Norwegian Olympic team in 1932, although he was hurt and did not compete. Ulland was the first to break the 100-meter mark by jumping 103 meters at Ponte di Legno, Italy, in 1935. Ulland coached the Italian team in the 1936 Olympics. Olav's brother Sigurd moved to this country several years before and had been successfully competing in ski jumping contests.

Ulland planned to give ski jumping lessons for the Seattle Ski Club at Beaver Lake, "with occasional weekends off for competition elsewhere." Ulland became a mainstay of Northwest ski jumping, and in 1941, he and ex-UW ski racer Scott Osborn formed a sporting goods store, Osborn and Ulland, in Seattle. Olav was inducted into the U.S. Ski and Snowboard Hall of Fame in 1981, the Washington Sports Hall of Fame and the Northwest Ski Hall of Fame in 1990.

In December 1937, Peter Hostmark, PNSA president, traveled to the National Ski Association meeting in Milwaukee. He carried bids from the Cascade Ski Club of Portland to hold the national downhill and slalom championships, the Seattle Ski Club for the 1939 national jumping championships and the Leavenworth Winter Sports Club for the same event.

1938: TOURNAMENTS INCLUDE WORLD-FAMOUS NORWEGIAN JUMPERS BIRGER AND SIGMUND RUUD

Two famous Ruud brothers (Birger and Sigmund) toured the United States in the winter of 1938 to promote ski equipment in the American market. The Ruuds participated in jumping tournaments all over the country, including the Seattle Ski Club's tournament at Snoqualmie Summit in March.

Birger Ruud and his brothers Sigmund and Asbjorn dominated ski jumping in the 1930s, winning world championships in 1931, 1935 and 1937. Birger won gold medals in jumping in the 1932 and 1936 Olympics, and Sigmund won a silver medal in 1928. The Ruuds' American tour was the subject of a master's thesis written for the University of Oslo in 2013, "Are Norwegian Americans 'Born on Skis?': Exploring the Role of Skiing in North America Ethnic Identity in the 1930s Through the Adventures

of Sigmund and Birger Ruud," by Kristofer Moen Helgrude. Sigmund Ruud had competed at a number of tournaments in 1937, including one at Snoqualmie Summit. The *Salt Lake City Tribune* said the Ruuds were "mighty little men...who had the precision of machines," and if they became any better, they would no longer be classified as "genus homo."

The Ruuds were welcomed all over the country by Norwegian organizations and participated in a series of tournaments:

> *January 16, 1938: Norge Ski Club annual tournament, at Fox Grove River, Illinois*
> *January 23, 1938: Bush Lake, Minneapolis, Minnesota*
> *February 7, 1938: Winter Carnival, Menomonie, Wisconsin*
> *February 14, 1938: the "Times Meet" at Soldier's Field, Chicago, Illinois*
> *February 20, 1938: Eastern Championships, Brattlesboro, Vermont*
> *March 1, 1938: Memorial Coliseum, Los Angeles, California*
> *March 6, 1938: Seattle Ski Club's tournament at Snoqualmie Summit, Washington*
> *March 15, 1938: Sun Valley, Idaho, on Ruud Mountain*

At Fox Grove River, they jumped in front of 30,000 spectators who arrived in 10,000 cars. Another 10,000 spectators attended the event at Chicago's Soldier Field, where they jumped on a 184-foot man-made structure as tall as an eighteen-story building that swept 425 feet down over its wall into the huge stadium, covered by tons of snow imported from Michigan. In Los Angeles, 100,000 spectators saw the California Open Ski Meet held at Memorial Stadium where a special ski jump was constructed for the Ruuds. It was a 165-foot structure described as a "giant web of steel" supporting a long wooden runway that spilled to the earth in two graceful curves over the goal posts, covered in ice ground from one-hundred-pound blocks.

The Seattle Ski Club's tournament at Snoqualmie Summit was changed from February 27 to March 6, 1938, so the Ruud brothers could participate. Their appearance caused a sensation, with the *Seattle Times* publishing twenty-one articles about them in February and eighteen in March. Sigmund Ruud joked when he arrived in the Northwest, "We've jumped in seven tournaments in this country...and this will be the first on natural snow. They had to haul it in every place else."

The big jumping event of 1938 was Seattle Ski Club's Jumping Championship in March at Snoqualmie Summit on the "Big Hill" at

Beaver Lake, featuring "truly an amazing field of jumpers." The *Seattle Post Intelligencer* said the Seattle Ski Club had attracted "mighty fine skybusters" to its earlier tournaments but never had any "whose names were as great as the Ruud brothers." Birger Ruud "is a powerful jumper. His downhill ski ability is astounding." He won eight successive tournaments on his U.S. tour. Olav Ulland said, "The whole world will be wanting to know how it comes out. That is how important this sport of skiing has become, and how important Birger is."

One of the competitors at the 1938 tournament was Matt Broze, who took a number of photographs of the event. Broze competed in a number of tournaments through the Northwest and won the 1942 Silver Skis race on Mount Rainier. His son, Matt Broze, provided the pictures in this book taken by his father.

Seven of the sixteen jumpers were from Kongsberg, Norway, and proudly displayed white Ks on their sweaters, a symbol of their hometown: Birger and Sigmund Ruud, Olav and Sigurd Ulland, Rolf Syvertsen, Tom Mobraaten and Hjalmar Hvam. Several were raised within a block

Birger Ruud at the 1938 Seattle Ski Club Beaver Lake Tournament. *Courtesy of the Matt V. Broze family.*

Sigmund Ruud at the 1938 Seattle Ski Club Beaver Lake Tournament. *Courtesy of the Matt V. Broze family.*

of one another. "Those who cannot learn to be a good jumper must go to work. That is the law of Kongsberg," according to Birger Ruud. Nineteen Class A jumpers entered the tournament, "all of them worthy of the name 'great,'" including Nils Eis, the world's intercollegiate champion; Olaf Ulland, who held the world's distance record; and all of the greatest Northwest jumpers. The Milwaukee Road ran special trains to Hyak, and buses took passengers back to Snoqualmie Summit where a crowd of ten thousand could be handled. The highway department was clearing space for two thousand cars at the Summit. Expectations were high that the Big Hill's record of 210 feet set the prior year by Alf Engen would be broken.

Birger Ruud won the jumping championship at Snoqualmie Summit, beating his fellow Norwegians in front of eight thousand spectators, with the *Seattle Times* of March 7, 1938, announcing, "Birger Ruud Is Summit Ski King—Leaping Star Lives Up to All Notices." Ruud had scores of 19.0 and 19.5 out of a possible 20.0 points under very difficult conditions,

which were more treacherous than the judges had seen in years. The Big Hill was "cold to the point where skis failed to break the crust on either the in-run to the take-off, or the out-run to the flat. Skiers sidestepped it, but the skis wouldn't bite in. They took shovels and chiseled. They took rakes and scratched and tore. The hill remained…adamant." At the end of his "meteoric" descents in front of four thousand spectators, Birger "didn't come to a casual, christying stop. No. He somersaulted." The *Seattle Times* said Birger Ruud "is to skiing what Sonja Henie is to ice skating."

After the tournament, the Ruud brothers "topped the greatest day in Seattle Ski Club history with a perfect double jump, both off the takeoff together, and landing in unison, 196 feet down the hill." The *Seattle Times* of March 7, 1938, carried a picture of Birger and Sigmund doing their double jump, flying through the air side by side. Other jumpers also entertained spectators with double jumps.

During the 1938 Snoqualmie tournament, several of the competitors stayed at a cabin on Snoqualmie Pass later owned by the Hanson family, friends of the author, where they decorated and signed a cabinet door. Birger

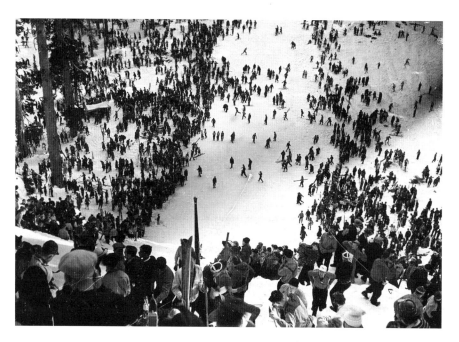

Large crowd of spectators, 1938 Seattle Ski Club Beaver Lake Tournament. *Courtesy of the Matt V. Broze family.*

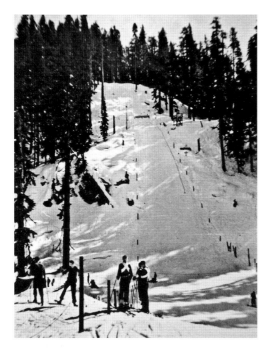

Left: View of jumping hill, 1938 Seattle Ski Club Beaver Lake Tournament. *Courtesy of the Matt V. Broze family.*

Below: Birger Ruud jumping at the Seattle Ski Club Beaver Lake Tournament, 1938. *Courtesy of the Museum of History and Industry.*

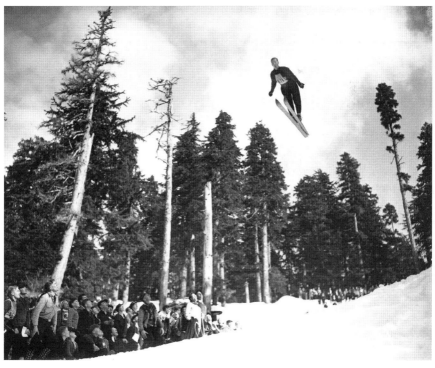

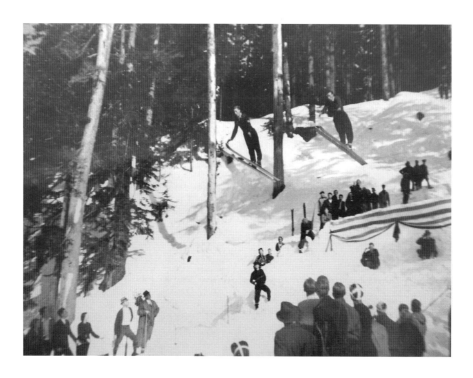

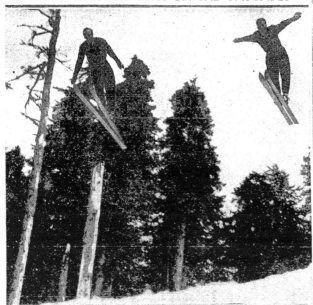

THE RUUDS LOOK DOWN ON THE CASCADES

That is Sigmund Ruud, left; three times a member of the Nor- | a double jump at Big Hill, Summit, yesterday, after Birger had won
wegian Olympic team; and that is Birger Ruud, right, twice Olympic | the club's jumping championship. They jumped 194 feet.—A. P. photo
Games winner and last year world's champion ski jumper. They did |

Above: Olav Ulland and Nils Eie executing a double jump at the Seattle Ski Club Beaver Lake Tournament, 1938. *Courtesy of the Matt V. Broze family.*

Left: Sigmund and Birger Ruud doing a double jump at 1938 Seattle Ski Club Beaver Lake tournament, *Seattle Times*, March 7, 1938. *Courtesy of the* Seattle Times *Historical Archives.*

Cabinet door from Hanson cabin at Snoqualmie Pass signed by Birger Ruud, Olav Ulland and Nils Eie, 1938 Seattle Ski Club tournament. *Courtesy of the Hanson family.*

Translation from Norwegian.

Guttas beste takk!
The boys' best thanks!
Birger Ruud 5th March 1938

Unforgettable memory
Nils Eie

De beste ønsker i fremtiden fra din elev. Du vil nå langt 3/3–3/8.
The best wishes in the future from your pupil. You will go a long way.
Olav Ulland

Takk for mig.
Thanks from me. (Thanks for the stay.)
Olav

Ruud drew the picture of the ski jumper that appears above his signature, and Nils Eie and Olav Ulland also signed the door.

The Ruuds continued their tour by going to Sun Valley to compete in the International Open Downhill and Slalom championships, where eight Northwest men were part of the fifty-four contestants. Dick Durrance won the combined title, and Birger Ruud won the jumping event, setting a new hill competitive record of forty-eight meters. Ruud was outjumped by Alf Engen, who soared fifty and a half meters, but this was done pre-competition, so it did not count in the tournament. Regardless, the feat became a new official record for the hill.

1939 and 1940: New Distance Record Temporarily Set at Leavenworth, Norwegian Stars Prevail

The thirteenth annual Leavenworth Tournament held in late January 1939 was plagued by a lack of snow. "The whole town of Leavenworth pitched in to transfer snow from the golf course and carry it in apple boxes to the Class A jump." For the second year in a row, the tournament was won by Sigurd Ulland of Lake Tahoe, California, the 1938 National Champion, in front of four thousand spectators. He had a long jump of 249 feet, a new American distance record. Sigurd's brother Olav Ulland was second. The tournament was the "greatest competition Leavenworth has ever known." "Leavenworth had never seen such a jumper who had such takeoff power as Sigurd Ulland. As he left the high takeoff, he catapulted himself high in the air, then floated." Sigurd had not wanted to jump against his brother Olav the prior year at Leavenworth "because I am not in the same class with him." This year, Olav said, "if I jumped 339 feet at Ponte di Legno, what do you think Sigurd would jump? Four hundred."

However, later that day, Sigurd learned that his "friendly enemy," Alf Engen, jumped 251 feet at the Big Pine, California tournament, taking the new American distance record away from him, although Norway's Reider Anderson won the tournament. Sigmund stayed in Leavenworth after the tournament practicing jumping, as he was headed to National Championships at St. Paul, Minnesota, the following week, where he would jump against Alf Engen, Reidar Anderson and others.

The Seattle Ski Club's Northwest Championship tournament on Snoqualmie Summit in early March 1939 was headlined by National Champion Sigurd Ulland. The tournament was declared an "open tournament," so Sigurd's brother Olav could jump, since as a ski instructor, Olav was ineligible to jump as an amateur.

Before the tournament began, the new Ulland/Engen distance marks set earlier in the year were bested by Bob Roecker from the Duluth, Minnesota Ski Club, who jumped 257 feet at Iron Mountain, Michigan, a new record for an American in a competition.

The 1939 Snoqualmie tournament had "the best field of Class A jumpers the Coast has ever seen this year." A *Seattle Times* writer said, "I regret the absence of Reidar Andersen. He is, of course, the unofficial world's champion, because he is Norwegian champion…and that is the same thing. But with Sigurd Ulland and Olav, his brother, and the other sixteen Class A

jumpers, you have a tournament. A GREAT tournament." Tom Mobraaten won the Class A event with jumps of 167 and 171 feet in front of three thousand spectators who braved a heavy snowfall. Sigurd and Olav Ulland "fought out a brotherly battle for second place," with Sigurd winning "in spite of a knee injury that kept him from walking down stairs. He had to hop on one leg—but he could still jump."

The jumping hill at Leavenworth had been "made even better" over the summer of 1939 by CCC workers who raised the knoll and dropped the transition, meaning that earth was added to the bulging part of the landing hill and the "dip" deepened.

Leavenworth's 1940 tournament pitted Sigurd Ulland against Alf Engen of Sun Valley, Idaho. Ulland had moved to Leavenworth in 1940 and was in charge of maintenance of its "great jumping hill." Commentators predicted that a new American competitive record would likely be set "since two Americans capable of setting it are there, and the hill is big enough." "We have the hill you can better that record on....It's a bigger hill than it was last year. The Leavenworth Winter Sports Club leveled a challenge against the giant new jumping hill which had been built at the Ski Bowl which the Milwaukee Road expected to become 'the greatest in America.'" "I'll bet we get greater distance on our hill...We're not asleep, you know." Hundreds of spectators would come on Great Northern special trains. "The snow was perfect."

Alf Engen won the Leavenworth event, jumping 252 feet in what the Leavenworth Winter Sports Club said might have been a new national competitive record. Engen "had come winging down to the take-off at high speed and the power of his drive was such, and his form so fine, that he sailed, and sailed before he came down to rest 252 feet down the hill." Engen had never jumped in better form. The tournament director told Engen, "We'll give you a bigger hill next year....How about two-eighty." Sixteen jumpers sailed more than 200 feet. Tom Mobraaten finished second, followed by Sigurd Ulland. Alf Engen, the "31-year old star from Sun Valley, Idaho," went on to win the 1940 National Ski Jumping Championships in Berlin, New Hampshire, in late February.

6

Milwaukee Ski Bowl Opens, Revolutionizing Local Skiing; Northern Pacific Plans a New Ski Resort; and Ski Bowl Builds a World-Class Ski Jump, 1938–1939

The period from the late 1930s to the start of World War II was a seminal time for Washington, which was recognized as being one of the best winter sports areas in the country. The *Seattle Times* said Washington was "concededly the greatest skiing area in North America," and the *American Ski Journal* reported that "Seattle, Tacoma and adjoining western Washington communities lie within easy reach of the finest ski terrains in America." Alpine skiing came to the forefront during this period, Washington's first modern ski resort opened and three ski areas got rope tows, making skiing much more accessible to the public, dramatically changing Washington skiing.

Inspired by the success of Union Pacific's Sun Valley Resort, in January 1938, the Milwaukee Railroad opened a new ski area at its Hyak stop on the east end of its tunnel under Snoqualmie Pass. The area was accessible by train in two hours from Seattle and had a modern ski lodge, an overhead cable ski lift known as a J-bar and lighted slopes for night skiing. It revolutionized skiing in the Northwest and created some of the same excitement locally that Sun Valley did when it opened. The ski area was initially called the Snoqualmie Ski Bowl but was renamed the Milwaukee Ski Bowl after World War II to differentiate it from the Snoqualmie Summit ski area. To eliminate confusion, it will be referred to as the Milwaukee Ski Bowl hereafter.

The Milwaukee Road was just one railroad that began operating snow trains during the Depression to boost ridership and profits:

Snow trains, a Depression-era innovation to boost passenger ridership, spread throughout the country in the 1930s as railroads started winter promotions in New England, Colorado, California, Washington, Wisconsin and other states. Some railroads built resorts: Union Pacific, Sun Valley for elite skiers; and Milwaukee Road, a modestly priced lodge at Snoqualmie Pass in Washington.[24]

1938: SKI BOWL OPENS AT HYAK, CHANGING LOCAL SKIING

The *Seattle Times* of October 27, 1937, published a number of articles about the new ski area that was being built at Hyak. The Milwaukee Road's newly developed two-hundred-acre Ski Bowl was

mostly wooded but with cleared ski runs from the Old Milwaukee grade crossing down out of the "rim" section of the Bowl to the flat area in which the railroad company has erected a two-story, 24 x 94 foot ski cabin. Gradient from zero to 40 degrees. Ski lift, Sun Valley type (minus chairs) being installed at present by Ben Paris Recreation, which also will maintain lunch counter in ski hut. The lift will be 1,800 feet long with a vertical lift of 300 feet. It will be powered with an electric motor; operate day and night, for flood light are being installed on all five of the runs cut through the trees.

Two special trains will leave Seattle each Sunday morning for the area; containing as well as "reserved" coaches in which every skier will have a seat, a baggage car equipped with ski checking racks and waxing tables (with hot irons), and a recreation car, sixty feet long and nine feet wide… with an orchestra. There'll be dancing, going and coming, a two hour trip. One train will return late in the afternoon; the other later in the evening.

Arriving at Snoqualmie Ski Bowl, skiers will alight on a platform fully covered and go through a boarded tunnel into the ski hut proper. There will be little, if any, wading in the snow. The ski hut's first floor will have the catering bar, and checking divisions. The second floor will be given over to waxing, lavatories and chairs and lounges on which skiers may rest. The second floor, too, will open directly onto the snow; the start of the hill will be less than 100 yards away.

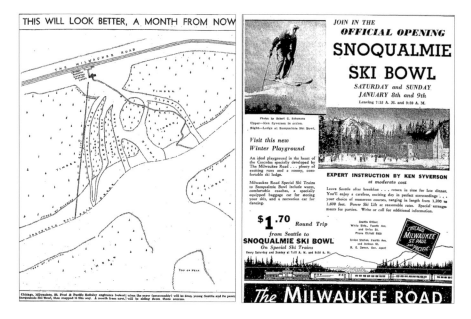

Left: Milwaukee Ski Bowl map, "This Will Look Better, a Month from Now," *Seattle Times*, November 17, 1937. *Courtesy of the* Seattle Times *Historical Archives*.

Right: Milwaukee Road ad for Milwaukee Ski Bowl opening, *Seattle Times*, January 5, 1938. *Courtesy of the* Seattle Times *Historical Archives*.

Milwaukee Railroad ran the first of its ads promoting the Ski Bowl, announcing, "All aboard for the newest of the winter playgrounds, Snoqualmie Ski Bowl (61 miles east of Seattle)."

Ben Paris, who operated a Seattle restaurant and sports shop, was responsible for the ski lift that was being installed by Cooley Engineering Company. It had two towers, and the top tower, located above the old Milwaukee Road grade crossing, had "a huge 9-foot wheel":

> *The Ski Lodge came first....Then Ben Paris Recreation stepped in, took over the concessions, and guaranteed the food. Then Ben Paris, looking at the contemplated ski runs, decided a ski tow was necessary to make the Bowl complete. It's virtually ready now...1,800 feet of it, modeled on the Sun Valley lift, which has an endless, horizontally-operated cable, from which, next year, chairs may be suspended. It will hoist skiers who don't need to take off their skis, 300 feet in vertical distance, over the 1,800-foot-long run to the Milwaukee's old grade crossing. Then they will have their choice of downhill runs...steep, or casual. And they won't*

have to wax for uphill climbing. They'll use downhill wax, for both up and downhill running.

The region's first overhead cable lift was described as "a Sun Valley type lift without chairs" (known as a J-bar), which "will give skiers what they seek, a quick and painless ascent to slopes down which they may slide."

Suspended from the cable are other cables, ending in a trapeze-like wooden handle to which the skier clings. He stays on his skis, keeps in a track, and is pulled up the course at about four miles an hour—a moderate pace, but it takes no time to get to the top. Then when he leaves the grade crossing, he has his choice of five downhill runs, each named after a crack Milwaukee train.

The *Seattle Times* would provide free lessons to Seattle high school students in a ski school under the direction of Ken Syverson, who taught with Otto Lang at Mount Rainier. "Milwaukee Line officials…ordered a special 'instruction course' cleared close to the ski cabin and bulldozers and men were felling more trees today."

On January 5, 1938, the *Seattle Times* published an eight-page special section headlined "Snoqualmie Ski Bowl's Formal Opening Coming Saturday." Sam Racine, the head of Wilson's Business College, was responsible for the area being developed, since he wanted a place for his six or seven hundred college kids to play on weekends during the winter. Working with the Seattle PTA, he convinced Seattle Milwaukee Road officials that the railroad should develop a ski area, and they convinced the Chicago head office to allocate the money.

There was no access by car to the Ski Bowl; one could only reach the area by train. Special ski trains had reserved seats, "warm, comfortable coaches, a specially equipped baggage car for storing your skis, and a recreation car for dancing." Skis could be taken to the seats or checked for a nominal fee, and the baggage car was accessible so riders could wax their skis en route. Ski trains should "come in first in the ski area's rating of excellence.…They take the skier to the mountains without the bother of driving.…They give him the opportunity to relax on his tired way home." Ski trains left Seattle on Saturday and Sunday mornings at 7:15 a.m. (the Early Bird) and 9:30 a.m. (the Morning Rest, for those who were up late in the night), for the two-hour trip to the ski area, costing $1.70. "Leave Seattle after breakfast, return in time for dinner. You'll enjoy a carefree,

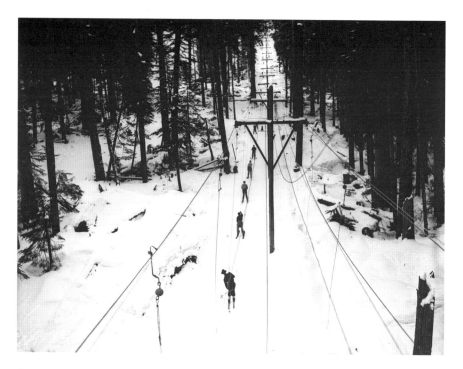

Overhead cable lift (J-bar) at Milwaukee Ski Bowl called "a Sun Valley type lift without chairs." *Courtesy of the Museum of History and Industry.*

exciting day in perfect surroundings…your choice of numerous courses ranging in length from 1,200 to 1,600 feet. Power Ski Lifts available at reasonable rates." More than three hundred tickets were sold for one of the first weekend's trains.

The ski lodge was a two-story building "capable of unlimited expansion. Skiers had their choice of downhill runs, steep or casual." The amplifying system "will be unique in Northwest ski area development. It will broadcast occasional announcements, give skiers warning when it is time to board the train, and handle music the rest of the time." The railroad was considering developing countless miles of fine ski trails beyond Snoqualmie Ski Bowl; better accommodations, including overnight privileges; and an extension of the ski lift into Silver Creek Basin. Further development depended on the skiers. "If they like the Bowl, the ski trains, the lights, we'll go all the way to give them more."

Ken Syverson wrote an article describing the importance of the ski lessons he would provide at the Ski Bowl:

Skiing, properly done, is a grand sport, the grandest sport there is. But skiing improperly learned is too frequently scary. That is why ski schools are necessary. Given the fundamentals, the correct way, the average person, be he young or middle-aged, can get around and derive real pleasure from the flow of skis across the snow. But if he hasn't learned those fundamentals, skiing becomes, not an exhilarating adventure, but a source of fear, of desperation....

My school will teach the accepted technique that is necessary for skiing in the alpine regions of Washington—the Arlberg technique. It calls for energetic practice of the stem—the snowplow. And I can promise that a few instructions under my assistance or under me will give you a facility far beyond what you would acquire by going away by yourself and trying the same thing. That's been proved already. From the snowplow, we'll go to more advanced turns—but the stem comes first. After balance is acquired on skis (and it comes from practice under the eye of some one who can correct a fault before it becomes chronic), we can talk about the faster modes of skiing—culminating in the schuss. That's the "straight" business you hear about in racing. But don't try it until you know how.

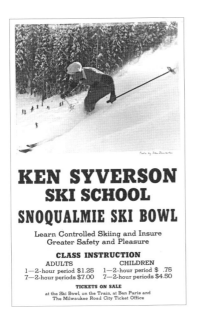

Left: Ken Syverson Ski School poster. *Courtesy of the Moffett family.*

Right: Bests Apparel and Ski train ad, *Seattle Times,* January 5, 1938. *Courtesy of the* Seattle Times *Historical Archives.*

Left: Cunningham's Ski Store ad, *Seattle Times*, January 5, 1938. *Courtesy of the* Seattle Times *Historical Archives.*

Below: Opening day at Milwaukee Ski Bowl, *Seattle Times*, January 23, 1938. *Courtesy of the* Seattle Times *Historical Archives.*

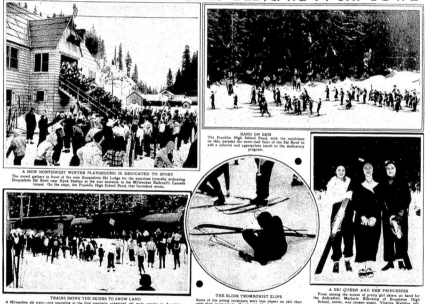

A BAND AND PRETTY GIRLS DEDICATE A SKI BOWL

The Ski Bowl's formal opening the weekend of January 8 and 9, 1938, attracted 1,200 skiers. Every Seattle business that carried sporting goods advertised its wares to coincide with the event, from the small to the most established. Many ads mentioned the Ski Bowl.

The Ski Bowl's opening ceremony included music by the Franklin High School band and the crowning of a queen. The ski lift experienced some problems—the skiers' enthusiasm derailed the cable twice, as the boys and

girls swung back and forth on the "hangers." There were 1,584 rides taken on the lift despite the delays. The lift's capacity on opening weekend was 300 skiers per hour but was expected to double by the following weekend. A picture showed Marjorie Ellenberg of Broadway High School, who was crowned queen of the ceremonies, walking through an arch of raised skis at the Ski Bowl, and "then everyone went skiing."

The opening of the Ski Bowl overcame opposition to skiing from parents and school officials worried about the dangers of making the trip to the pass by car on snowy roads.

> *Today, however, with ski trains carrying these youthful ski aspirants, the opposition is melting to a great degree....It is expected that the Ski Bowl and ski trains will do much in the future to erase the official objection for high school students. The availability of supervised ski instruction will also do considerable for the youthful skiers. Under the capable guidance of Ken Styveson Ski School, the student may learn the rudiments of controlled skiing, thereby assuring himself of greater pleasure and safety.*

Ski trains operated from Seattle's Union Station were an immediate success, and the Ski Bowl quickly became the primary destination of Seattle-area skiers. The railroad's catchphrase, "Let the Engineer do the Driving," highlighted the ski package's ease and convenience.

The recreation car, equipped for entertaining passengers with music, was a popular part of the trip. "Let it be said here that doing the 'Big Apple' is an excellent way of limbering up for skiing":

> *Heretofore skiers were cramped into automobiles while traveling to their favorite terrains, with little more to do than wait until their arrival at their destinations, but now all sorts of diversion can be had during the trip. Dancing is the chief amusement of the passengers in the recreation cars. The "Big Apple," "Suzy Q," "Truck'em," and just the ordinary dancing can be enjoyed. It is a place where fellow skiers can become acquainted and overcome the factors which have prevented comradeship among skiers heretofore.*

To support the dancing on the Ski Bowl trains, retailers such as Best Apparel sold appropriate footwear: "We know you need ski-train-slippers, $2.50, for dancing or after-skiing."

The Ski Bowl was located on an electrified railroad line so lights for night skiing were installed. Starting Friday, January 14, 1938, Wilson Modern

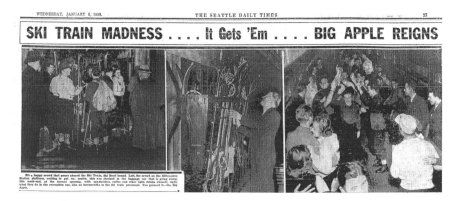

"Ski Train Madness," Milwaukee Ski Bowl opening day, *Seattle Times*, January 5, 1938. *Courtesy of the* Seattle Times *Historical Archives.*

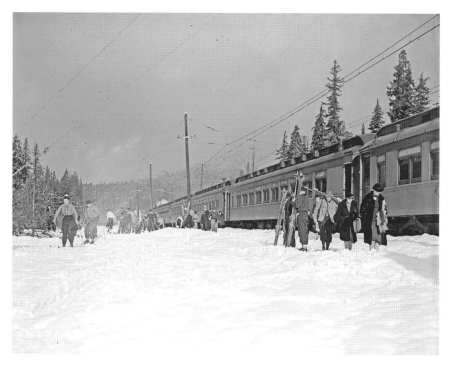

Skiers departing from Milwaukee Road ski train. *Courtesy of the Museum of History and Industry.*

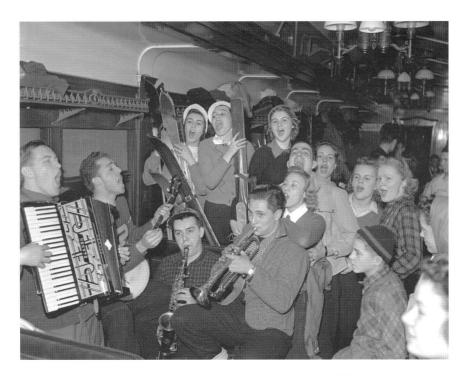

Band playing on Milwaukee Road ski train. *Courtesy of the Museum of History and Industry.*

Business College ski trains left Seattle for night skiing at the Bowl. Tickets for the 250 seats were limited to students and graduates of the college, their friends, high school students or special invitation. "There will be two big recreation coaches for dancing. Geo Smith's famous orchestra will provide music, but to have even more fun, bring your own instruments too." Trains left Tacoma at 4:45 p.m. and Seattle at 6:00 p.m. and arrived at the Bowl at 8:00 p.m., returning at 10:00 p.m.

It was determined, after "profound research," that this was the first night ski train in America. "They've been running overnight ski trains in the East… but they haven't run any…where you'd leave the city late in the afternoon, be on the snow in a couple of hours, get in your skiing and be home and in bed not long after midnight." The first night ski train "went down in history today as a skiing success," as the train carried three hundred skiers to an "Evening's Sport at Bowl." In their three hours at the Bowl, the participants got all the skiing they wanted and arrived back in Seattle at 1:00 a.m. The night's record was twelve runs for a total of 3,600 feet of skiing, and the average was six or seven runs. "Ski Train History Made…Right Here."

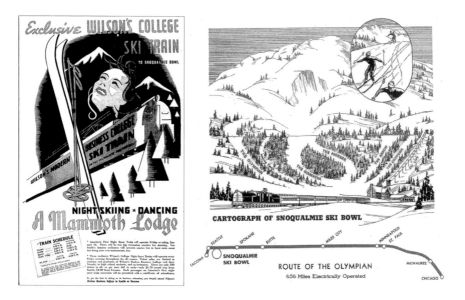

Left: Wilson Business College ad for Milwaukee Road ski train, *Seattle Times*, January 23, 1938. *Courtesy of the* Seattle Times *Historical Archives.*

Right: Milwaukee Road ad for ski train and Ski Bowl. *Courtesy of the Milwaukee Road Historical Association.*

Railway Age published an article on March 26, 1938, "Snoqualmie Ski Bowl a Traffic Builder." The Ski Bowl was built to develop passenger traffic from the ninety-five thousand ski enthusiasts in Seattle and Tacoma. It worked. Since its opening on January 9, the area attracted one thousand skiers a day rather than the three hundred that were expected. The Seattle PTA endorsed the Ski Bowl since students could safely ride the train instead of facing the dangers of snow-covered mountain roads. "An interesting side light on this venture is the discovery that at least 35 percent of the patrons of the ski trains have never been on a train and these excursions provide their first introduction to a railroad." The skiers' paradise had courses for the novice and expert, a ski trail and tow and a lodge, all of which were "electrically lighted for night use." There were five "slides" from 1,200 to 1,600 feet, named for Milwaukee Road trains, which end in a large bowl at the base of the hill: the Olympian, Hiawatha, Pioneer, Arrow and the Chippewa.

High school ski clubs in Seattle grew rapidly, attracted by the ability to ride the train to the ski area, and thousands of high school students took advantage of the free ski lessons. Seattle's Queen Anne Ski Club had a

membership of 116, including Margaret Odell (the author's mother), who was the club's faculty advisor and a longtime skier.

Record crowds showed up at local ski areas over Washington's birthday weekend in 1938, "Skiers Startle Resorts, Unexpected Outpouring Packs Areas." There were 2,287 skiers at Paradise on Mount Rainier; 546 on the one ski train to Snoqualmie Ski Bowl; 1,300 at Cayuse Pass; and 1,200 at Mount Baker. Ski competitions were held at Mount Rainier, Mount Baker and the Ski Bowl (which held another "no-fall" competition). Over 250 members of the American Institute of Bankers crammed on a special train to the Ski Bowl.

The Seattle Ski Club built a smaller ski jump on Snoqualmie Summit in the fall of 1938, "scarcely 500 feet from the highway" for Class C training and competitions. It had a one-hundred-foot capacity and crossed the foot trail leading to the big hill at Beaver Lake. Sahalie Ski Club built a new ski tow at its lodge. A "Resthaus" was completed at at Snoqualmie Pass by the WPA "to take care of skiers tired from great endeavors" with "inviting fireplace and a comfortable lounge."

The Ski Bowl closed for the year on March 16, 1938, after being open for eleven weekends and hosting eleven thousand skiers transported by rail. The Ski Bowl had a three-year plan and would keep expanding its facilities each year.

The *Seattle Times* of July 24, 1938, reported that over the last decade, skiing had become Seattle's favorite wintertime sport, featuring areas on two mountain ranges, and the manufacture and selling of ski equipment had become a $3 million industry:

> *Within a comfortable four hours distance a half-dozen of the outstanding ski terrains in the entire nation, Seattle has become the hub of intense activity through the winter months. Every week-end finds 20,000 or more skiers turning to the glistening snowfields of the Cascades, Olympics, to Mountain Rainier and Mount Baker....In the Cascades east of Seattle, ski-fans find opportunity at Snoqualmie Pass, Naches Pass, and a half-dozen other points. Newest of the areas is the Snoqualmie Ski Bowl, accessible by ski trains from Seattle and Tacoma.*

A substantial amount of work was done at the Ski Bowl in the summer and fall of 1938, which was described by the *Seattle Times* and the *Milwaukee Road Magazine* of January 1939. The lodge was doubled in size, and the covered concourse from the train platform to the lodge was lengthened

from one hundred to four hundred feet so passengers using all doors would be out of the weather. The second floor of the original building would be used for dining, and the new wing had a comfortable lounge and activity room with a large fireplace, wide windows with a sweeping view of the ski hill through large plate-glass windows, a place for card playing and an area for dancing. A covered sun porch was built on the face of the lodge. A new unique device had been installed to remedy the problems of hot-waxing skis, consisting of three steam radiators laid flat and built into tables in the lodge's waxing room on the lower floor of the new wing. There was no danger of overheating skis since the "steam heat, regulated by a convenient control, will warm the skis evenly and safely." The area's ski slopes "were given a good manicure, and all underbrush, fallen timber and stumps were entirely cleared out of the ski lanes" to make it "smooth as the skin you love to touch," so skiers could ski soon after the first snow. The ski lift was streamlined and sped up so its capacity doubled, and bugs were taken out of the mechanism. A new ski lane over three-quarters of a mile long was cut down the face of the mountain from Rocky Point, which could be accessed by climbing. The popular ski train was operating as usual, and Ben Paris was in charge of food, with increased space in which to work.

1939: NORTHERN PACIFIC PLANS MAJOR NEW SKI RESORT, MILWAUKEE SKI BOWL CONTINUES ITS SUCCESS, SELECTION PROCESS FOR 1940 OLYMPIC TEAM, WORLD-CLASS JUMPS BUILT AT THE SKI BOWL

The year 1939 was a banner one for Northwest skiing. Northern Pacific Railroad planned to open a new ski resort at Martin near Stampede Pass. The Milwaukee Ski Bowl had a successful second season. High school ski clubs were led by the Garfield Bulldog Ski Club, the perennial champions of the prep ski circuit and the oldest and largest prep club, with over two hundred members led by advisor H.B. Cunningham. The high school ski tournament would be held at the Ski Bowl instead of the Summit as in past years. Nationally significant ski tournaments brought the world's best skiers to the Northwest. The Mountaineers, "by dint of painstaking labor," widened the lane at its Meany Ski Hut at Martin and installed a rope tow up the big ski trail with 900 feet of pull and 330 feet of lift. Ski tows were "sprouting like weeds throughout the country," with twenty-

two being sold in New England the prior year and fifteen installed on the Pacific coast.

Northern Pacific Plans a New Ski Resort at Martin

By 1939, railroads had demonstrated that ski areas could be successful. Union Pacific's Sun Valley Ski Resort, opened in December 1936, had attracted legions of skiers from all over the country to the remote mountains of Idaho. The Milwaukee Ski Bowl at Hyak revolutionized local skiing and brought large numbers of new skiers into the sport.

Based on these experiences, Northern Pacific Railroad decided to open a major new ski resort at Martin, the eastern portal of its tunnel under Stampede Pass, where The Mountaineers built Meany Ski Hut in 1929, and the railroad had encouraged skiing for years by providing bunk cars where skiers could stay overnight. In 1936, the *Northwest Ski Guide* said, "Snow trains are not confined entirely to Boston and the east. At Stampede the railroad provides more than a dozen cars for accommodation, fitted with spring bunks, heating stoves, and free coal."

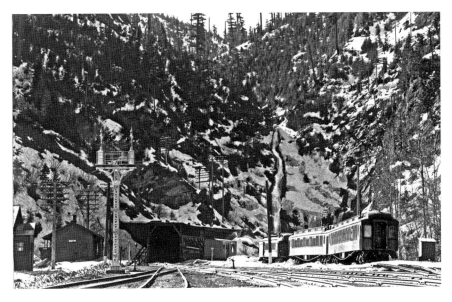

Stampede Pass tunnel and Northern Pacific bunk cars for skiers at Martin. *Courtesy of the Northern Pacific Historical Association.*

Recognizing the "increasing vogue of the sport of skiing in the Pacific Northwest," the *Seattle Times* of November 16, 1938, discussed Northern Pacific's plans to

> *convert the Martin area into one of the finest ski grounds in America. Quarters will be installed for the accommodations of ski devotees with lunch rooms and other facilities, including a lift 700 to 1,000 feet in length, depending on the route selected. This course seemingly is designed by nature for skiing....Experts have given it an unusually high rating and when the improvements are in, it should prove an important feature among Washington's many sports and scenic attractions. The terrain is so shaped as to give a course of maximum length with a relatively short lift back to the starting point. Experts see in the plans for development a course that will recommend itself to the most proficient skiers as well as to the novices who are just warming up to the sport. The Martin area is well sheltered from sweeping winds and quality of the snow that falls there is the best known for fast skiing.*

Northern Pacific planners recognized that a ski lift was critical for the new ski area. They looked into the purchase of a Sweden Speed Ski-Tow for Martin, manufactured by Sweden Feezer Manufacturing Company of Seattle, Washington, a self-contained ski tow able to carry skiers at five hundred feet per minute. In November 1938, a "tram expert" representing the aerial tramway firm of Moss and Groshong was in Seattle "discussing chair-lift plans for Martin" with Northern Pacific representatives.

Northern Pacific operated a small facility in the winter of 1939, known as the Martin Ski Dome, with one building that had room for 30 overnight guests who had to furnish their own bedding. There were two large living rooms with fireplaces, bunks in the women's and men's dormitories and a kitchen where skiers could cook their own meals. The railroad planned to open a large hotel the following year to accommodate 200 to 250 overnight guests. "All the facilities and attractions of a modern sports resort will be found in this development when completed. Martin is only a short train ride from Seattle, and for several years, skiers have taken the train there to enjoy the unusually attractive snow conditions."

Documents in Northern Pacific's archives show the company lost money operating the Martin Ski Dome in 1939, in spite of having four hundred skiers stay at the lodge between Christmas and April 1. The cost of running the facility was $1,500 for the season, with $1,000 collected in lodging fees

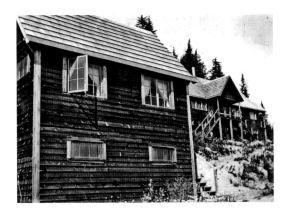

Left: Caretaker's cabin and small lodge at Martin Ski Bowl. *Courtesy of the Northern Pacific Historical Association.*

Middle: Northern Pacific train unloading skiers at Martin Ski Bowl. *Courtesy of the Northern Pacific Historical Association.*

Bottom: Northern Pacific plan for a large lodge at Martin Ski Bowl. *Courtesy of the Northern Pacific Historical Association.*

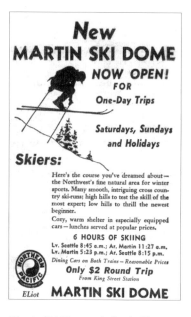

Martin Ski Dome ad, *Seattle Times*, January 19, 1940. *Courtesy of the* Seattle Times *Historical Archives.*

and train fares. The operations were an attempt to create goodwill for Northern Pacific, but "this good will was purchased at a considerable expense for the N.P. Ry. Co."

In the summer of 1939, Northern Pacific reassessed its decision to build a large ski lodge at Martin, comparing the investment required and predicted operating revenue to expenses. It would cost $69,200 to build a ski resort, and a budget of $75,000 was suggested. It would cost $35,700 to prepare the hill and install a lift, $16,000 for a Tandberg lift, $20,000 to build a lodge and $10,000 for equipment and fixtures. A forty- by one-hundred-foot lodge was designed for 160 people, with a first floor of eight thousand square feet.

Northern Pacific determined that the cost to build a ski resort at Martin was too great compared to the anticipated profit, so it was never built. However, Northern Pacific operated the small facility, the Martin Ski Dome, until World War II. Day trips on weekends offered six hours of skiing for a two-dollar round-trip ticket from Seattle.[25]

Milwaukee Ski Bowl Has a Successful Second Season

The first ad of the season was run by the Milwaukee Railroad in the fall of 1938, promoting skiing at the Ski Bowl and trumpeting the "Double-Size Lodge, new ski runs, improved facilities."

For the Ski Bowl's big opening on January 7, 1939, two fourteen-car trains operated. Activities included a girls' style show with a prize for the girl who was "the most attractively and intelligently costumed for skiing," a yodeling contest and a giant slalom race from Rocky Butte to the Bowl with men and women from the Washington Ski Club competing. Between three hundred and four hundred students were expected to attend the *Seattle Times* ski school that year. Classes were free of charge and were held each Saturday for ten weeks at the Milwaukee Ski Bowl, taught by the Ken Styveson Ski School.

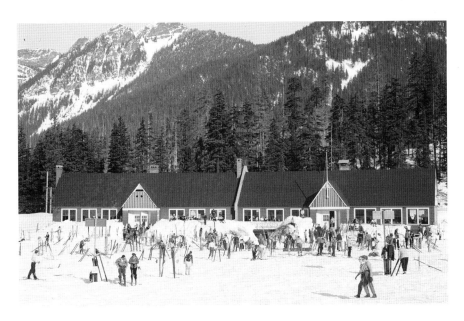

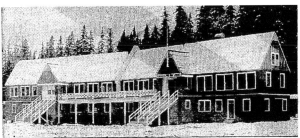

Above: Milwaukee Ski Bowl lodge and skiers, circa 1940. *Courtesy of the Milwaukee Road Historical Association.*

Left: Milwaukee Road ad for Milwaukee Ski Bowl, October 16, 1938, *Seattle Times. Seattle Times Historical Archives.*

Double-Size Lodge ... new ski runs improved facilities ... at

SNOQUALMIE SKI BOWL

SNOW TRAINS
every Saturday and Sunday

Milwaukee Road snow trains are powered by giant electric locomotives and carry fine modern coaches; baggage car for checking ski equipment; recreation car with music for dancing. Ticket sales limited to seating capacity of train.

GOING Saturdays and Sundays
(Weather permitting)
Lv. Seattle 8:30 a. m.
Ar. Ski Bowl10:30 a. m.
RETURNING—
Lv. Ski Bowl 6:00 p. m.
Ar. Seattle 8:00 p. m.

$1.70 Round Trip $2.00 from Tacoma

Watch for further announcements. Send for descriptive folder.
For information ask any Department or Sporting Goods Store, or any Milwaukee Road agent.

This season The Milwaukee Road is prepared to offer winter sports at their best to even larger crowds at the popular Snoqualmie Ski Bowl. Come out the very first week-end and see what we've done to insure you a perfect day on the snow.

ENLARGED LODGE—A new wing has been added that doubles the size of the lodge. Mammoth lounging room with open fireplace . . . new open-air sun porch . . . new waxing room with steam table for warming skis . . . enlarged cafeteria-restaurant . . . central heating.

IMPROVED TRAILS—Down timber and rocks have been removed and the trails generally widened and smoothed to provide better, easier skiing with less snow.

HIGH SPEED RUN—A mile-long run for experienced skiers has been developed on the steep, open slopes on the east face of Rocky Point that towers high above the ski bowl.

IMPROVED LIFT—Re-designing of the 1,400-foot electric lift has almost doubled its capacity per minute.

The MILWAUKEE ROAD

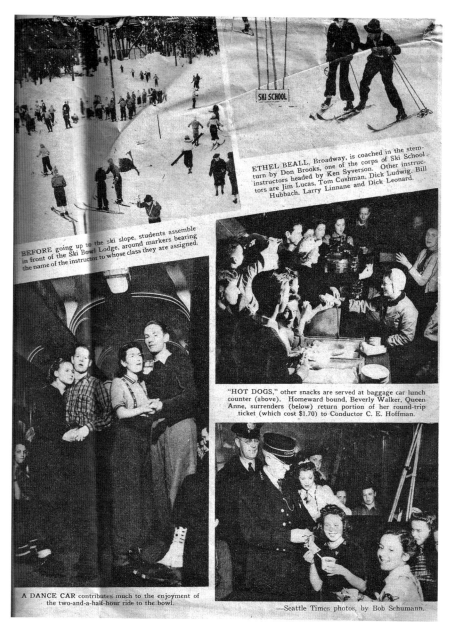

Milwaukee Ski Bowl, *Seattle Times*, February 12, 1939. *Courtesy of the* Seattle Times *Historical Archives.*

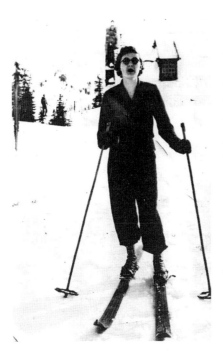

Margaret Odell, faculty advisor to the Queen Anne Ski Club at Milwaukee Ski Bowl, wearing a UW crew letterman's sweater, 1939. *Courtesy of the Lundin family.*

Every week, the Ski Bowl featured a different high school. The *Seattle Times* covered the activities of each weekend and described progress made by students in ski classes. The third weekend of January was the Queen Anne–Garfield Ski Day. Students were "bustling about, getting ready for their day at the Bowl. And a combined Garfield–Queen Anne day is something because Queen Anne interest in the Times Ski School is as intense as Garfield's." By the end of January 1939, 365 students had taken ski lessons, improving their techniques in just two weeks.

No more than twenty students per class were allowed so each could obtain the maximum personal instruction. Classes were from one and one-half to two hours in length. Two school advisors, Margaret Odell of Queen Anne and H.B. Cunningham of Garfield, said they were delighted with the instructions at the Times Ski School. "'We're glad to see skiing taught to them so sanely and effectively,' said Miss Odell. 'Another thing, the presence of the Milwaukee's special agents on the train as supervisors is an excellent idea. That is a remarkably well-controlled ski special.'"

On March 27, 1939, the *Seattle Times* said commendations had been showered on its ski school, which taught five hundred students that year. The *Empire State Ski News* said, "New York newspapers should pick up the *Seattle Times* Ski School idea.…They could help thousands of youngsters." The *National Ski Yearbook* gave further praise:

> *The school's purpose was simple—to teach Seattle high school ski beginners the right way to snow-plow and stem-turn. All high speed turns evolve from the stem-turn, and surest proof of that was contained in photos of Saturday's race winners, who, given a stem course to run, were unconsciously whipping through in pure christies.*

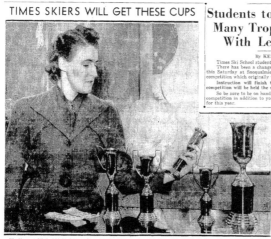

TIMES SKIERS WILL GET THESE CUPS

Students to Vie For Many Trophies Along With Lesson No. 10

By KEN BINNS

Times Ski School students, attention, please!

There has been a change in plans for Class No. 10, due this Saturday at Snoqualmie Ski Bowl, and for the slalom competition which originally was slated for April 1.

Instruction will finish this Saturday—and the slalom competition will be held the same day.

So be sure to be on hand, if you want that first taste of competition in addition to your last taste of free instruction for this year.

Several things contributed to the change. It's getting toward the end of the season, and there has probably been a fairly heavy drain on dad's pocketbook, getting you to the Bowl and back.

Besides, April 1 would tend to conflict with the Spring Ski Carnival of the Junior Chamber of Commerce at Paradise Valley.

And in addition to that, there really SHOULD be instruction every time you go to the Bowl. Under the original concept, there would have been no instruction on April 1 . . . just the slalom competition.

So when skiers arrive at the Bowl this Saturday, they'll go right into classes. And Max Sarchett will lay out three slalom courses, for the afternoon's competition.

There will be trophies for boys and girls in each of the three classes—A, B and C.

Six cups will be awarded, to the Class A, B and C winners in both boys' and girls' competition. Gold and silver ski pins will go to the second and third-place winners. The youngsters will be graded and assigned to races according to ability.

Only those now registered in The Times School will be eligible for the races. They must sign up at the Ski School desk in Snoqualmie Ski Lodge immediately upon arrival at

Miss Margaret O'Dell, girls' ski adviser at Queen Anne High School, is shown with some of the cups that will be awarded to winners in slalom races that will conclude the Times Free Ski School next Saturday day at the Snoqualmie Ski Bowl. Cups will go to the boys and girls winning the six races, while gold and silver ski-shaped pins will be awarded to second and third-place winners.

Margaret Odell and *Seattle Times* ski school trophies, March 21, 1939. *Courtesy of the* Seattle Times *Historical Archives.*

March 25 was the last day of the ski school, and races were held for the students, with six trophy cups given to the winners. Max Sarchett would lay out three slalom courses, and parents were encouraged to come and watch their sons and daughters compete. Margaret Odell was shown holding the cups in the *Seattle Times* of March 29, 1939:

> *Miss Margaret O'Dell* [sic], *girl's ski advisor at Queen Anne High School, is shown with some of the cups that will be awarded to winners in slalom races that will conclude the Times Free Ski School next Saturday at Snoqualmie Ski Bowl. Cups will go to boys and girls winning the six races, while gold and silver ski-shaped pins will be awarded to second and third-place winners.*

The Seattle Park Board's Report for the Snoqualmie Ski Park for 1936–39 gave weekly attendance figures for the last three years of its operation, together with snow conditions and accidents. The figures showed a substantial jump in the number of skiers in 1938, after the rope tow was installed, but a drop in participants in 1939, perhaps reflecting the popularity of the Milwaukee Ski Bowl. In 1937, 19,865 people went to the park; 26,025 in 1938; and 22,880 in 1939.

Selection Process Starts for the 1940 Olympic Games, Which Were Cancelled

Preparations began in 1939 to select the U.S. Olympic team for the 1940 Winter Games. The National Ski Association decided the American Ski Team would be based on the team selected to go to the Federation Internationale de Ski (FIS) Championships planned for Norway in February 1940.

On April 3, 1939, the *Seattle Times* listed skiers the National Ski Association considered eligible to compete for the FIS team, including six with a Seattle connection: Grace Carter Lindley, Dorothy Hoyt, Shirley McDonald, Bob Barto, Peter Garrett and Bobby Blatt. Sun Valley's plans to play a major role in preparing the team for the Olympics were announced in the *Seattle Times* of August 30, 1939, by Dick Durrance, "America's No. 1 skier from Dartmouth and official photographer for Sun Valley," who visited Seattle. "Sun Valley, the Union Pacific's Idaho resort, wants to employ the eighteen first-string American skiers next winter—legitimate employment too—and at the same time give them training under Friedl Pfeiffer and Peter Radacher, two great European racers, for the more strenuous skiing they'll get in the F.I.S. meet." Durrance said when the United States went to the 1936 Olympics, they learned that

> *a hastily-recruited ski team had no chance against the Europeans….They were training for a year. We had only a few weeks. If the team can go to Sun Valley, however, and work on the Bald Mountain downhill course, which needs a lot of work, it can get in condition before the first big snow… and then we can dig in and really learn some skiing before going to Norway.*

The *American Ski Annual, 1939–1940*, listed the skiers selected for the 1940 U.S. Ski Team for the FIS meet in Norway, from which the U.S. Olympic team would come. There were a number of Washington skiers on the downhill and slalom squad: Robert Blatt, Peter Garrett, Don Fraser, Grace Carter Lindley, Dorothy Hoyt and Gretchen Kunigk Fraser. International events intervened, however, which led to the cancellation of the 1940 games after a series of twists and turns. Japan, the original host of the 1940 Olympics, forfeited the games after the Sino-Japanese War broke out in July 1937. St. Moritz, Switzerland, was named as the new host of the 1940 Winter Olympics. However, a conflict arose with the International Olympic Committee over whether ski instructors could

participate in the games as amateurs, and the games were transferred to Garmisch-Partenkirchen, Germany. In November 1939, the IOC ruled that a belligerent country could not hold the Olympics, and the 1940 Winter Olympic Games were canceled.[26]

Northwest Ski Royalty Wed

In August 1939, the Northwest's "ski royalty" announced their engagement: Gretchen Kunigk and Don Fraser, two "prominent and popular" local skiers, would marry in October.

> *Blond, smiling and attractive, Miss Kunigk is a well-known skier, a brilliant downhill-slalom racer, holder of the Northwest slalom championship and combined downhill-slalom championship in 1937. Miss Kunigk doubled for the motion picture actress, Sonja Henie, in Northwest-made sequences for "Thin Ice."...Miss Kunigk hurt her knee last winter and did not recover until the American championships on Mount Hood, where she made a brilliant showing in slalom racing...*
>
> *Mr. Donald F. Fraser was a member of the American Olympic team at Garmisch-Partenkirchen, Germany in 1936; has been repeatedly downhill-slalom champion of the Northwest; and was winner of the Pan-American slalom championship in July 1937, near Santiago, Chile.*

The couple would live in Omaha, Nebraska, where Fraser was the Midwest representative for the Sun Valley Resort.

Plans for 1940: National Four-Way Championships to Be Held in Northwest, World-Class Ski Jumps Are Built at the Ski Bowl

Major changes had been made at Sun Valley in the summer and fall of 1939. Bald Mountain was opened for general skiing after being accessible in prior years only by snow cat or hiking. Three single chairlifts were built from the bottom of the mountain at River Run to the top of the 9,200-foot mountain, and new ski runs were cut through the trees, significantly expanding skiing at the resort. On March 10, 1940, the *Seattle Times* called it a

skier's paradise where there are unlimited miles of long, smooth mountain slopes not "obstacled by timber or rocks," where the snow is always "powder" and never wet and crusted, where ski lifts take all the dirty work out of climbing....All you do is sit down and go merrily to the top of the hill. No need to take off your skis....The climate is usually so mild you'll find your self taking "sun" baths right out in the snow!

On October 9, 1939, the *Seattle Times* published next season's ski racing schedule. Sun Valley would host the National Downhill Slalom Championships from March 21 to 24, 1940, and ski competitions were set for nearly every weekend in Washington. The National Four-Way Championships would be held in Washington at three different ski areas on March 30 and 31, 1940, which was the major national tournament of the year. Downhill and slalom racing would take place on Mount Baker, with cross-country races at Snoqualmie Summit and jumping at the Ski Bowl.

In the fall of 1939, the Milwaukee Road spent $15,000 building facilities for the jumping events of the National Four-Way Ski Championships. It built a giant Class A ski jump at its Ski Bowl, a smaller Class B jump next to it and a lift to carry skiers to the top of Rocky Point, the big hill behind the Bowl; it also cleared forty acres. The Class A and B jumps were designed to take advantage of the natural slope of the land, and the Class A jump had more than a two-hundred-foot capacity. The jumps were a three-year dream of Peter Hostmark, a graduate of Norway's Institute of Technology, president of the Pacific Northwestern Ski Association and a national authority on ski jumping. When Hostmark toured the undeveloped Ski Bowl site in 1936, he was asked what he thought of the area for skiing. He replied "fine" in a detached manner. "But it would make a beautiful site for a ski-jumping hill! A magnificent site!"

A *Seattle Times* headline on September 16, 1939, read, "Snoqualmie Ski Jump to Be Big." Hostmark designed the facility to attract "the world's greatest ski-jumpers. Seattle and the Pacific Northwest may rightfully claim one of the most tremendous jumping hills in the United States." He predicted that 270-foot jumps were possible at the Four-Way Combined Championship tournament. "The hill will take that jump handily....Veteran northwest jumpers who have viewed the new hill are enthusiastic over its possibilities. The inrun has a fine natural curve; is unlimited because of [the] timber free slope above the hill and may thus be modified for varying snow conditions," according to the *Tacoma News Tribune*, November 27, 1939. Bob St. Louis, a

member of the University of Washington Ski Team who competed on the big jump, described it in *Ancient Skiers of the Pacific Northwest*:

> *Unlike lots of other jumping hills, the Bowl was very different. The in-run was not a high scaffold to provide a short high speed run but ran up the mountainside, providing a long, undulating run to gain the necessary speed (maybe 60 mph). The hill itself was a large scaffold affair built out from the hill to provide the necessary contour. The out-run, instead of being a dished out affair with an upslope, continued a gradual down slope to the lodge next to the railroad tracks.*

A judging tower was built next to the Class B jump on the Olympian run. The sign on the tower read, "The Olympian Hill, Snoqualmie Ski Bowl, The Milwaukee Road 1939. Computed Possible Maximum Jump—Hill 'A' 280 feet, Hill 'B' 210 feet." Pictured here are the Class A jump on the right and the Class B jump on the left. The judges' tower is next to the Class B jump, and a warming hut for jumpers can be seen above it.

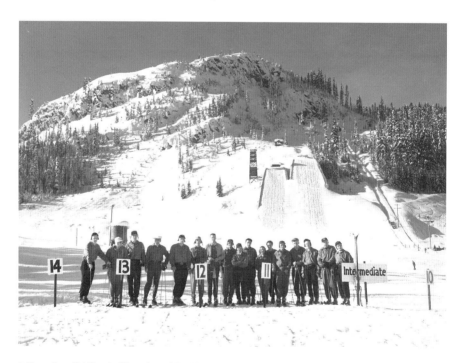

Milwaukee Ski Bowl, Class A and B ski jumps, ski class, Olympic Tower and jumper's warming hut. *Courtesy of Walter Page.*

The *Milwaukee Road Magazine* of December 1939 published an article titled "Ski Bowl Gets a Pair of Wings." Two ski tows were available for 1940, including a new 1,400-foot electric ski tow on the eastern slopes above the old tow, which opened up the wide-open terrain east of Rocky Point. New high-speed trails were created for advanced skiers, providing a one-mile unobstructed run from Rocky Point to the foot of the mountain. Old trails were leveled and smoothed. Timber was removed to provide new vistas from the lodge. For non-skiers, there was a sledding and tobogganing hill separated from the ski hill. The public announcement system had been improved. The prior year, the system broadcast music and announcements about the train schedule. For 1940, it had been extended all the way up the hill and would be in use at the championship jumping competition. Being able to travel to the Ski Bowl by train and the enlargement of the ski school to take students from communities surrounding Seattle were major attractions.

The Milwaukee Ski Bowl Is the Center of Local Skiing; Jumping Tournaments Attract World-Class Competitors, 1940–1941

*I*n 1940, the Mercer Island floating bridge (later named the Lacey V. Murrow Memorial Bridge) was opened, going through tunnels on the Seattle side, crossing Lake Washington onto Mercer Island, over a second new bridge to the east side of Lake Washington and then continuing to Issaquah, where it intersected with the old Sunset Highway. This new route replaced the portion of the highway that went south around Lake Washington through Renton or north through Kenmore, shortening the trip to Snoqualmie Pass and making the drive quicker and easier.

MILWAUKEE SKI BOWL IS AGAIN THE CENTER OF NORTHWEST SKIING

In the winter of 1940, the *Seattle Times* again offered free ski lessons at the Ski Bowl for Seattle High School students, which had the philosophy "Control Is Ski School Idea; Instructors Frown on High Speed Didoes."

A controlled skier has a reasonable certainty of getting through his skiing without a broken leg. It's when they click skis together, point straight downhill and start a-booming, that they get into trouble. That sort of skiing will be sharply discouraged in the Times School....Here's what arriving high school students will be told when they get their skis and go for their

first class. That any fool can schuss—for a moment. Schuss means roaring downhill, at cut-'er-loose speed. Only a skier who has mastery of his skis can make a turn. Only a skier who has learned the fundamentals correctly will, later, be able to make a correct, high-speed turn.

Dick Durrance (Dartmouth's champion skier then working for Sun Valley) visited the Ski Bowl on opening day of 1940. He was impressed how the ski school handled the 904 enthusiastic students who piled off the ski train and were quickly put into well-organized classes. "There's nothing like it in the East....There's nothing like it in Europe. Not even in Germany, and I thought they developed mass organization of their skiers. You've got something here the whole world needs to know about." Olav Ulland made the christening jump on the Ski Bowl's giant new ski jump and said, "The potential of the hill, all the jumpers admit, is enormous." Ulland jumped 210 feet, but Durrance said Olaf "was pulling his punches...[and] the hill wasn't packed very well."

A record 579 students signed up for the Times Ski School in 1940. Each week, a different high school took charge of organizing the activities, and January 21 was "Kuay day," honoring Queen Anne High School. There

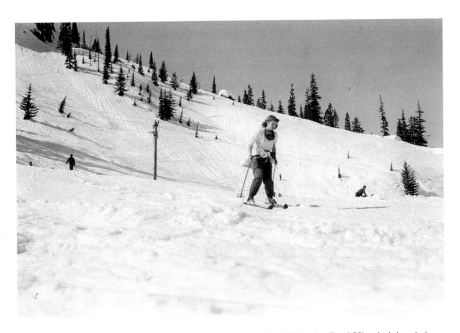

A woman skiing at the Milwaukee Ski Bowl. *Courtesy of the Milwaukee Road Historical Association.*

were 200 Queen Anne students were in charge "under the guidance of Miss Margaret Odell, Kuay Ski Club advisor....The Hilltoppers organized their group, marshaled the students from other high schools, junior high schools, and the University of Washington, and put their day over with a bang." A phonograph provided music on the train trip up and back, creating "infectious swing-time dancing and singing aboard the train that set the tempo for the day." The student in charge of the phonograph described the train's social scene. "'I can't keep up with 'em,' he declared. 'Too many requests, not enough "hot" records. They love to ski and they love to dance in their ski clothes. I'll bet I've played "Oh, Johnny, Oh Johnny" fifty times. That's the best thing about this trip to the Bowl; you not only have the fun learning to ski, but you have fun on the train too.'"

In February 1940, the Washington Motor Coach Company began offering bus trips to the Ski Bowl from Ellensburg on Saturdays and Sundays, allowing eastern Washington residents to come to the Ski Bowl for the first time. The Ski Bowl did not permit private cars into the ski area since "to do so would have opened the bowl to those who came from sections which we served by special ski trains."

1940: Major Ski Tournaments Held, Sigurd Hall Killed in Silver Skis Race, Seattle Gets Out of Ski Business

National Four-Way Championships Held in the Northwest

The National Four-Way Championships were held in the Northwest between March 13 and 17, 1940, at three different ski areas and were publicized throughout the winter by Seattle newspapers. Downhill and slalom races were held on Mount Baker on courses set by Dr. Otto Strizek; the cross-country race was held on Snoqualmie Pass on an eleven-mile course set by Hans-Otto Giese; and the jumping competition was held at the Milwaukee Ski Bowl on a giant new jump constructed for the event.

One of the main stories of this tournament was the emergence of Seattle's Sigurd Hall, an immigrant from Norway who had made his reputation in ski-mountaineering and climbing. He arrived on the national ski racing scene showing that he was one of the best four-way skiers in the country.

This tournament was the high point of Hall's career, which was tragically brought to an end one month later.

On March 13, 1940, the *New York Times* described the level of competition in the nationally important tournament, which featured "the country's foremost all-around skiers including Alf Engen, Sigurd Hall, Olaf Rodegard and Hjalmar Hvam," who were to compete "in the most difficult of all national championships." "With most of America's premier skiers in the West for the 'Spring Circuit,'" and the numbers increased since "the European war has kept Americans home this season, the competition should be exceptionally keen."

Sigurd Hall of the Seattle Ski Club won the downhill race at Mount Baker on March 13, getting a break as the heavy weather that hindered earlier skiers cleared for his run. Alf Engen was third, following his brother Sverre, but the next day Alf won the slalom—which had two thousand vertical feet—beating two dozen racers. Hall finished third in the slalom but led in the point standings as the action changed to Snoqualmie Pass.

The eleven-mile cross-country event at Snoqualmie Pass began and ended at the same spot and consisted of one-third downhill, one-third uphill and one-third on the flat. "If the winner isn't close to the dish-rag stage when he's all through he can take a place alongside Superman, the new hero of the Times comic strips." Both Engen and Hall were accomplished cross-country skiers, and they finished one place apart in the competition. Engen was fourth, and Hall was fifth.

The jumping event at the Ski Bowl got most of the publicity. Torger Tokle, "snow star from the Norway Ski Club of New York," entered, seeking another chance to jump against Alf Engen, who had beaten him at the National Jumping Championships at Berlin, New Hampshire, earlier that year. Special trains took spectators to the pass leaving every half hour, beginning at 8:30 a.m. Thousands of spectators were expected to line the course, and outdoor eating facilities were set up. Expectations were high that the national jumping record of 257 feet would be beaten. Under the headline "Engen, Tokle to Head Up Special Event," on March 17, the *Seattle Times* predicted, "They'll shoot the works at the Ski Bowl Today, and girls and boys, we do mean shoot." Twenty jumpers would compete on the Class A jump on the Bowl's Olympian Hill, which had not been tested before in competition, and others on the Class B jump.

Tokle had longer jumps than Engen, but Engen won the tournament as Tokle "failed to display the form" shown by Engen on a day when "the weather was perfect and the snow fast." Tokle jumped 238 and 235 feet,

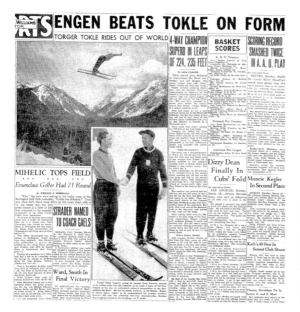

"Engen Beats Tokle on Form" in the jumping event at the National Four-Way Tournament at the Milwaukee Ski Bowl, *Seattle Times*, March 18, 1940. *Courtesy of the* Seattle Times *Historical Archives.*

while Engen jumped 224 and 235 feet. The best jump of the day fell 19 feet short of the record. Tokle said he had practiced distance jumping and had not worked hard enough on form. "The newsreel boys expressed disappointment that they only had one spill to film in the jumping event, as only the first jumper fell, and the rest rode out their leaps."

Alf Engen, "the stocky skiman from Sun Valley, went off with the works" and won the overall title in the Four-Way Competition. Sverre Engen was second, Sigurd Hall placed third and Hjalmar Hvan of Portland was fourth.

Engen was far more experienced in ski jumping than Hall, and that made the difference in the tournament. In 1939, Hall was still a Class B jumper, while by 1940, Engen had won the National Jumping Championship multiple times, including that winter, and was one of the best jumpers in the world. Alf Engen was awarded the National Ski Association's American Ski Trophy in 1941, indicating he was the country's outstanding skier based on his winning the National Four-Way Championship and the National Ski Jumping Championship. At the awards banquet, Alf and Sverre Engen, who finished first and second overall, hoisted Sigurd Hall on their shoulders to the tune of "He's a Jolly Good Fellow," according to an article in the *American Ski Annual*, 1940–41. Hall's third-place finish against this level of competition was impressive and showed that he was one of the best four-way competitors in the country and an upcoming star.

Silver Skis Race Ends in Tragedy

The year 1940 ended on a tragic note, as Sigurd Hall was killed in the Silver Skis Race on Mount Rainier in April when he veered off course a half a mile from the top and hit a rock in a dense fog, becoming the first death in ski competition in the United States. The accident was described by the *Seattle Times* on April 14, 1940:

> *Sigurd Hall, of the Seattle Ski Club, one of the Northwest's outstanding downhill ski racers, was killed on Mount Rainier yesterday during the running of the annual Silver Skis race. Hall, who last month had captured third place in the downhill portion of the national Four-Way tournament on Mount Rainier, crashed into some rocks approximately three-quarters of a mile from the start of the 3.16 mile race.*
>
> *The 25-year-old skier was placed on a toboggan to be carried to Paradise Inn, but died en route to the lodge. Dr. S.F. Herrmann of Tacoma said it was apparent that head injuries were the cause of Hall's death. Witnesses suggested that fog, which at times covered the upper portion of the course, probably was the cause for Hall's loss of control. Snow on that portion was crusty, icy in spots, and terrifically fast. Contestants attained speeds of close to fifty miles an hour soon after starting.*
>
> *Hall, as he approached the rocks just below Anvil Rock, lost his balance and fell headlong. Two other contestants were injured in this race. Vince Broz, Seattle, suffered a fractured leg, and Paul Sceva, Jr., also of Seattle, sprained a knee.*

Paul Gilbreath of the Washington Ski Club won the race, "but there was no elation over the win. Death took Sigurd Hall, Seattle Ski Club downhill star, during the running." Tony Matt of North Conway, New Hampshire, finished second by two seconds. Nancy Reynolds of Sun Valley, Idaho, won the women's race, beating Shirley McDonald of the Washington Ski Club.

Sigurd Hall's death had a significant impact on the nation's skiing community. A Northwestern Ski Association committee held a hearing into Hall's death. The *American Ski Annual* published several articles about Hall's death, summarized by Lowell Skoog in his Alpenglow Ski Mountaineering History Project.[27]

Seattle Gets Out of the Ski Business, Ski Park Is Taken Over by Ski Lifts Inc.

Seattle's special use permit with the Forest Service issued in December 1933, which gave the city the right to use the property for the Seattle Park Board's Snoqualmie Ski Park, expired in December 1939. In early 1940, the Seattle Park Board got out of the ski business after Seattle residents concluded that Snoqualmie Pass was too far away for a city park. The *Seattle Times* of January 29, 1940, said the "municipal hill just turned back to the forest service," indicating that the Seattle Park Board had given up its permit at the beginning of the 1940 ski season. This ended Seattle's innovative role in ski operations at Snoqualmie Summit. The ski area was taken over by Ski Lifts Inc., the company that installed the rope tow in the fall of 1937 and ran the concessions. The main ski run there continued to be known as "Municipal Hill" or "Government Hill." The area was renamed Snoqualmie Summit Ski Area and thrived under Webb Moffett's management before and after World War II.

Improvements are Made at the Ski Bowl

A number of improvements were made at the Ski Bowl for 1941. A stairway was removed in the lodge, giving more room for skiers on the first and second floors; thirty lockers were installed to allow skiers to check their equipment overnight or from weekend to weekend; and ten murals with ski motifs were painted on the wall. A new ski lane was opened, stumps were removed for the two ski tows "and skin-smooth skiing assured on all of the favorite sitzmark slopes." One tow took skiers to the old railroad grade, where after a quarter mile of skiing, a second rope tow lifted them one thousand feet higher to the crest of Rocky Point. Round-trip fare on the ski train was $1.25, and students had a special rate of $1.00 on Saturdays, with one train leaving from Seattle at 8:30 a.m. and returning at 5:00 p.m.

In the fall of 1940 and winter of 1941, the Ski Bowl began a transition from being called the Snoqualmie Ski Bowl to being known as the Milwaukee Ski Bowl. When Seattle got out of the ski business, Ski Lifts Inc. took over the Ski Park and called it the Snoqualmie Ski Area, and later the Summit Ski Area. There was no formal announcement of the change of the name of the Ski Bowl at the time, but it was a matter of practice. For its reopening

in 1947, the *American Ski Annual*, 1946–47, said, "In order to avoid confusion with the Snoqualmie Ski Area, the name has been changed to the Milwaukee Road Ski Bowl."

In November 1940, there was a rumor that the Milwaukee Ski Bowl might become the training site for special U.S. Army ski troops, and select soldiers would drill from Monday to Friday with Ken Syverson Ski School instructors. Adding credence to the rumor was the story that the Third Division (Regular Army) and Forty-First Division (National Guard) were authorized to purchase skis.

1941: SKI SEASON IS A BUSY ONE AS WAR LOOMS, TOKLE SETS DISTANCE RECORDS

The winter of 1941 was the last peacetime ski season before World War II started. Enthusiasm for skiing continued to grow, but hints of the coming conflict were seen.

A number of ski competitions were held on Snoqualmie Pass in January. A slalom race was held at the Milwaukee Ski Bowl for seventy-five of the best skiers in Washington and Oregon. The nearly mile-long race started on Rocky Point and was watched by 1,249 spectators who rode two "specials" to the Ski Bowl. Scott Osborn, "veteran Northwest ski racer," won the giant slalom and announced he was joining the Ken Syverson Ski School the following weekend to coach racing. The Mountaineers hosted Washington Ski Club with a dinner and dance on Saturday night and ski competitions both days. Plans for the Pacific Northwest Skiing Association's cross-country championship hosted by Sahalie Ski Club were being finalized "for the huff and puff boys of skiing." The ten-mile course was a figure eight configuration starting at Sahalie's clubhouse, making a loop toward Snow Lake, returning to the clubhouse, going east toward Hyak and then returning to Sahalie. On January 26, the Snoqualmie Pass championship was held at Paradise, a four-way competition between the Washington Ski Club, Seattle Ski Club, Sahalie Ski Club and The Mountaineers.

Special events were held at the Ski Bowl throughout the winter. The Mountaineers chartered a train for a Friday night event, which included "singing and dancing their way to the Ski Bowl for an evening of skiing." Cunningham's Ski Shop offered a Friday night special ski experience. For $1.95, skiers could rent ski clothing and equipment and ride a chartered train to the Bowl for an evening of skiing.

Demonstrating the popularity of skiing, the *Seattle Times* published a section in its society pages on February 2, 1941, "Seattleites Let Their Cares Slip Away on Skis, Throngs Hie to Mountains for Exciting Snow Sport":

> *You can see the caravan of automobiles rolling mountain-ward each week-end. Strapped on top of the cars are skis. Inside the cars are skiers, Seattleites seeking escape from a work-a-day world; socialites shrugging their shoulders at their calendars; business and professional people finding temporary release from their worries; and students trying to forget the Greek "lit" tests! Ah, yes, each week-end at Mount Rainier, at Mount Baker, at Snoqualmie Pass, Seattleites eagerly exchange yawns for yodels, ice cubes in the glass for icicles, and glamorous evening gowns for cozy, snug ski outfits. Middle-aged men haven't forgotten how to play…and they're delighted. Mothers and even grandmothers feel the years slipping away as they skim over the snow. Debs and college men lose some of their cynicism and start acting as natural as children.*
>
> *And then, when Seattle skiers have tired of their own fields, Mount Baker, Mount Rainier, Snoqualmie Pass, they take jaunts over to Oregon, where they have a stimulating weekend at Timberland Lodge, or go over to the swanky Sun Valley, which is fast becoming the winter playground of the entire effete United States. Well, anyway, the effete population devoted to skiing.*

The Milwaukee Ski Bowl opened its third season on January 4 and 5, 1941, with ads saying, "You can enjoy endless thrills and healthful fun at the beautiful snow fields at the Milwaukee Railroad's popular Milwaukee Ski Bowl. With its facilities improved every year, the Ski Bowl is better and more popular than ever." On Sundays, Olav Ulland would provide free ski jumping instruction, and there was to be a giant slalom race. "All activities can be viewed from the big, comfortable lodge," accessible by trains with "warm, up-to-date coaches, recreation car and lunch facilities." The *Seattle Times* ski school offered racing lessons led by Scott Osborn, veteran Northwest racer. Although a "slack-off in ski school attendance" was anticipated, participation increased as "more than 400 tenth-grade, high school and University of Washington students seriously applied themselves to the snowplow, stem turn and stem christie."

A Class C jump had been erected at the Milwaukee Ski Bowl to provide "junior skiers of Seattle and vicinity an opportunity to learn the art of ski-jumping on a small, appropriate hill." Milwaukee Road crews used a bulldozer to fashion "a suitable contour for a small Class C jumping hill," so "the juniors will have a fine, small-gauge hill at their disposal." The Pacific

Northwestern Ski Association provided coaching for juniors on the new jump. In the past, the Seattle Ski Club had a limited junior jumping program on its small Sunset Hill at Snoqualmie Summit but said "a second Class C jumping hill is welcome," according to the *Seattle Times*, January 22, 1941.

Torger Tokle Sets Two New National Distance Records

In the winter of 1941, jumping competitions focused on national distance records, starting at Leavenworth in February followed by the National Jumping Championships at the Milwaukee Ski Bowl in early March. The highest artificial ski slide in the world had been erected at Iron Mountain, Michigan, in 1939, and Bob Roecker of Duluth, Minnesota, set a new American record of 257 feet at the area's baptismal tournament, a record that still stood in 1941.

Torger Tokle said he was out to break the North American ski jump record of 257 feet at the Leavenworth tournament. The takeoff at the Leavenworth jump had been pushed back 8 feet, and Tokle said a 260-foot jump was a conservative estimate of the hill's capacity. Tokle had a practice jump of 273 feet, but to count, the jump had to be done in a competition. A Great Northern Railroad special would leave Seattle at 7:30 a.m., arriving at 12:15 p.m., and leave Leavenworth at 4:15 p.m., arriving in Seattle at 9:25 p.m. The round trip cost $2.50.

On February 9, 1941, Alf Engen from Salt Lake City broke the American distance record at Iron Mountain, Michigan, jumping 267 feet (although he lost to Walter Bietila on form points). "But the happy patrons of Pine Mountain woke up the next morning to learn that Engen's 267-footer lasted for exactly two hours as a record. Later in the afternoon, a chap named Torger Tokle had soared 273 feet at Leavenworth." The *Seattle Times* commented, "too bad Alf."

On February 9, Torger Tokle had a "mighty leap of 273 feet" at Leavenworth, setting a new North American record. The *Seattle Times* published a picture on February 10 of Tokle going off the jump, "Tokle Outjumps Engen." The caption said Tokle

> *seemed to be riding the top of the trees as he soared past the judge's stands, out, out and out, and finally to klump down on the steep landing. Needless to say, 5,500 mouths were agape and official measurers scurried breathlessslessly to their steel measuring tapes as Tokle rode out his prodigious*

jump.... Tokle's leap was supreme, the longest jump ever recorded in North American amateur competition.

This set the stage for the upcoming Milwaukee Bowl tournament.

Excitement was great for the National Jumping Championships at the Milwaukee Ski Bowl on March 3, 1941. Tokle's new record made him a favorite, but competition would be tough. Two Beitila brothers from Wisconsin entered the event and were expected to give Tokle a fight. Walter Beitila was a member of the 1936 U.S. Olympic jumping team. In mid-February, Eugene Wilson of the Duluth Ski Club had beaten Tokle.

The *Seattle Times* of March 2, 1941, said, "Here is the greatest ski-jumping field ever gathered on the Pacific Coast, the men who will shoot into space over Olympian Hill, Snoqualmie Ski Bowl." Before the tournament, Tokle jumped "an amazing 276" feet, exceeding the 273-foot North American record, although it did not count since it was done in practice. National champion Alf Engen was the favorite, as he typically has better form than Tokle and was a wily competitor, and Ralph Bietila from Wisconsin "must be reckoned with."

Tokle, the "human sky rocket from New York," jumped 288 feet at the Milwaukee Ski Bowl, setting his second North American record in less than a month in front of an excited crowd of 5,500 fans. "Ski Leaper Gambles, Makes Record Flight of 288 Feet for Title," exclaimed the *Seattle Times*

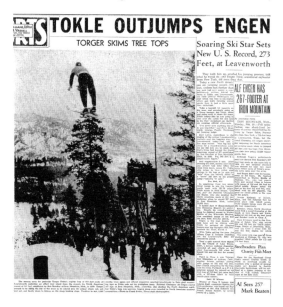

"Torger Skims Tree Tops" while setting a new American distance record of 273 feet at the 1941 Leavenworth tournament, *Seattle Times*, February 10, 1941. *Courtesy of the* Seattle Times *Historical Archives.*

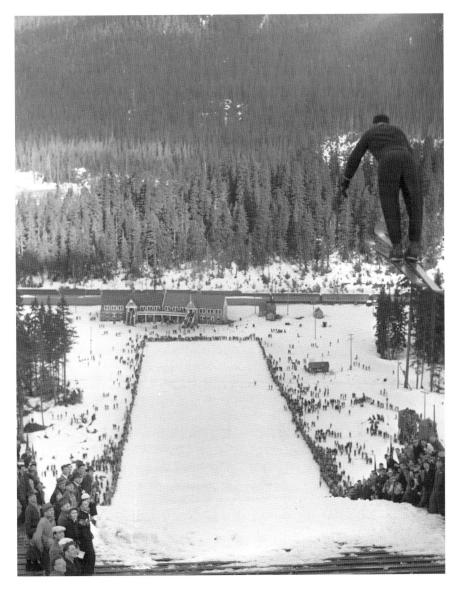

Jumper going off a ski jump heading toward the Ski Bowl lodge at the 1941 National Ski Jumping Championships, Milwaukee Ski Bowl. *Courtesy of the Tacoma Public Library.*

of March 3, 1941, which published a picture of Tokle soaring over the mountains in the background, saying, "There Goes the Record." Alf Engen was second, and Arthur Devlin of Lake Placid was third. Tokle said that he wanted to be invited back next year, and if the takeoff was moved back 30

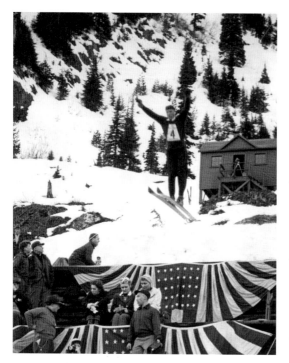

Left: Jumper going off a ski jump facing the camera at the 1941 National Ski Jumping Championships, Milwaukee Ski Bowl. *Courtesy of the Tacoma Public Library.*

Below: "There Goes the Record." Torger Tokle jumping 276 feet at the Milwaukee Ski Bowl to break his own distance record set at Leavenworth one month before, *Seattle Times*, March 3, 1941. *Courtesy of the* Seattle Times *Historical Archives.*

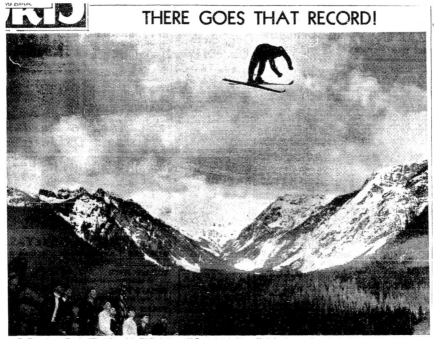

THERE GOES THAT RECORD!

Hurtling out over Olympian Hill at Snoqualmie Ski Bowl, 21-year-old Torger Tokle, Norwegian-born New Yorker, is shown in midflight of the 288-foot jump that broke his own North American record, won him the National Ski Jumping Tournament title yesterday. He lost a few points on form on this jump.—A. P. photo by Paul Wagner.

feet, he could jump 325 feet. After the tournament, Tokle said he thought he could jump 400 feet "on the proper sort of hill." Since Tokle set a record with his 288-foot jump at Seattle, "this left a lot of people wondering just what sort of hill he considers proper," mused the *Seattle Times* of March 5, 1941. A short time later, Tokle raised the American distance record to 289 feet at Iron Mountain, Michigan.

The number of jumpers who were later inducted into the U.S. Ski and Snowboard Hall of Fame demonstrates the level of competition at the tournament: Torger Tokle (1959), Alf Engen (1959), Arthur Devlin (1963) Walter Bietila (1965), Ralph Bietila (1975) and Olaf Ulland (1981).

Other Skiing Activities in 1941

In 1941, Gretchen Kunigk Fraser became even more successful at ski racing. She won the women's portion of the Jeffers Cup competition in Sun Valley in January, and in early February, she obtained the "Diamond Ski and Sun, Sun Valley's most coveted skiing award. Many of Sun Valley's best skiers have tried to earn the award and failed." At the National Downhill and Slalom Championships in Aspen, Colorado, in March 1941, Gretchen won the women's downhill race with "a brilliant run," beating the second-place finisher by eleven seconds.

At the last day of ski lessons at the Ski Bowl, there was an advanced race for students who had taken Scott Osborn's racing lessons, with the Ken Binns Memorial Trophy awarded to the outstanding student in achievement and inspiration. Binns, who was the longtime ski reporter for the *Seattle Times* and had a big part in founding the Times Ski School, had died earlier in the year. The trophy was a lasting tribute to his contributions to local skiing.

For the 1941 Mountaineers Patrol Race, the *Seattle Times* said "the 'he-man wanted' sign" went up for the "grueling" nineteen-mile race. Two army ski patrol teams were expected to enter. The race was won by the Washington Alpine Club team of Al Wilson, Grant Lovegren and Carleton Greenfield. Second was the Forty-First Division Army Ski Patrol team from Camp Nisqually on Mount Rainier. The UW team of Bob Behnke, John Scott and John Woodlin "deserve a cheer for their efforts officially gone haywire. Legs were 'shot' when the patrols reached the Meany Lane run to the finish line, check turns were difficult on the icy going, and most of the tired patrol members staged a sprawling act for the officials at Meany Ski Hut."

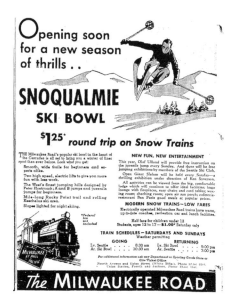

Ski Lifts Inc. ad in the *Seattle Times*, October 13, 1941. *Courtesy of the* Seattle Times *Historical Archives.*

In October 1941, Ski Lifts Inc. ran an ad in the *Seattle Times* announcing that eleven tows were available to Northwest skiers. "You'll ride NEW lifts on the practice hill at Paradise, up Alta Visa and on the Seven Hills at Mount Rainier, improved ski tows at Naches, at Snoqualmie and Edith Creek Basin." On November 12, the *Seattle Times* described Ski Lifts Inc.'s rates for 1942. At Mount Rainier, a ride on the "big tow" cost $0.10 cents or $1.50 to ride all four tows in Paradise Valley all day long. For $0.05, skiers could ride the new seven-hundred-foot Edith Creek tow extending down the back side of Alta Vista to Edith Creek basin and the two beginners tows on the practice hill. At Mount Baker, the all-day charge was $1.50, the Bagley tow cost $0.10 per ride and the new Seven Hills tow cost $0.05 a ride. Charges at Snoqualmie Pass would be around $1.00 for all day and $0.05 a ride.

Skiing was a $1 million industry in the Northwest in 1941. An estimated 500,000 people went to sports resorts in Washington, and there were around 65,000 skiers in Western Washington. Mount Rainier was the most popular area, with 125,000 skiing visitors. Other popular ski areas included Snoqualmie Ski Bowl at Hyak, Cayuse Pass, Mount Baker, Stevens Pass, Martin, Deer Park, American River, Mount Spokane and Leavenworth.

Skiing during World War II, 1942–1945

1942: SKIING CONTINUES BUT THE WAR BEGINS TO AFFECT THE COUNTRY

World War II started for the United States on December 7, 1941, when Japan bombed Pearl Harbor and war was declared on Japan and Germany. The war changed everything, although it took some time for its full effects to be felt. Skiing slowed as men went off to war and women had to deal with wartime living conditions, which included rationing of items such as food, clothing, gasoline and tires. Initially, skiing continued, as did scheduled tournaments. As in past years, jumping tournaments were held at the Milwaukee Ski Bowl, Leavenworth and other sites, and Alf Engen and Torger Tokle competed for jumping crowns.

Local Skiing and Tournaments

Ken Syverson's ski school at the Ski Bowl emphasized practicing turns more slowly, improving one's swing and "feeling that 'flow of motion,' which is so essential in handling a greater speed with ease, accuracy and gracefulness." The Seattle Ski Club and Olav Ulland ("topnotch ski-jumping instructor in the Pacific Northwest") would offer a junior jumping class "on the brand new slope which Milwaukee Railroad workers

constructed during the fall months alongside big Olympian Hill." Ski-jumping requires an early start and expert coaching, and this program intended to develop well-rounded skiers. The national championships held at the Ski Bowl in 1941 demonstrated the need to promote and stimulate ski jumping in the Pacific Northwest, and with "Olav teaching young skiers the art of jumping, a national four-event champion may emerge from the ranks of Ski Bowl-goers."

Milwaukee Road ads said Olav Ulland would provide free instruction on the juvenile jump along with a thrilling exhibition. Ken Syverson was to hold open slalom races. All the activities at the Ski Bowl could be viewed from the big, comfortable lodge, which contained a huge lounge with fireplaces, easy chairs and card tables; a waxing room, checking room and an open air porch; and a cafeteria-restaurant where Ben Paris offered good meals at popular prices. Two ski trains left Seattle for the Ski Bowl, one at 8:30 a.m. and the second at 10:30 a.m., with return trips scheduled for 5:00 p.m. and 7:00 p.m. A round trip for students cost $1.25.

The Ski Bowl opened the weekend of January 3 and 4, 1942, and eight hundred people boarded the ski special on January 10 for Garfield Day. Skiers found new improvements, including work done to smooth out the Bowl's runs. Seattle's Boeing and shipyard defense workers were provided a free night of skiing at the Milwaukee Ski Bowl with transportation provided on a special Milwaukee Road train.

Milwaukee Road ad for Milwaukee Ski Bowl, *Seattle Times*, November 12, 1941. *Courtesy of the* Seattle Times *Historical Archives.*

The Seattle Ski Club hosted a jumping competition at the Ski Bowl in the winter of 1942, with proceeds going to the Red Cross War Fund. Torger Tokle, "the human airplane" from the Norway Ski Club of New York, would compete along with twenty of the West Coast's best jumpers. Tokle was "a gambler who shoots at the hill mark virtually every time he hits the inrun." He would be challenged by "stylists," including Reidar Anderson, Birger Ruud and Alf Engen.

Milwaukee Road ski specials would leave for the tournament at 8:30 a.m., costing $1.31 plus $1.00 for entry into

the event. Those driving would pay $1.50. Olav Ulland led a party that foot-tramped the big Olympian hill to make it ready for the competition. To the disappointment of ski jumping fans, Alf Engen, the Sun Valley ski jumper, was ruled "out of jumping" from all competition by the U.S. Ski Association because he had been listed as the "All-American champion" in an advertisement for ice skates named after him. The use of Engen's title and skiing records made him a professional, but he might be reinstated if changes were made to the ad.

Tokle won the Milwaukee Ski Bowl event as he "outsoared, outperformed and outscored" the other jumpers. His jumps of 248 and 263 feet were "beautiful to behold as he twice reached for the clouds….Critics who had been labeling Mr. Tokle as strictly a powerhouse leaper, one who sacrifices form for distance, ducked their noggins and blushed yesterday." Tokle said the Olympian Hill was too big for jumpers that early in the season, as skiers "haven't our legs, and we're not ready for the biggest ski-jumping hill in the country in January." After the tournament, Sverre Fredheim, who finished fourth in the Class A event, left for the National Ski-Jumping Championships at Duluth, Minnesota, in early February. Fredheim was the top American ski jumper in the 1936 Olympics and the PNSA champion in 1942 and would wear Washington Ski Club colors.

The fourteenth annual Leavenworth tournament was held in late January 1942, but there were no Great Northern special trains because of "wartime transportation demands." Canada's Tom Mobraaten won the tournament with jumps of 224 and 245 feet "with a heavy crowd watching." Howard Jensen from Chicago was second, and Olav Ulland was third. John Ellerson of Stanwood provided the day's main thrill when he lost a ski in midair after the takeoff, landed safely on his one ski after a jump of 208 feet and finished his run before spilling.

Changes at the Ski Bowl had to be made because of the war. Limits were placed on the size of the ski trains, so the Milwaukee Road ran only one train per day, limited to seventy skiers. Tickets were $1.31 for adults. In February 1942, the Interstate Commerce Commission ordered that all passenger train rates be increased. The new prices for tickets were $1.16 for students and $1.47 for adults.

The final weekend for the Milwaukee Ski Bowl was on March 28 and 29, 1942. Over twenty thousand skiers went to the Ski Bowl that year, an all-time high in spite of the fact that the country was at war. The road to Paradise on Mount Rainier was closed from the winter of 1943, to the end of the war.

Army Ski Troops Train in the Northwest

With World War II being fought in Europe, the U.S. Army was preparing its troops for future combat. U.S. Army Ski Troops were stationed at Fort Lewis and trained on Mount Rainier from 1940 to 1942, forming the Ski Patrol Troops of the Third Division's Fifteenth Infantry Regiment, before moving to Camp Hale, Colorado, in 1943, where the Tenth Mountain Division was formed. Twenty-five army skiers from Fort Lewis were stationed at Longmire in January and February 1941, where they held extended cross-country maneuvers throughout the park to test ski equipment and food suitable for snow-covered terrain. Another twenty-five men were stationed at Camp Nisqually in the late winter 1941. Lieutenant John Woodward, a former star of the University of Washington ski team, trained a select group of army recruits in ski techniques. In February 1941, Woodward led his ski troops on a seven-day overland traverse "along difficult mountain terrain" from Snoqualmie Pass to Chinook Pass east of Mount Rainier.

Local newspapers took notice of the U.S. Army Ski Troops. On January 9, 1941, Rita Hume reported on her visit to Mount Rainier in an article in the society pages, "Feminine Version, Skier Rita Visits Army Skiers," after being entranced by these tough young men. "Definitely professional-looking are these ski troops in their forest green downhill pants and parkas. (They do a few quick-change tricks, too, when occasion demands all-white ski toggery.)" In late March 1942, the Army Mountain Troops held maneuvers on Mount Rainier overseen by the commanding general of the IX Army Corps. The *Seattle Times* published a front-page article about the event and a Rotogravure section with a number of pictures of the troops in action on March 29, 1942.

The army permitted its ski troops to enter competitions where their skills could be tested against non-military skiers, including the Silver Skis race on Mount Rainier in 1942, where

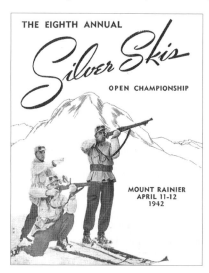

Ad for 1942 Silver Skis Race featuring army ski troops. *Courtesy of Kirby Gilbert.*

they were described as "dangerous," competing against the cream of the crop of local racers. The 1942 Silver Skis race was the last held until after the war.

In the spring of 1942, Seattle ski writers asked, "What's to become of skiing?" Many old-guard skiers would be in the service, although some would continue skiing as members of mountain regiments. The rest were left to wonder how to get to the mountains with gasoline and tire rationing. The Pacific Northwestern Ski Association planned a competitive season at Stevens and Snoqualmie Pass, where the highways would be kept open. Ski clubs discussed combining resources to charter buses to take their members skiing, and Snoqualmie Pass clubs were already getting together on ski problems. The Rainier National Park Company planned to be open during the winter of 1943. Sid Gerber, a ski-equipment manufacturer, was going to knit all summer so there would be enough merchandise available for skiers. The Husky ski coach said Washington would have a powerhouse team next year, and the school planned to send its team to meets by rail. "All in all, the ski experts agree it's hard to tell just what will happen next year, but they are leaving no stone unturned in an effort to continue the sport." A surprise wedding took place in Sun Valley when Lieutenant John Woodward married Verone Lynch. Woodward was one of two officers and ten men assisting Hollywood movie men shooting training films for the army ski troops.

Moffett Acquires Ski Lifts Inc., Gas Ration Coupons Allow Skiing to Continue at Snoqualmie

In May 1942, after several years of internal conflict among the shareholders of Ski Lifts Inc., Chauncey Griggs sold his stock to Webb Moffett and Rance Morris for $3,500. Skiing continued at Snoqualmie Summit in spite of the war-imposed rationing and thrived under Moffett's management. Moffett described how the Summit Ski area survived during the war in spite of gas rationing:

With the outbreak of war in 1941, the future appeared rather dismal. Rainier was set aside for the training of mountain troops, Mt. Baker was closed for the duration, and, the most critical problem for everyone was gas rationing. The Tacoma people decided to bow out and sold the operations at Rainier, Mt. Baker, and Snoqualmie for $3,500. Even the Milwaukee Bowl, which had been very popular by virtue of the ski trains, had to

175

Webb Moffett. *Courtesy of the Moffett family.*

close down for lack of rolling stock. Curiously, it was gas rationing that saved Snoqualmie. People still wanted to ski and they could pool their five gallons of gas a week, jam-pack their cars, and drive the shorter distance to Snoqualmie. Business quadrupled the first year, and Snoqualmie grew with more and more rope tows.

Moffett said in 1942, Ski Lifts Inc. grossed $28,000 at Mount Rainier, and Snoqualmie only grossed $1,500. During the war years, Snoqualmie Summit was the only ski area operating in the area, and the company's gross income was $800, $1,600, and $3,200 from 1943 to 1945. Under Moffett's leadership, the Snoqualmie Summit Ski Area was substantially expanded toward the end of the war and improved afterward.[28]

War Finally Shuts Down Skiing

The full impact of the war was seen in October 1942, when the Leavenworth Winter Sports Club announced it would not hold its 1943 tournament and intended to buy $1,000 of war bonds. In December 1942, the Office of Defense Transportation ordered railroads to stop running sports specials for the war's duration. The Milwaukee Road would not operate its ski train or Ski Bowl the upcoming season so it could commit its resources to the war. The Times Ski School was canceled, but the paper pledged to start ski lessons again once the war was over.

Sun Valley was disrupted by the war, announcing in early December 1942 that it would close on December 20 for the duration of the war. "Scarcity of help, shortage of food, fuel rationing and rail-traffic conservation were given as reasons." Hundreds of persons with reservations for the Christmas holidays were notified, including 500 Seattle area skiers who were forced to change their plans. The University of Washington ski team canceled its trip to compete in an intercollegiate ski meet over the holidays. The

closure meant the cancelation of three ski meets in 1943 and affected 625 Union Pacific employees and a ski-instructor staff of 10 men headed by Otto Lang.

Virtually all the well-known skiers served in the military during World War II, many in the Tenth Mountain Division where their skiing ability played a vital role. A number were killed or wounded in combat, including the famous ski jumper Torger Tokle, who was killed in Italy in May 1945, fighting with the Tenth Mountain Division. Tokle had broken twenty-four jumping records and won forty-two of the forty-eight tournaments in which he competed. "Others had better form, but none had his power and daring." Many of those who returned played major roles in the ski industry after the war..

During World War II, Northwest skiers and mountaineers assisted the War Department by helping to train mountain troops and organize assistance for mountain rescue of downed military airplanes. Dwight Watson, a local mountaineer, described the help the local ski patrol gave to the military after it was asked to "have a knowledge of the mountainous areas in event of disasters such as plane crashes etc." Ski patrol personnel were to "become thoroughly familiar with local terrain to the end that they may be prepared to furnish guides to the Army and to extend the anti-aircraft warning and anti-parachute defense systems into comparatively inaccessible regions." Patrol activities included making maps, testing equipment and conducting winter training. Eventually, a program was developed that broke up the Cascades into ten-mile sections, each a patrol region.[29]

1943 AND 1944: SOME SKIING CONTINUES, SKI CLUBS HOST SERVICEMEN

Some organized skiing events were held in February 1943. "Just when Northwest skiing appeared to be on its last legs, Leavenworth came up with a blue-ribbon jumping tournament...on the city's famous Big Hill." Leavenworth canceled its annual jumping championships because of transportation difficulties, but this tournament had "all the color and class of the championships." Most of the Northwest's crack jumpers would attend, and the proceeds of the event would go to the Camp Little Norway Association at Toronto to aid young Norwegian jumpers training in Canada during the war.

The same month, ski teams from Washington and Washington State met at Mount Spokane, where six-man teams competed in four events: downhill, slalom, cross-country and jumping. Sahalie Ski Club held its club championships at Snoqualmie Summit, with downhill and slalom races for both men and women. Skiers reported that conditions at Snoqualmie Summit were the best in ten years, with a twelve- or thirteen-foot base and a "fine covering of powder snow." The annual Seattle High School ski championships were scheduled for Snoqualmie Summit the last weekend of February, "one of the few snow tourneys which hasn't folded up for the duration." Fifty skiers from Roosevelt, West Seattle and Lincoln would fight for the team title. Boys competed in downhill, slalom and cross-country and girls in slalom. The annual Washington State High School ski tournament was called off since most ski areas were closed and those remaining open were too far to be practical with gasoline rationing.

Sahalie Ski Club led efforts to provide skiing for soldiers and sailors stationed in the Seattle area by bringing them to its lodge on Snoqualmie Pass and teaching them the sport:

> *The Sahalie Ski Club, which has been host to more than 200 service men at Snoqualmie Summit this season, will open its lodge to 25 Fort Lawton soldiers today. Many of the service men have never had skis on, but that won't make much difference because the Sahalie program today calls for an obstacle race in which the competition will ski on everything from barrel staves to ice skates.*

The PNSA supported the service skiing programs "in which Sahalie has taken the lead." Sahalie housed as many service skiers as could come to the Summit, but there were not enough cars to transport everyone who wanted to participate so the public was called on to help. Most servicemen had never skied or seen snow before. Skiing was also available at the Jefferson Park Recreational Camp in Seattle when there was snow. A soldier-civilian ski party was held at Snoqualmie Summit on February 10, 1943, where soldiers from McChord Field and the Jefferson Park Center could ride the Summit tow, which operated for the event. Sahalie Ski Club held a dance at the Sand Point Country Club in February to raise funds to clear trees behind the clubhouse and hosted thirty-five servicemen from all parts of the country.

On April 16, 1943, the four-story Sahalie Ski Club lodge at Snoqualmie Pass burned to the ground, the result of defective wiring on the fourth floor. The lodge, which had sleeping accommodations for eighty-five, had been

used for ski parties for servicemen during the war and would have been used as a servicemen's recreation camp the following summer. The fire resulted in a $20,000 loss, and the club had $5,000 of insurance.

Since Sahalie could no longer host servicemen, the Seattle Ski Club hill at Snoqualmie Summit was put into use. The U.S. Army Recreation Camp at Jefferson Park had 160 sets of equipment "and toggery" donated by Seattleites used each weekend by groups who wanted to go skiing. Service members were taken to the Snoqualmie Pass on army trucks. In August 1944, the Seattle Ski Club met to plan for the ski season of 1945. "As was done last year, the club again will cooperate to the fullest extent with the Army."

Skiing picked up somewhat in the winter of 1944. In February, there was a meet between the University of Washington and Washington State College at Mount Spokane, where winning honors were divided between the two schools. A benefit jumping event was held at Leavenworth, where everyone paid their own expenses and the gate went to the Camp Little Norway fund. Olaf Ulland won the Class A event, and one of his jumps was just ten feet short of Torger Torkle's hill record (and one time national mark). He landed farther down the hill than did Torkle, but heavy snow shortened the incline so no new record was set.

On October 2, 1944, The Mountaineers' lodge and caretaker's cabin on west side of Snoqulamie Pass burned to the ground when a spark from the fireplace fell on the roof. C.L. Anderson, who helped build the lodge thirty years before, "fought a lone and unsuccessful battle to save it from fire" but was injured when he fell off the roof. Only the natural rock fireplace remained. It would cost $10,000 to rebuild the lodge, and reconstruction would not be attempted until after the war.

9

Skiing Expands after
World War II, 1945–1946

The German instrument of surrender ending World War II in Europe was signed on May 7, 1945, and ratified on May 8 in Berlin. Atomic bombs were dropped on Japan in August 1945, and Japan surrendered on September 2, 1945.

Skiing resumed in anticipation of the end of the war and expanded after World War II ended as men returned from the war and the country hurried to get back to normal life. There was a pent-up demand to resume activities that were enjoyed before the war. Interest in skiing was stronger than ever, resulting in an expansion and upgrading of local ski areas.

Ski jumping continued its popularity after the war. Many of the same Norwegian jumpers competed as before the war, and new ones emerged as an influx of Scandinavian skiers began in 1947 and added new blood to the local community. The years between 1946 and 1950 featured jumping tournaments where Northwest jumpers, mainly of Norwegian descent, competed against the best jumpers of the country. The Milwaukee Ski Bowl and Sun Valley did not reopen until 1947, so local jumping tournaments took place at the Seattle Ski Club's Beaver Lake jump on Snoqualmie Summit in 1946.

The prodigious amount of snow that falls every winter on Snoqualmie Pass was a continuing concern. In 1946, a consulting engineer from New York was hired to report on the feasibility of building a tunnel through the Cascade Mountains as an all-weather crossing. Of two possible economically feasible routes, he recommended that Snoqualmie Pass be the tunnel

location instead of Stampede Pass. The Snoqualmie Pass tunnel would cost $22 million, of which $17 million could be paid by a toll at $.50 per car and driver and a $.10 for each passenger. The 1947 Washington legislature inaugurated a program of building snow sheds instead of tunnels, and by 1950, snow sheds had been built over the road at Lake Keechelus and at the airplane curve to provide protection from heavy snowfall.

1945: SKIING HOPES GROW AS WAR END IS IN SIGHT

On October 30, 1944, the *Seattle Times* published the Pacific Northwestern Ski Association tournament schedule for the winter of 1945. Since wartime restrictions were still in effect, all competitions would be "no host affairs, with titular competitors finding their way to the tournaments as best they can, and there'll be no effort to interest spectators." Without spectators, there would be no income. On February 25, 1945, Seattle's annual high school ski meet for nine public schools and Seattle Prep, O'Dea and Lakeside would be held at the Summit, and The Mountaineers' downhill and slalom race would take place at Martin. On March 4, the Seattle Ski Club's jumping and cross-country tournament was scheduled for Snoqualmie Pass.

On December 10, 1944, the *Seattle Times* published an article describing the growth of skiing in the Northwest. Seattle skiers have "spread out before them as varied and as exciting a ski terrain in the Cascades as will be found anywhere in the United States, and most of it can be tapped within a day's travel." However, "only the fringe of this vast mountain territory had been utilized.…Perhaps, in the future, when more huts are erected by clubs and Forest Service, the active skier will be able to journey back and forth over the Cascades as is now possible in Switzerland and Austria." Stevens and Snoqualmie Passes were the most popular ski areas during the war. At Stevens, the Wenatchee National Forest maintained a lodge, and a private lift had run most of the prior winter. Snoqualmie Summit had attracted most of Seattle's skiers with many privately cleared slopes, as well as "the large Snoqualmie Forest Service Ski Hill where a lift ran all winter."

Skiing had only thrived locally for around fourteen years, when all the skiers who went to the Summit knew one another, "but now one is lost in the crowd." Much of the growth of skiing could be credited to the work done by local ski clubs. The Mountaineers and the Washington Alpine Club were the first clubs to sponsor skiing. The Mountaineers' Patrol Race from

Snoqualmie to Martin "was one of the year's great competitive events." The Washington Alpine Club was composed of cross-country skiers who traveled over all the accessible slopes around the pass. The Seattle Ski Club developed ski jumping and held many thrilling tournaments at Beaver Lake. "Some of the world's most noted jumpers have soared off from this Big Hill in the various meets." The Commonwealth (Sahalie) Ski Club came next, going in for social and cross-country skiing as well as a "modified

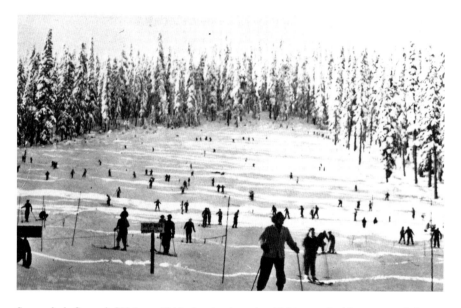

Snoqualmie Summit Ski Area, 1944, showing how the skiable area had been expanded since 1937. *Courtesy of the Moffett family.*

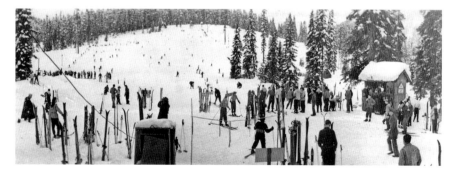

Snoqualmie Summit Ski Area, 1945, after the area was enlarged to twice its size through an extensive tree cutting program by the U.S. Forest Service in the summer of 1944. *Courtesy of the Moffett family.*

competitive program." The Washington Ski Club was responsible for the greatest growth in competitive skiing. It sponsored the Olympic trials in 1935 at Mount Rainier where Dick Durrance showed local skiers "what controlled skiing really meant." Since then, the club had hosted many tournaments in the Northwest. The Penguins were a competitive club that was building a lodge at Stevens Pass. The Huntoon Sliding and Social Club was a social organization at Mount Baker. "Marking time at present due to wartime restrictions, all of these clubs undoubtedly will expand and become stronger and more active than ever as soon as V-day arrives."

In the summer of 1944, the Snoqualmie Summit ski area had been enlarged to twice its size through an extensive tree cutting program by the Forest Service, and lights for night skiing were installed for the winter of 1945. Webb Moffett said the lights were put in so his employees would have a chance to ski after the area closed, but "it caught on with the customers, they began to enjoy it too." Moffett strung surplus degaussing tape, heavy wire that was put around ships during the war to counteract minefields, around the ski area and put up service station lights.

University of Washington Takes Over Martin Ski Dome

University of Washington *Tyee*, 1945–46, Husky Sports Club at Martin. *Courtesy of the University of Washington Special Collections.*

The University of Washington reinstituted its winter sports program for the ski season of 1944–45. The Husky Winter Sports Club (HWSC) was restarted, and on February 14, 1945, the Associated Students of the University of Washington (ASUW) bought the Martin Ski Hut and a nearby caretaker's cabin and 137 acres of land for $1,250 from Northern Pacific. Northern Pacific had spent $8,235 building the lodge and cabin to be the core of a major new ski area. Their salvage value was $1,250 in December 1944, and the railroad concluded it "would cost considerable to take it down, and the material would not be of much use to us anywhere." Gus Eriksen, the faculty advisor to the HWSC and ski coach, was

183

the moving force behind the purchase and oversaw work done at the ski area at Martin over the next few years. The lodge accommodated twenty-six but could hold fifty with improvements.

Over the next few years, the HWSC improved the Martin lodge, installed rope tows and offered ski lessons, saying Martin should "become one of the finest private resorts in the country." From the winters of 1945 to 1949, when the lodge burned down, Martin was the site where the UW ski team trained and held intercollegiate competitions, HWSC members spent weekends there and ski carnivals were held every winter.[30]

1946: WAR IS OVER, SKI AREAS EXPAND

In the fall of 1945, newspapers were filled with skiing news for the upcoming ski season. In October 1945, the *Seattle Times* sponsored an open house at Frederick and Nelson Department Store in Seattle that drew 1,200 skiers. Speakers included Dick Durrance, Harriman Cup winner and former Dartmouth University ski ace; Major John Woodward of the Mountain Troops fame; and Gretchen Kunigk Fraser, the Tacoma skier who was one of the Pacific Northwest's best skiers. Mrs. Fraser planned to teach "amputation-case vets" how to ski at Snow Basin, Utah. Durrance talked about ski techniques and equipment, and Woodward discussed fighting in Italy with the Tenth Mountain Division. Movies were shown, and representatives of ski clubs and lodges talked about their plans for the 1946 ski season.

Local skiers were disappointed that Sun Valley would not be reopened during the winter of 1946, as the Thirteenth Naval District continued to operate its convalescent center there for men suffering from wounds and combat fatigue. Dick Durrance, the country's best amateur skier in the 1930s, who had been working at Boeing Aircraft Company in Seattle, was moving to Denver, where he would make his own brand of skis, bindings, poles and edges. Durrance would not do much competitive skiing but would design and test ski equipment and get it into production. "Before I go, I'm going to try out Mount Baker, though....I've heard too much about the skiing there to pass it up."

Major improvements were planned for the Mount Baker Ski Area. $500,000 would be spent building a new one-hundred-room room lodge

and two chairlifts the following summer, and four rope tows would be in operation the winter of 1946. A new Talbot Trophy Race was scheduled for April 1946 that was expected to rival "the famed Harriman Cup races at Sun Valley and the Snow Cup competition at Alta, Utah." News at Mount Rainier was not so rosy, as the Department of the Interior announced that neither Paradise on Mount Rainier nor any other national park could be used for PNSA meets, the Silver Skis race or any other sanctioned ski competition. "Paradise Valley is finished as a competitive ski area unless the Department of Interior revises its winter-sports plan for all national parks." However, Washington State agreed to keep the road open to Paradise during the winter.

The Mountaineers installed a new high-powered rope tow at its Meany Ski Hut at Martin. The old rope tow's Fordson motor was replaced by a Chevy truck engine and transmission. "Additional clearings have been made on the club property and new runs lined up." The *American Ski Annual* of 1947 described the prior season at The Mountaineers' Martin facility:

> *The 1945–46 ski season was indicative of the great expansion in ski activities, that the end of the war made possible for the Mountaineers. Unlimited gas and a higher quota on the train helped to fill to capacity the Meany Ski Hut at Martin, Wash. Here a 1,000 foot tow and the excellent snow conditions in the cascades this winter provided many week-ends of fine skiing at the Hut.… The racing and touring activities in the first season after the war were numerous.… Keeping in step with the rest of the Northwest, the Mountaineers too, are planning additions and improvements to their facilities, with a proposed new tow at Meany and tentative plans for a new lodge at Snoqualmie Summit.*

The Husky Winter Sports Club planned to install two 1,500-foot ski lifts at Martin to carry skiers to the top of the hill south of the lodge, operated by one central engine. The lodge was expanded but could accommodate only sixty skiers after additional bunks were installed, and housing would be the club's toughest problem. The club had nine hundred members the prior winter, and even with the war still on, one thousand students "skied informally and laid post-war plans." Two thousand students were expected for the upcoming year. The HWSC became a PNSA member in the fall of 1945, and the school's ski team would compete in PNSA tournaments and intercollegiate races. A number of prominent skiers were returning to the university from military service who would be on the ski team, which

would start training in November. Its annual winter carnival would be held at Martin in February 1946. The club leased the Rustic Inn on the Sunset highway and the Sahalie ski hill, and Ken Syverson, former head of the Times Ski School at the Milwaukee Ski Bowl, taught ski classes to members using the club's best skiers as amateur instructors. The club was a nonprofit organization, and the prices of lodging, lift tickets and instruction were "calculated to fit a college budget."

John Hansen, vice president of the Husky Winter Sports Club in 1945–46, told the author that the club's lodge had been built by the Northern Pacific on the opposite side of the tracks from the Mountaineer's Meany Ski Hut. The top floor of the lodge was divided in half, with a wall separating the sleeping areas for men and women. The first thing the HWSC did was to tear down the wall, eliminating the barrier between the men's and women's areas. The lodge had railroad-type coal-burning stoves for heating and a big fireplace. Outhouses were up the hill. Students installed a rope tow using war surplus materials, hanging pulleys for the tow on trees along the ski hill. All of the work was done by the students, who had learned many skills during the war. The only available rope was sisal, which was hard to work with, and students had to learn to do a long splice to keep it operating. Coleman lanterns were hung on trees along the hill for night skiing. The university arranged for the Highway Department to clear the road from Highway 10 (later Interstate 90) to a quarter-mile walk of the lodge. Half of the students drove, and half took the train. Many taking the train drove to the East Auburn stop, since the train fare was cheaper from there than from Seattle.[31]

On February 3, 1946, the *Seattle Times* summarized the history of local skiing and the prospects for the ski season:

> *Skiing! When Paul Bunyan's blue ox "Babe" carelessly kicked up the Pacific Northwest into mountains, he made world-renowned playgrounds for skiers. With mountains virtually in our back yards, Seattleites can't help but be ski-minded. There are thousands of devotees to the sport which gives wings to the feet and to the spirit. Ski clubs are many in number and 1946, with wartime restrictions gone, promises to see an unprecedented number of skiers going to the snow-covered slopes of the Cascades and Olympics.*

The Seattle Ski Club's three-story lodge at Snoqualmie Summit would be open every day of the ski season. The hill behind the club "is excellent terrain for both accomplished skiers and beginners," and the club bought a tract of land at Beaver Lake for a mile-and-a-half downhill course that

would be ready next year. "When this is finished, the club will have facilities for schusses, downhill, slalom, and jumping unsurpassed by any in the Pacific Northwest." The club developed some of the best junior jumpers in the district and sent Olav Ulland to the national championships. The Penguin Ski Club's lodge at Stevens Pass would be completed the following year with volunteer labor, and its member Karl Stingle had been an active contender in local races.

After a four-year war-induced lapse, ski jumping competitions began in February 1946 with Leavenworth's fifteenth annual "world-famed ski jumping tournament....Crack jumpers from the Pacific Northwest and Canada" would compete on a new hill completed for the winter of 1946, rated in the three-hundred-foot jump class. Many of the jumpers who participated before the war would appear, including Olav Ulland, Earl Pietsch, Art Johnson, Ole Tverdal, Arnt Ofstad and Art Grandstom. Changes would be evident. Great Northern would no longer run special trains from Seattle and Everett, and "also gone will be the great Norwegian jumper, Torger Tokle, who was killed in Italy."

The 1946 Leavenworth tournament was won by Olav Ulland, "the high-flying Norse with steel springs in his legs," with jumps of 234 and 250 feet, who "was head and shoulders above the rest of the field in jumping form." Four thousand spectators came from as far east as Spokane and far west as Port Angeles, a crowd that was nearly prewar size. Ulland looked forward to competing at the upcoming national ski jumping contest in Colorado.

The *Seattle Times* of March 18, 1946, said, "Virtually the entire cast from the Leavenworth meet will be on hand to oust high-flying Olav Ulland...from his second Pacific Northwest title" at the Seattle Ski Club's jumping tournament at Beaver Lake. Tom Mobraaten, "the ski-jumping stylist," won the tournament with a long jump of 190 feet, beating Olav Ulland, Arnt Oftstad and Nordal Kaldahl. Ulland said over one hundred jumpers entered the tournament. "The weather again was against us and a heavy snowfall persisted throughout the day. The takeoff and landing hill became slippery and difficult. The bad weather and the hard hike up the hills kept the crowd away. Some very good jumping was exhibited in spite of the conditions....The closely fought B class jumping gave us hope for the future."

In March 1946, the University of Washington ski team "rolled over five college opponents at Martin over the week-end to cop the first postwar running of the Husky invitational meet." Dave Faires, "the Husky downhill

smoothie," won the downhill and placed second in the slalom. Washington won the tournament, followed by the University of British Columbia, Washington State College, Idaho and College of the Pacific. The slalom and downhill races were held at Martin, and the skiers jumped in the Seattle Ski Club's Beaver Lake tournament.

The *Seattle Times* of November 3, 1946, announced "New Skiing Area Planned in Cascades." Two University of Washington racers and Tenth Mountain Division veterans, Cliff Schmidike and Bill Dunaway, planned to operate a one-thousand-foot rope tow on the side of Mount Margaret, six miles east of Snoqualmie Summit. If the plan was successful, the Forest Service would clear additional land for the 1947–48 season.

Olympic Selection Tournaments Awarded to the Northwest

In February 1946, the head of the National Ski Association said skiing far in the West rated so high that Sun Valley was being considered to host the Olympic Games tryouts next winter. The association was looking at schools like the University of Washington for skiers for the Olympic Games, "for its skiers now in college who will provide most of the team we'll take to Switzerland in 1948."

In October 1946, "skiers throughout the Pacific Northwest" celebrated as the National Ski Association selected the Seattle Ski Club to host the Olympic jumping trials for the 1948 Games at the Milwaukee Ski Bowl "after spirited competition" with Steamboat Springs, Colorado; Lake Placid, New York; and Iron Mountain, Michigan. Four jumpers and two alternates would be selected for the U.S. Olympic team to compete at the 1948 Olympics at St. Moritz, Switzerland. Tryouts for the Olympic downhill and slalom teams would be held at Sun Valley, Idaho, in early March 1947, after regional competitions in Washington.

Olaf Ulland Discusses Ski Jumping in the Northwest

The challenges faced by the Washington ski clubs organized for jumping were described by Olav Ulland in an article in the *American Ski Annual*, 1947.

Ulland said the Seattle Ski Club's Beaver Lake site had an A hill good for 210-foot jumps on which the world's best jumpers had competed. It had a B hill good for 160-foot jumps and a C-hill on the side good for 90-foot

jumps. Its seven-year-old smaller practice hill was good for 70 feet, but it was abandoned after being broken by a heavy snowfall in 1945.

The Seattle Ski Club had problems keeping its jumping programs going because of the work it took to keep the jumping hills open. Over the years, there had been too few willing to work, and much of the work had been done by the "old timers...who have done a man-sized job to keep the jumping sport alive around Seattle." Many junior members had avoided doing their part of the job, which created a discord among those who worked so hard:

> *At meetings they have been told time and again how we had to swing a shovel, cut down trees and move huge rocks to build our practice jumps back in Norway and here also. But it has been in vain. The boys like to jump, but they do not want to waste half the Sunday preparing the hills.*

The jumpers from Norway were growing old, and two-thirds of the Class A competitors should have joined the seniors six to ten years ago. "The 'work horses' were dropping out of the picture and unless some easier training facilities could be brought about, the future of local ski-jumping would be jeopardized."

Milwaukee Road would reopen its Ski Bowl in 1947 and had reached an agreement with the Seattle Ski Club regarding use of the jumping hills there "for some years to come." The club would organize ski tournaments of national and international scope, as well as local divisional meets, and run a free jumping school for juniors. The club would maintain the jumping hills and hire a caretaker to keep them in shape the week around, rather than having jumpers do the work on the weekends.

The Milwaukee Ski Bowl would have four jumping hills when it reopened in 1947: a novice hill for 60-foot jumps; a C hill for jumps of 140 or 140 feet; a B hill for jumps around 200 feet; and the A hill for jumps up to 300 feet. Ulland said the area will have "the best possible practice facility for the Seattle area, and with this, ski jumping here has a great future ahead, especially with it accessible by train." "Our intentions are to build the annual meet at the Olympic Hill up to be one of the biggest in the country."[32]

10

Milwaukee Ski Bowl Reopens and Olympic Teams Are Selected, 1947

The ski season of 1946–47 was a significant one for Northwest skiing. Milwaukee Road reopened its Ski Bowl after substantial improvements were made to the ski hill, the Snoqualmie Summit Ski area was tripled in size and Sun Valley opened again. Competitions were held in the Northwest to select the U.S. ski team for the 1948 Winter Olympics in St. Moritz, Switzerland. The U.S. jumping team was selected in a tournament at the Milwaukee Ski Bowl, and the alpine team was selected at Sun Valley after preliminary contests in Washington.

1947: Major Improvements Made at Snoqualmie Pass

For the ski season of 1947, Ski Lifts Inc., under the leadership of Webb Moffett, invested $18,000 to make significant improvements to the Snoqualmie Summit Ski area, which the *Seattle Times* called "Seattle's famed near-home ski area." "Logging teams have slashed trees, bulldozers have scraped and graded, and workers have completed a drainage system for their separate ski areas.…[T]here'll be room to duck for the first time in Snoqualmie Pass history."

The skiable area at the Summit had been tripled in size by extensive clearing done in the fall of 1946, and three lifts were added for a total

of eight rope tows capable of carrying 6,500 skiers an hour. Two expert tows were constructed in the Beaver Lake area, where the terrain "is steep enough to attract any experienced skiman." The lifts on Government Hill had been lengthened and improved. "The long lines waiting for rides, so characteristic of the Snoqualmie Pass ski scene last winter, won't be repeated." A beginners' tow, formerly operated by the Seattle Ski Club, would run on the small cleared area south of the ski club's hut, and another beginners' tow would operate on the left side of Government Hill, "the big hill." An advanced tow, lengthened to 3,000 feet, would run from the base of Government Hill to the Beaver Lake trail. A beginners' tow would operate in a newly cleared area west of the advanced tow. A 30-foot-wide road was bulldozed from the top of Government Hill to Beaver Lake, and "Sno Cat" service would transport skiers to the "more rugged Beaver Lake country." A 120-foot building had been moved adjacent to the Forest Service warming hut to house a cafeteria, a ski-rental shop and a warming room. "Judging from the advance interest in skiing this year, the 2,500 skiers a week average set last winter will be boosted to 3,000 or more." An aerial photo of the Summit ski area showed the new skiing areas and tows.

Ski Lifts Inc. ran ads promoting skiing at Snoqualmie Summit in 1947. "Night Skiing, Tomorrow Night and every Wednesday and Saturday nights, 7:30 till 11 p.m. by floodlight…Only 1-hour drive from Seattle. Also dinners and refreshments at the Warming Hut. Tows also operating every day except Monday and Tuesday." Ads were run later in the year saying "Spring Skiing at its best at Snoqualmie Summit. Tows open every day of spring vacation (on other weeks every day except Monday and Tuesday). Take advantage of our private instruction."

Ski Lifts Inc., "Skiing Area at Summit Tripled," *Seattle Times*, October 23, 1945. *Courtesy of the* Seattle Times *Historical Archives.*

In the spring of 1946, the National Ski Patrol wrote to the *Seattle Times*, urging it to reopen its ski school as soon as possible because of the large number of injuries to skiers the prior season. On April 14, 1946, the paper announced that the Ski Bowl would reopen the following winter and the free Times Ski School would resume. This

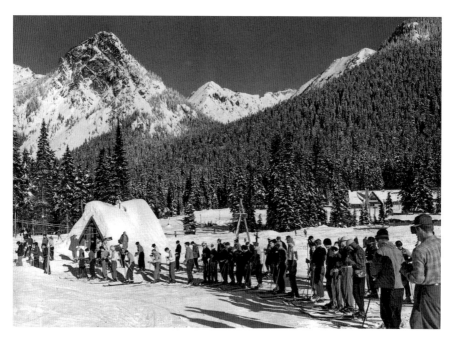

Rope tow shack and lift line at Snoqualmie Summit Ski Area, 1940s. *Courtesy of the Moffett family.*

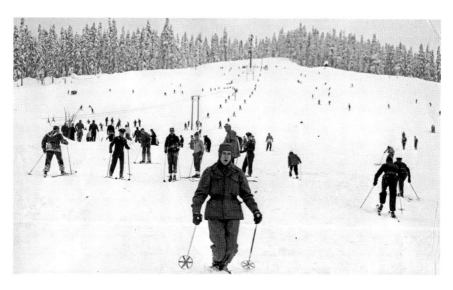

Snoqualmie Summit Ski Area, post–World War II, after the skiable area had been tripled in size by extensive clearing done in the fall of 1946 and three lifts were added for a total of eight rope tows capable of carrying 6,500 skiers an hour. *Courtesy of the Moffett family.*

would help meet the growing demand for a larger skiing area on Snoqualmie Pass and relieve the congestion that was experienced in the winter of 1946 at Snoqualmie and Stevens Passes. The Ski Bowl would have a new four-person toboggan lift to carry skiers to the top of Rocky Point, and the area would be expanded to 360 acres, opening up ski terrain west of Rocky Point to the Silver Peak Basin. Every weekend, an area would be roped off for use by the ski school. The need to resume the ski school was demonstrated the prior winter, as ski injuries "mounted on succeeding weekends." A new sixty-foot Class C jumping hill would be built next to the Class B jump so juniors could learn "basic training in snow flying." The Seattle Ski Club announced it would build a lodge at Hyak and offer free jumping lessons on Sundays to junior jumpers.

The Milwaukee Road published a newsletter in the fall of 1946, *The Skigram*, announcing improvements at the Ski Bowl:

> *During the past few months an extensive program has been carried on by The Milwaukee Road. Wide swaths of timber have been removed and the area graded to make the finest skiing area in the Pacific Northwest. New trails have been cleared of stumps, timber, rocks and general unevenness. The cleared courses vary in length from 1,200 feet to three-quarters of a mile, and offer slopes suitable for skiers of all degrees of proficiency. There is a run one mile long on the steep, open slopes up and beyond the face of Rocky Point, which towers far above the Ski Bowl. This is a highspeed thriller that will exercise the full skill of the more expert performers.*

A new company, Milwaukee Ski Lifts Inc., owned by Keith Talley and Burt Carr, was brought in as a concessionaire to install and operate new ski lifts at the Ski Bowl to replace Ben Paris Recreation, which had installed and operated the original J-bar lift. Ben Paris continued to operate the food concessions.

The first new tow designed by Keith Talley for 1947 was a four-person toboggan, as mentioned by the *Seattle Times*. Jack Corrock, father of the U.S. Olympic skier Susie Corrock Libby (winner of a bronze medal in downhill in the 1972 Games in Japan), worked at the Ski Bowl from the summer of 1946 through the spring of 1947. In an interview with the author, Corrock said Talley's four-person toboggans looked like a "Santa Claus sled" with an upturned front end, painted red with wooden floors. The sleds were connected to an overhead cable designed to go around the pulley at the top of the hill and then down the hill to its starting point. A motor at the

bottom of the hill pulled the cable and sleds. This system was tested in the fall of 1946 and was found to have problems. The sleds were constructed of a lightweight metal that bent when they went through snow; there was no shock-absorbing system to connect the sleds to the overhead cable so they started with a jerk and they could not make the turn around the pulley at the top of the hill.

Corrock said a Washington Iron Works engineer named Craney was brought in to design a new lift system, and he adapted technology utilized in mining operations. He designed, and Washington Iron Works built, a new ski lift consisting of two large sleds, each capable of carrying thirty-two persons standing up. An electric motor located at the top of the lift pulled a cable attached to the sleds, dragging one sled up the hill while the second sled attached to the other end of the cable went down the hill, which Corrock called a "push-pull system." A building was constructed at the top of the lift to house the electric motor, and for passengers to load and unload. The new system was called a Skiboggan, as it resembled a toboggan and could carry both skiers and non-skiers up and down the hill.

The Talley-Ho Skiboggan was the first high-capacity ski lift on Snoqualmie Pass, described by the *The Skigram* as a "massive sled that carries 32 snow riders a time up the steep slopes to Rocky Point," one of several new tows at the Ski Bowl.

> *The Tally-Ho Skiboggan is an innovation which is creating great comment among all ski enthusiasts. In comparing this revolutionary chair lift with others, which normally accommodate 285 people an hour, the Skiboggan will accommodate a capacity of 1,440 skiers an hour. This lift may be used by non-skiers as well, as one may ride down the lift as well as up. Non-skiers too, will be interested in the many hikes available, the comforts of the lounge, and watching the winter sports.*
>
> *In addition to this lift, there will be three other rope tows, and a sled tow pulled on a cable, the latter of which will be made accessible from the top of the Skiboggan, extending approximately 1,200 feet, developing a rise in altitude of about 400 feet, far above Rocky Point. This will make available to expert skiers an interesting run of one mile and one-half.*

The following map shows the new Skiboggan lift to the right of the ski jumps, along with three rope tows that were in operation for the winter of 1947. The rope tow on the left of the jumps took skiers above the old

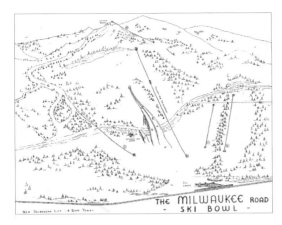

Left: A 1947 map of Milwaukee Ski Bowl showing three jumps and three rope tows. *Courtesy of Kirby Gilbert.*

Below: TallyHo Skiboggan at Milwaukee Ski Bowl. *Courtesy of Walter Page.*

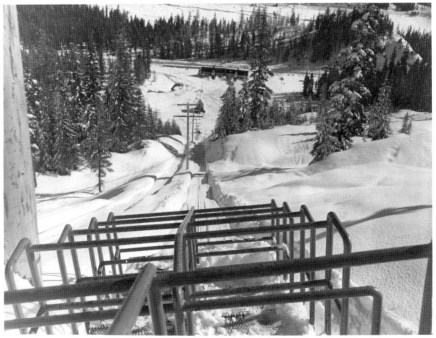

Milwaukee Road roadbed, which had been abandoned when the tunnel under Snoqualmie Pass was completed in 1914. Two rope tows on the right-hand side of the ski area replaced the J-Bar. A new rope tow is shown above the top of the Skiboggan to take skiers up to Rocky Peak for long, downhill runs.[33]

MILWAUKEE SKI BOWL REOPENS TO GREAT EXCITEMENT

On December 22, 1946, the *Seattle Times* announced that its free ski lessons at the Ski Bowl would be offered for the first time to college students as well as to high school students. Students at all eight Seattle high schools, parochial and private schools of prep ratings, University of Washington, Seattle College and other colleges were eligible to enroll to learn controlled skiing from Ken Syverson:

> *The pupils will learn correct snowplow, stem-turn and racing technique from many instructors who are veterans of previous Times schools and others who served with the far-famed Tenth Mountain Division in Kiska and Italy. At the end of eight weeks some of the young skiers will be hard to distinguish from the instructors as they burn down the big hill from Rocky Point at the Ski Bowl.*

Skiers would not recognize the Ski Bowl since it had a "face lifting." New runs had been cut through the timber tripling the skiable area, rope tows had been installed and "the revolutionary toboggan-type lift had been built." The lodge had been remodeled and improved with new waxing rooms available. The *Times* published pictures of Syverson demonstrating the steps to advance from the beginner's classification to intermediate or advanced status, which included doing a kick turn, the snowplow, the side slip and the downhill or straight running position. Syverson was critical of new ski techniques used elsewhere, saying, "The parallel technique never will be adopted in the Northwest because its not suited for deep-snow skiing."

Special Seattle Transit System ski coaches "will cover every district in the city to haul skiers to Union Station for the Milwaukee Road's snow trains each Saturday morning this winter." Skiers would have to get up early, as the buses left the terminal at 5:30 a.m. for their routes, arriving at the train station at 6:40 a.m. The fare was ten cents.

The *Seattle Times* of January 4, 1947, reported, "Students Jam Station as Train Departs" for opening day. "Union Station was packed to capacity with grinning, cheering and in some cases anxious high school and college students" for the first ski train since the winter of 1942, "and it took a long time and a lot of work to unsnarl the traffic jam caused in the vicinity of the station by the cars in which friends and relatives had brought the school participants to the train." Ski patrolmen were "wearing grins a mile wide" as ski classes resumed, which "will remove skiing once and for all

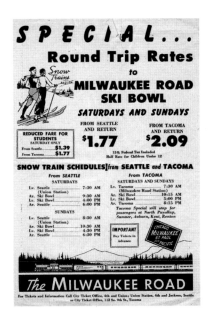

Milwaukee Road ad for Milwaukee Ski Bowl, *Seattle Times*, January 5, 1947. *Courtesy of the* Seattle Times Historical Archives.

from the ranks of hazardous sports in this area." Ken Syverson's instructors stressed the importance of controlled skiing to the 2,000 new students, the biggest crowd in the history of the *Seattle Times*–sponsored ski lessons and one of the biggest ever to invade the bowl. The skiers traveled there on four special ski trains that cost $1.77 from Seattle and $2.09 from Tacoma. Milwaukee Road ads said the Ski Bowl was "bigger and better than ever," featuring the "Tally-Ho Skiboggan Chair Lift" and a mile and a half run above Rocky Point. The Ski Bowl's opening Saturday attracted 2,856 people, who filled seventy-nine coaches on the four trains (three from Seattle and one from Tacoma). On Sunday, one train went to the Ski Bowl, for a total of 4,030 skiers participating on opening weekend.

Seattle Ski Club's Olav Ulland would coach high school and college jumpers on a specially prepared Class C hill designed for sixty-five- to seventy-five-foot jumps. Ulland stressed, "We want to develop jumpers here who will eventually be able to compete on even terms with the best the European countries can offer….And we can do just that by holding these jumping classes." Classes would be held on Sundays for eight consecutive weeks "and the ski club will have at least two of its ski stars on hand each Sunday, including tournament days."

The Skiboggan was not ready for opening day but began its operations on February 8, 1947, when sunshine and superb skiing conditions attracted 1,651 skiers to the Ski Bowl. Jack Corrock said the new ski lift was not tested before the opening ceremonies when various dignitaries rode it, causing nervous moments. The large sleds initially did not stay in their tracks and would be pulled off the vertical, so employees were stationed along the uphill track to push the sleds back in line. Once grooves were dug into the snow, the sleds could go uphill on their own.

A group of railroad and skiing officials took the Skiboggan's maiden trip. "And then, being sissies, they rode down again, but not until they enjoyed a

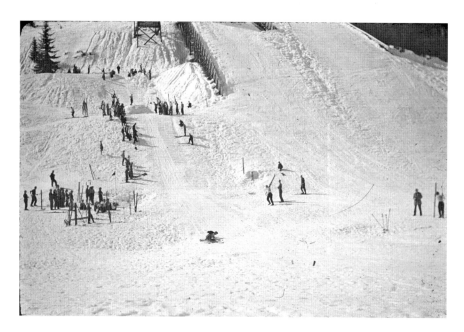

Jumper falling after going off a Class C jump at Milwaukee Ski Bowl. *Courtesy of the Milwaukee Road Historical Association.*

panorama of some 20 ski classes scattered over the spacious terrain of the bowl." Once they gave their stamp of approval to the lift, it started taking skiers up 1,800 feet to an elevation 725 feet above the bottom of the bowl, "and they started cavorting down in glee." Even though the lift did not start up until after noon, it carried more than seven hundred better skiers the 1,800 feet toward Rocky Point, where they enjoyed longer downhill runs.

The *American Ski Annual,* 1947, discussed the reopening of the Ski Bowl. To avoid confusion with the Snoqualmie Ski Area, its original name, the Snoqualmie Ski Bowl, was changed to the Milwaukee Road Ski Bowl. "A three-year plan of development now under way will make it one of the largest skiing areas in the United States. The initial program contemplates the clearing of approximately 360 acres of skiing terrain, of which about half will be completed this year, barring unforeseen difficulties." The new lift, called a Skiboggan, would open up new territory. A pass for all lifts on week days cost $1.50 and $2.00 on the weekends. A rope tow pass cost $1.00. Single ride tickets were $0.10.

The area's three-year plan included building a half-mile-long toboggan run adjacent to the ski lodge with a four-hundred-foot drop in elevation; an eight-mile ski lane to Bandera from the top of Rocky Point, where ski

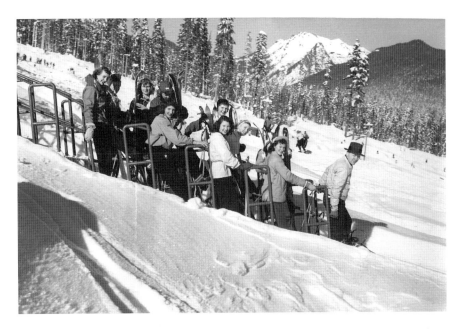

TallyHo Skiboggan carrying passengers down the hill at Milwaukee Ski Bowl. *Courtesy of Walter Page.*

trains would pick up skiers to return to Seattle; and snow cat skiing from the top of Rocky Point to the top of Silver Peak. There were no overnight accommodations, but ski trains were to run every two or three hours from Seattle and Tacoma, allowing people to "ski at the most novel ski resort" and stay in their favorite hotels elsewhere. Special trains would be run for groups of 250 or more.

During the first weekend of February 1947, good weather brought 11,500 skiers to local areas, the largest crowd of the season. Mount Rainier had the biggest crowd of 2,800, followed by Stevens Pass with 2,500, Snoqualmie Pass with 2,000, Mount Baker 1,600, Milwaukee Ski Bowl 1,500 and Chinook Pass 750.

The Ski Bowl's season closed with 8,000 people coming to watch tryouts for the U.S. jumping team for the 1948 Olympic Games. The end of the 1947 ski season was celebrated by a "gala finale" dinner on board the Milwaukee Road's "crack Olympian train." "Tables groaned under the weight of turkey dinners and ski school trophies during the celebration," which was attended by the Seattle Council of the PTA, the Seattle Chamber of Commerce, Milwaukee Road officials, ski instructors and students. The top 19 students out of the 4,250 who took lessons received trophies.

OTHER SKI NEWS

The *American Ski Annual*, 1947, described the reopening of Sun Valley in December 1946. The "world-famous year 'round resort" of Sun Valley, "arranged by bountiful nature and glorified by man's handiwork...nestled in a sun-splashed valley of the Sawtooth Mountains amongst the choicest skiing peaks of this range" would reopen and offer "every need for perfect vacation living." The fifth annual intercollegiate ski meet would be its first event in late December, followed by the International Downhill and Slalom Championships, the Sun Valley International Open, the National Four-Event Combined Championship and other races that would attract "the greatest performers on skis from all over the world." Ski lessons would be available in the Friedl Pfeifer Ski School, and Learn to Ski Weeks, begun in 1940, would continue. The Baldy Mountain lift was the longest in the world with a length of 11,500 feet, and all of the area's ski runs were designed by "outstanding ski experts of Europe and America....Sun Valley, the skier's paradise, promises the sports lover every item for full vacation enjoyment. Perfect ski conditions coupled with metropolitan luxuries of the resort cover every taste for energetic sport or complete relaxation."

In February 1947, a ski carnival was held at Martin in conjunction with the Northwest intercollegiate races. The Husky ski team competed against racers from Idaho, Washington State, College of Puget Sound, Whitman, Oregon and University of British Columbia in downhill, slalom, cross-country and jumping. A ski queen was selected who had to "know how to ski to qualify for her crown." The 1947 *Tyee*, the University of Washington student annual, said, "The ski year of 1946–47 will be remembered in Husky Winter Sports Club history as one of new additions, improvements and general hard work."

On September 11, 1947, Webb Moffett purchased all other outstanding shares of Ski Lifts for $15,000 and became sole owner of the company. Webb and his family eventually expanded the company's operations so it owned all four ski areas on Snoqualmie Pass.

U.S. OLYMPIC TEAMS ARE SELECTED, THREE NORTHWEST STARS MAKE THE U.S. ALPINE OLYMPIC TEAM, JUMPING TEAM IS SELECTED AT THE SKI BOWL

The U.S. Alpine team for the 1948 Olympic Games at St. Moritz, Switzerland was selected at tryouts in Sun Valley on March 8 and 9, 1947, where the sixty-two top ranking Americans competed, and in the Harriman Cup Races that followed. Five Washington skiers were part of the twenty men and ten women who qualified for the final selection race: Gretchen Kunigk Fraser, Don Amick, Jack Nagel, Dave Faires and Paul Gilbreath. On March 18, 1947, the *Seattle Times* boasted, "11 Western Stars in U.S. Line-up." Two Washington skiers made the Olympic team, Gretchen Fraser and Dave Faires, who was one of five alternates on the men's team. Fourteen-year-old Andrea Mead of Rutland, Vermont, a high school freshman who was "by far the outstanding entrant in the trials," finished second to Gretchen. The team remained in Sun Valley for two weeks of spring skiing and training, after which, according to Gretchen's biographer, the women were "told to get physically fit on their own over the summer and admonished…not to wear high heels…so our Achilles tendons wouldn't get short."[34]

Although Don Amick was not initially named to the Olympic team, the *Seattle Times* of October 12, 1947, announced that Amick, "the veteran Washington Ski Club speedster," was named to the U.S. Olympic downhill and slalom team. Gretchen Fraser was named the ski team's no. 1 skier and captain of the women's team. Dr. Edmund H. Smith of Seattle was the surgeon for the Olympic winter sports teams.

Jumpers for the 1948 Olympic team were selected after competing in three tournaments in Washington: one at Leavenworth in January, a pre-Olympic meet (the Northwest Jumping Championships) at the Milwaukee Ski Bowl on February 16 and trials held at the Ski Bowl on March 22 and 23, 1947. The three events brought the country's best jumpers to the Northwest to compete. "Jumping trials become little Olympics."

More than five thousand fans watched the Leavenworth tournament in January. Art Granstrom from the Everett Ski Club won the tournament, edging out Olav Ulland, the defending champion, with jumps of 237 and 234 feet. Art Devlin, one of the top hopes for the 1948 Olympic Games, jumped a "breathtaking" 286 feet, which would have been a new hill record, since it was 13 feet longer than Tokle's jump of 273 feet in 1941. However, he fell on the landing so it did not count. Devlin wrenched his

knee and would have to stay off his skis for at least two months, keeping him from the national championships at Ishpeming, Michigan, and the famed Holmenkollen meet in Norway on March 15. The knee injury would not keep him off the Olympic team, however, since the rules were elastic enough to provide for that kind of emergency.

On February 16, 1947, the Seattle Ski Club hosted the PNSA Jumping Championships at the Milwaukee Ski Bowl "that will qualify Northwest skiers for the Olympics." Three thousand spectators saw Michigan's Joe Perrault win and boost his Olympic Games stock by making two spectacular jumps. Torger Tokle, who held the hill record and was killed in World War II, was remembered in a simple ceremony in which skiers placed a wreath of flowers over crossed skies at the 288-foot mark on the hill. Perrault had been coached by Tokle when both served in the Tenth Mountain Division. Tom Mobraaten, who was on the Canadian 1936 Olympic team, took second.

On March 22 and 23, 1947, the final tryouts for the jumping team for the 1948 Olympic Games were held at the Milwaukee Ski Bowl. "Skiing's last fling will be its best, as never before has a jumping event comparable to the one that will compete in the Olympic Games tournament today at the Snow Bowl." The Seattle Ski Club promised that "one of the best jumping fields ever assembled in the history of Northwest skiing" would compete on the "giant Olympian hill." An expected crowd of six thousand would ride special snow trains to the Ski Bowl.

Arnold Kongsgarrd, "the spring-legged Norwegian flyer who left a German concentration camp a short two winters ago, boomed 294 feet in an exhibition jump," exceeding the late Torger Tokle's American record by 6 feet. However, the jump was not official, as it was not made during a competition. Joe Perrault from Ishpeming, Michigan, finished first in the competition. Six jumpers were selected to the U.S. Olympic team after the event, the first five finishers, plus Art Devlin, who injured his knee at the Leavenworth tournament but earned his berth "with flossy jumping" in other events. Those selected include Joe Perrault, Sverre Fredheim, Gordon Wren and Ralph and Walter Bietila. After the competition, the jumpers left for Sun Valley for two weeks of intensive training. Alf Engen, the co-coach of the U.S. ski team, strapped on his jumping skis to try the hill for the first time since the war, and "the old master" flew 260 feet. This tournament closed the Milwaukee Ski Bowl for the year.

Gustav Raaum was a member of the Norwegian Ski Team that came to the Milwaukee Bowl in 1947 to perform an exhibition before the jumping

tournament. Raaum was an outstanding young ski jumper who won "the famed Holmenkollen junior event last year."

Encouraged by Olaf Ulland and others, Raaum stayed to attend the University of Washington, where he led its jumping team for several years. He won the NCAA national title in 1947 and 1950, the Pacific Northwest Class A title in 1948 and 1950 and the national Class A title in 1956. Raaum became a mainstay of Northwest ski jumping and wrote a short history about the sport, *Scandinavians' Influence in the History of Ski Jumping in the Northwest.* Raaum encouraged other Norwegian jumpers to attend UW, and this was the beginning of the recruitment of Norwegian jumpers and cross-country skiers by many Northwest schools. Raaum worked in the ski industry for much of his life and was inducted into the U.S. Ski and Snowboard Hall of Fame in 1980 and the Northwest Ski Hall of Fame in 1990.[35]

Milwaukee Ski Bowl Hosts National Jumping Championships; Gretchen Fraser Wins Olympic Medals; and Ski Bowl Burns Down and Closes, Ending a Skiing Era, 1948–1950

1948: SKI AREAS EXPAND, GRETCHEN FRASER IS STAR AT WINTER OLYMPICS, NATIONAL JUMPING CHAMPIONSHIPS HELD AT SKI BOWL

In October 1947, the Pacific Northwestern Ski Association scheduled a record thirty-two tournaments for the upcoming ski season. The Mountaineers built a lodge on seventy-seven acres of land between Ski Acres and Snoqualmie Summit ski areas to replace the one lost by fire during World War II, using volunteer labor from 160 members.

The *Seattle Times* of August 15, 1947, discussed the improvements that had been made to the Milwaukee Ski Bowl in the summer of 1947 in "More Room at Ski Bowl, New Tows Will Reach Additional Area." Milwaukee Road had done "an extensive summer clearing and grading program" where more than fifty thousand skiers "sped down the snow-covered slopes the prior winter." Three new rope tows had been installed for the winter of 1948, which opened

a complete new ski area for veteran and intermediate runners high above the Ski Bowl's famed runs on its big hill. The new tows will carry skiers 200 feet beyond the top of Rocky Point, which is at the 4,000 foot level, assuring snowflyers of good, dry snow during the entire Ski Bowl season.

The Skiboggan, which carried skiers from the foot of the main jumping hill to above the jumpers' take-off hut, was

> *improved and reconditioned to carry capacity loads....And the new ski runs sweeping down from Rocky Point together with the cleared beginners' area near the lodge, will offer a total of 300 acres of ski area for snow-burners next winter. The tows will handle up to 7,700 skiers an hour...so we're looking for the biggest season yet.*

The Ski Bowl had eight rope tows for the winter of 1948, in addition to the Skiboggan, as shown by the map here. One new tow at the top of the mountain took skiers past Rocky Point into the valley beyond, and another new rope tow began behind the lodge that connected with rope tows going beyond the old railroad grade east of the lodge. A third rope tow was added on the west side of the lodge where the J-Bar had been.

The *Seattle Times* of December 14, 1947, announced that it extended its free ski lessons into King County to reach sixteen high schools. This expansion was made possible by additional clearing and grading at the Ski Bowl and the availability of more Pacific Northwest Ski Association instructors. To relieve congestion at Union Station caused by parents dropping their children off for lessons, the Seattle Transit System would accept skiers and their equipment on city buses on the weekend and holidays if the points on their ski poles were ground off.

At the Snoqualmie Summit Ski Area, the main hill had been doubled in length, and an extensive land clearing program had opened "a vast new area," with a new tow installed high on Government Hill to take skiers

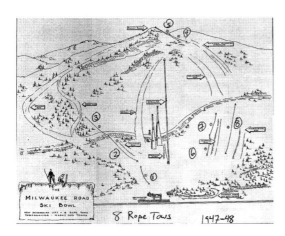

A 1948 map of Milwaukee Ski Bowl showing eight rope tows. *Courtesy of Kirby Gilbert.*

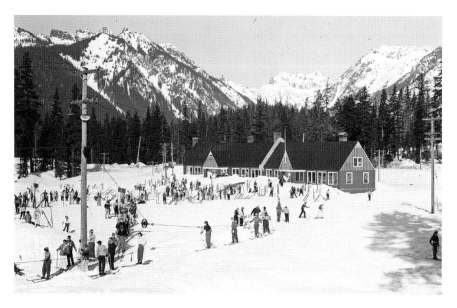

Lodge and rope tow at Milwaukee Ski Bowl, 1947. *Courtesy of the Milwaukee Road Historical Association.*

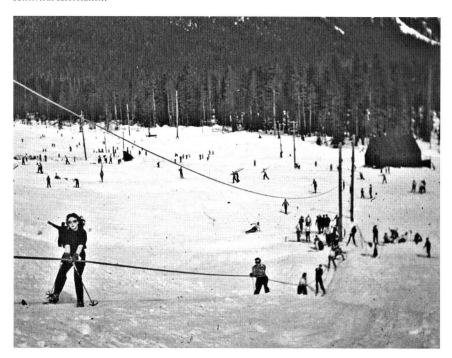

Woman riding the rope tow at Milwaukee Ski Bowl, 1947. *Courtesy of the Milwaukee Road Historical Association.*

HUSKY WINTER SPORTS CLUB
1947-48

University of Washington *Tyee*,
1948–49, Husky Sports Club at Martin.
*Courtesy of the University of Washington
Special Collections.*

to the Beaver Lake runs. Its slopes had been bulldozed "to a new smoothness so a light snowfall will enable winter-sports enthusiasts to ski earlier in the season than ever before." A sledding area was created for children, along with a bobsled course where one-man bobsleds would be available with two steep runs on hills away from the ski area. Seven tows would operate: three for beginners, one for intermediates and three for advanced skiers. Night skiing would take place Wednesdays using floodlights.

The Husky Winter Sports Club improved its lodge and ski hill at Martin for 1948. Members built a tow house for the main tow, which was lengthened, and installed a more powerful motor that would run at 750 feet a minute and handle six or more people at once. Floodlights were installed on the main ski slope for night skiing so "[y]ou can read a newspaper at the bottom of the hill." A microphone system was installed "capable of broadcasting both music and voice over a large part of the Martin ski area," which would "provide skiers with professional yodeling and sweet music." The lodge could sleep 120, compared to 42 the prior year. Mattresses and pillows were provided, but guests had to furnish sleeping bags. New plumbing facilities were installed to provide ample hot water for new shower rooms, the kitchen and wash rooms. The prior year water was heated on the stove. [36]

The University of Washington ski team won the Northwest Intercollegiate Ski Championship in mid-February 1948 with downhill and slalom events at Martin and the jumping events at Beaver Lake. It also won the Northern Division Pacific Coast Conference meet in March, "thanks to a strong showing in…the jumping event."

1948 Winter Olympic Games in St. Moritz

The winter Olympic Games in St. Moritz, Switzerland, the first held since 1936, were the year's big ski story. There was substantial interest in the Northwest as three local skiers were on the U.S. team: Gretchen Kunigk Fraser, Don Amick and David Faires. Europeans were expected to win the skiing events, but training the U.S. team received on Sun Valley's long runs prepared them to compete on equal terms with the Europeans.

Tacoma native Gretchen Kunigk Fraser was the "unexpected heroine" of the Games, winning a gold medal in the special slalom and silver in the alpine combined, in spite of facing adversity. She was the first U.S. athlete to win any medal in the Winter Olympics. The special slalom was held on a freezing-cold day and on an icy course. Gretchen was first to start, the most difficult position in a ski race. Gretchen won the first run and was first to start again in the second run. The electronic timing system being used for the first time malfunctioned, and Gretchen had to wait for seventeen minutes before she could race, most of the time standing in the starting gate. Undeterred, Gretchen skied with the "relaxed smoothness and awesome power that was her trademark" and had a "beautifully thought-out run."[37]

Otto Lang, who covered the Olympics as a special correspondent for the *Seattle Times*, said, "Little Gretchen is toast of American skiers and cheered by them whenever they gather in St. Moritz tonight....It was a turning point in American skiing—an historic achievement, considering the field of international competitors." "Europeans were stunned," according to Gretchen's biographer. "Americans were not supposed to win medals in alpine skiing." Lang said the U.S. men failed to live up to the country's hopes and did not win a medal. "Technically American racers were virtually equal to their opponents, but they lack in experience and cunning of frequent big-time competitions, and also need to master the art of 'waxing.'" Fifteen-year-old Andrea Mead was three seconds ahead of the field at mid-course in the downhill but took a bad fall and did not finish, although she came back to win gold medals in slalom and giant slalom events in the 1952 Olympics at age nineteen.

"Americans fell short in the special ski jump won by Pete Hugsted of Norway and dominated by Europeans," where Norwegians finished one-two-three. Hugsted's leap of seventy meters was just nineteen feet short of Birger Ruud's Olympic record set in 1932. Birger Ruud, a coach of the Norwegian team, decided to compete in the jumping event and placed second, winning a silver medal. Even though he had won Olympic gold in 1932 and 1936,

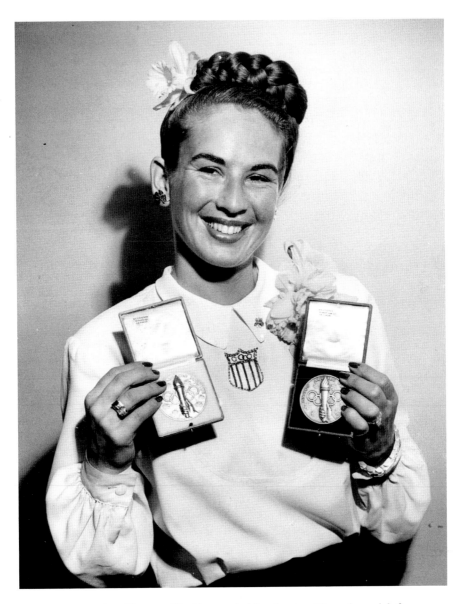

Gretchen Fraser from Tacoma, Washington, holding her two Olympic medals from the 1948 Games at St. Moritz, Switzerland (gold in the special slalom and silver in the alpine combined). She was the first U.S. athlete to win any medal in the Olympic Winter Games. She was called "unexpected heroine" of the games, who "stunned" European skiers as "Americans were not supposed to win medals in alpine skiing." *Courtesy of the Tacoma Public Library.*

Ruud said his silver medal in 1948 was his greatest Olympic achievement. Gordon Wren from Winter Park, Colorado, "flew off the runway with the best of the great Northerners" and kept up with Hugsted's length of jumps, but could not match his "impeccable style in the air." He placed fifth, the first time an American male ever scored a point in an Olympic ski event. Sverre Friedheim of St. Paul, Minnesota, placed eleventh in the jumping event; Paul Perrault of Ishpeming, Michigan, finished fifteenth; and Walter Bietila of Iron Mountain, Michigan fell. Wren and Bietila were inducted into the U.S. Ski and Snowboard Hall of Fame in 1958 and 1965. Walter Bietila was a member of three U.S. Olympic jumping teams (1936, 1940 and 1948).

Gretchen Kunigk Fraser is honored for her Olympic achievements at Sun Valley with a ski run (Gretchen's Gold on Seattle Ridge); a bronze statue at the base of the area's Warm Springs run; and at the large Olympian display at the Washington State Ski and Snowboard Museum, which has a replica of her gold medal and other memorabilia. She was inducted into the U.S. Ski and Snowboard Hall of Fame in 1960, and her husband, Don, was inducted in 1972. Both Frasers were inducted into the Northwest Hall of Fame in 1987.[38]

THE MILWAUKEE ROAD SKI BOWL, SEATTLE
SPONSORED BY SEATTLE SKI CLUB
MARCH 6th AND 7th, 1948

Milwaukee Road poster for 1948 National Championships at Milwaukee Ski Bowl. *Courtesy of the Milwaukee Road Historical Society.*

National Jumping Championships Are Held at Ski Bowl

In early March 1948, the Milwaukee Ski Bowl was the site of the National Jumping Championships, the country's biggest tournament of the year. The winner would receive the Torger Tokle Memorial Trophy, the "most coveted ski trophy in the nation," given by the Norway Ski Club of New York to the National Ski Association. It was thirty-nine inches high, carved in sterling silver and valued at $1,200. The event included "three flyers" who jumped for the U.S. in the 1948 Olympics: Ralph and Walter Bietila and Joe Perrault.

One of the most terrible snowstorms of the winter swept in from the northeast, postponing the tournament until the following day, to the disappointment of three thousand "winter-

sports fans who arrived by train and car to view the annual classic." Some of the nation's top flight riders performed exhibition jumps to entertain the spectators, "but jumping was almost impossible in the face of driving snow." Arne Ulland, "the star visiting from Norway, stretched for 244 feet…just about perfect in view of the storm." On Monday, Arne Ulland, "who makes ski jumping look so easy, topped one of the best fields of American skiing" to win the national championships, with jumps of 280 and 281 feet in "near perfect form," just missing Torger Tokle's hill record:

> *Officials and the few spectators who braved showers to watch the championships sensed Ulland was hitting for distance when he sped down the inrun the second time. The Norse flyer literally flew off the hill's take-off, booming into space with a tremendous leg kick. Ulland landed easily just eight feet short of Torger Tokle's hill mark of 288 feet and roared down the inrun with near perfect form. Judges gave him top score on form.*

Walter Bietila took second, and Joe Perrault, "who captured the fancy of Seattle ski fans in the Olympic Games trials last March, racked up two 250 foot leaps," was third. Gustav Raaum, "the Norse exchange student at the University of Washington," finished sixth.

1949: Ski Bowl Improved, New Distance Record Set

The winter of 1949 had record cold temperatures and snowfall, creating challenging conditions for all Northwest ski areas. Life at Martin was particularly difficult, and Northern Pacific struggled to keep its rail line open over the mountains. The snowfall at Martin led to the postponement of the Northwest Intercollegiate Ski Union Championships scheduled for the last weekend of February 1949. Unfortunately, word of the cancellation did not get to all of the competitors, and teams from Washington State and Montana showed up. UW coach Buster Campbell hastily arranged a three-way meet, with jumping at Beaver Lake on Snoqualmie Summit and a cross-country race and slalom at Martin.

The University of Washington winter sports program changed abruptly when the Husky Winter Sports Club's lodge at Martin burned down after the ski season of 1949. Beginning in 1950, the club's activities took place on Stevens Pass.[39]

Milwaukee Ski Bowl Is Improved

The Milwaukee Road improved its Ski Bowl for the 1948–49 season. Special railroad crews worked overtime for two months in the summer of 1948 to brush and grade new areas for beginning, intermediate and advanced skiers. A teaching area was prepared for Ken Syverson's ski classes. An area to the right of the Skiboggan's base was graded so intermediate and advanced skiers had additional runs. A racing trail was prepared from the top of the Skiboggan to the foot of High Speed Lane. Skiers would find "plenty of newly smoothed terrain." The Milwaukee Road planned to give the area a facelift each summer "until enough area is cleared to assure beginning, intermediate, advanced and racing flyers of runs of their choice." Four trains would bring skiers to the ski lessons provided by the *Seattle Times*, three from Seattle and one from Tacoma. Milwaukee Road ads promoted skiing at the Ski Bowl:

> *Again a brilliant new season of snow sport thrills at your favorite winter playground—reached swiftly, smoothly, safely, by Milwaukee Road Snow Trains! A skier's Paradise—eight rope tows, two 32-passenger Skiboggens serve every sporting run in the fast Ski Bowl area. Controlled skiing taught by crack instructors. Waxing rooms, ski rentals, and all-day meal and snack service in the Big Alpine Lodge. Breakfast at home—enjoy a full day of snow sports—then home in time for dinner. Note very low round-trip fares.*

Round-trip fares for students were $1.39 and $1.77 for adults: "No highway worries when we ride the Snow Trains! Off after breakfast—lunch at the Lodge—home for dinner after a full day of grand Ski sport in our favorite winter playground!" "The Snow Trains Are Rolling Again," announced *Milwaukee Magazine* in February 1949.

John Woodward, "one of the all-time ski greats in the Pacific Northwest," was hired to head the racing section of the Times Ski School:

> *Woodward, a veteran of mountain warfare during the Second World War with the far-famed Tenth Mountain Division in Italy, will be in charge of all racing activities for the seventh edition of the school, which will get under way January 8. Woodward is one of the really outstanding ski instructors in the United States....His addition to our already experienced group of instructors means even better ski teaching in our school.*

The racing program would feature plenty of high-speed work under Woodward's expert tutelage on the Milwaukee Road's famed High Speed Lane.

On the Ski Bowl's opening day, four ski trains took 2,500 ski enthusiasts from Union Station in Seattle and Milwaukee Station in Tacoma to the Ski Bowl. The Times Ski School, co-sponsored by the Seattle PTA, "the largest of its kind in the world," was ready for its students. Attendance was up 30 percent over opening day of 1948.

New American Jumping Record Is Set at Milwaukee Ski Bowl

The winter of 1949 was an exciting one for ski jumping, with Norwegian exchange students attending Northwest schools competing against local jumpers and Norwegians living elsewhere in the United States.

In January 1949, the Milwaukee Ski Bowl was the site for the Pacific Northwestern Ski Association's jumping tournament. The Milwaukee Road offered special trains to the event costing $2.67 for adults and $1.39 for children, including admission. Parking would be provided along the highway, and tickets could be purchased for $1.40. Kongsberg, Norway, a town that had turned out some of the world's best jumpers in the past twenty years, was well represented by Petter Hugsted, Olympic gold medal winner; Sverre Kongsgarrd; Tom Mobraaten; Kjell Stordalen; Olav Ulland; and tournament judges Hjalmar Hvam, Rolf Dokka, Howard Dalsbo and Earl Little.

Sverre Kongsgaard, "the high-flying Norwegian ski ace enrolled at the University of Idaho," soared to a new North American distance record of 290 feet, beating Torger Tokle's 288-foot record set there in 1941 and his subsequent record of 289 feet set in 1942, at Iron Mountain, Michigan. Sverre was a cousin of Arnhold Kongsgaard, who set a new mark of 291 feet at the Ski Bowl two years before, which did not count since it was not in competition. Kongsgaard flew "over crown of the hill for what seemed minutes until his grooved runners smacked the snow near the bottom of the landing." However, the tournament was won on form points by Georg Thrane, a Norwegian exchange student at Washington State College, despite a lack of practice that season. Petter Hugsted of Norway, the 1948 Olympic jumping champion, "was great...but try as he might, he couldn't match Thrane," and he placed second. Kongsgaard finished third, Arthur Tokle (Torger's brother) finished fourth and Gustav Raaum finished sixth.

The victory meant a great deal to Thrane since he had been removed from Norway's jumping team at the 1948 Olympic Games and replaced by Hugsted, who won the gold medal. Thrane "mastered the art of floating for great distances....He seems motionless in the air until his skis slapped in the snow in a perfect telemark landing," according to the *Seattle Times*, January 31, 1949.

In March 1949, the Seattle Ski Club hosted an Invitational National Championship Classic Combined tournament, consisting of cross-country and jumping events that attracted eighty stars, the "best ski field ever gathered together in the Pacific Northwest." The cross-country race was on Snoqualmie Summit and the jumping at the Ski Bowl.

A week before the Seattle Ski Club meet, Kongsgaard's record was broken, as a new American distance record of 297 feet was set at the Pine Mountain jump at Iron Mountain, Michigan, by Joe Perrault, "the flying Frenchman from Ishpeming, Michigan....In fact, the [Milwaukee Ski] bowl record of 290 feet was smashed five times that afternoon." The Milwaukee Road ad for the tournament listed the "daring cloudbusters" who would defy gravity: Joe Perrault; Sverre Kongsgaard; Petter Hugsted of Norway, the world's champion jumper; Art Devlin; Gordon Wren; Gustav Raaum; Olav Ulland; and others. "That's why the patrons of Pine Mountain will have jumping dreams or maybe a nightmare Sunday night."

A stiff crosswind affected the jumping at the tournament, and Petter Hugsted was forced to "give one of the best displays of bad-weather jumping in Milwaukee Ski Bowl history," as he edged out Georg Thrane in the jumping portion of the combined. The Norse star "settled a feud" by beating Thrane, who had beaten him in late January on the hill. Art Devlin of Lake Placid, New York, was third; Joe Perrault, the new North American distance record holder, was fourth; and the UW's Gustav Raaum was fifth. Ralph Townsend from the University of New Hampshire won the national combined championship.

1950: Ski Bowl Is Improved but Burns Down in December 1949 and Closes in Spring 1950

The Milwaukee Road spent $25,000 to $30,000 improving the Ski Bowl for the ski season of 1950, anticipating a landmark year. On August 28, 1949, the *Seattle Times* published pictures of giant bulldozers working on the

ski hill. Stumps were removed with fifteen sticks of dynamite ("although larger ones required a double dose"), and small stumps were scooped out by bulldozers:

> *And what a face-lifting the Ski Bowl has had for the Ski School Season! Giant bulldozers have worked on Ski Bowl runs since early summer, improving beginning and intermediate areas and preparing a new run for advanced and racing-class skiers. The newly developed run, to the far right of the Ski Bowl, winds down from well above the old railroad grade. And a new tow has been installed by Milwaukee Ski Lifts to provide speedy uphill transportation for young runners. Too, a trail has been cut from the tip of the Skiboggan Lift so skiers can swing down to the new run from the Skiboggan. The Ski Bowl has been developed as a ski resort for skiers of all abilities....We have slopes for beginning, intermediate, advanced and racing flyers the equal of any in the Cascades.*

The Seattle Ski Club was considering seeking sponsorship of the 1951 National Jumping Championships at the Milwaukee Ski Bowl in conjunction with Seattle's centennial celebration. The club expected a fight, as eastern ski clubs thought that too many title events had been held in the West the past couple of years.

For the second year, complimentary lessons from the *Seattle Times* were open to college students. The president of the University Winter Sports Club said that a number of skiers would be taking the lessons in controlled skiing. Ski students would learn the All-American system developed by Ken Syverson for use in the deep, heavy snows of the high Cascades. Fares on the ski trains were $1.39 for students and $1.77 for adults.

The *Seattle Times* of December 28, 1949, said that a new ski resort, Ski Acres, opened three-quarters of a mile east of the Snoqualmie Summit. It was operated by Don Deering and Ray Tanner on 350 acres of land that Tanner purchased from Northern Pacific Railroad. It featured the first chairlift on the pass and two rope tows. The *Seattle Post Intelligencer* offered ski lessons at Ski Acres, in competition with the *Seattle Times* ski lessons that had been offered at the Milwaukee Ski Bowl since 1938. Ray Tanner said when the area first opened, they were fortunate to have 200 to 300 people skiing there, although the ski school on weekends drew between 1,200 to 1,400 skiers. An Osborn and Ulland Sports Store ad in the *Seattle Times* of November 6, 1949, said it operated "two ski stores strategically located at the two most popular ski areas in the Northwest, Stevens Pass

and Snoqualmie Pass (Ski Acres) and offer the same complete service as we do in town, plus a complete line of accessories at city prices."

In November 1949, the *Seattle Post Intelligencer* published a map of Washington ski areas, with an article describing Ski Acres:

> *A ski terrain that is increasing rapidly in popularity is Ski Acres which is only three-quarters of a mile east of Snoqualmie Pass. It is here that the Post-Intelligencer and the Parent-Teacher's Association are co-sponsoring a ski school which will be held each Saturday during the season under the skilled instruction of Bob Albouy, a famous ski teacher. The children are taken to the area in Greyhound buses. The terrain is equipped with a chair lift, one-half mile in length that is supplemented by tow rope tows. This excellent terrain is operated by Don Deering and Ray Tanner. It is only 50 miles from Seattle and has an area of 300 acres. It is open to the public on week-ends, Sundays and holidays.*

The map showed ski areas at Stevens Pass, Ski Acres, Mount Baker, Snoqualmie Pass, Leavenworth, Chinook Pass, Cayuse Pass, Tipsoo Lake Area, American River, Blewett Pass, Deer Park on the Olympic Peninsula, Spirit Lake at Mount St. Helens and Toll Gate in southwest Washington.

During the first weekend of February 1950, there were 3,275 skiers at Snoqualmie Summit, 1,375 at Stevens Pass and 600 at Ski Acres. The 1950 Northwest Intercollegiate Ski Union Championships were held at Ski Acres and Snoqualmie Summit in March 1950, where twelve colleges competed with 6-man teams in a four-way meet. Slalom and giant slalom races were held at Ski Acres, and Snoqualmie Summit hosted the cross-country and jumping events.

Tragedy Strikes as Milwaukee Ski Bowl Lodge Burns Down in December 1949

The improvements to the Milwaukee Ski Bowl hill in the summer and fall of 1949 came to naught. On December 1, 1949, tragedy struck, as the Milwaukee Ski Bowl Lodge caught fire and burned to the ground. On December 2, 1949, a *Seattle Times* headline read, "Fire Razes Ski Bowl Lodge; Loss $180,000; Two Story Structure Burns Fast." The lodge was being readied for the ski season when the fire started in the recreation room "of the large rambling, Alpine-style frame structure" at 1:45 a.m., and it

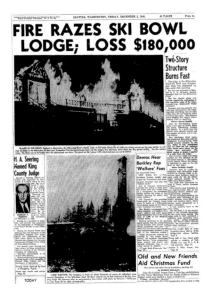

Milwaukee Ski Bowl, "Fire Razes Ski Bowl Lodge," *Seattle Times*, December 2, 1949. *Courtesy of the* Seattle Times *Historical Archives.*

spread rapidly. Two painters reported things were fine when they left at 9:00 p.m. Calls for firefighting equipment went out to North Bend, Ellensburg, Cle Elum, Yakima and Seattle, but the structure was a roaring inferno by the time they arrived.

All that remained were the chimneys for the lodge's kitchen, main lobby fireplace and heating plant, which were dynamited along with half of the four-hundred-foot passenger-loading platform as a safety precaution. The lodge was located sixty-two miles from Seattle and had contained a cafeteria, a large recreation room, restrooms, a ski-equipment shop, a ski patrol office, a first-aid station, ski instructors' quarters and other facilities. Milwaukee Road officials were stunned by the loss and would determine what facilities could be made ready for the ski school that year, which had enrolled three thousand students. The railroad had recently spent thousands to make the area the "best all around ski center in the state." The *Times* published pictures of the ski lodge in flames captioned "doomed to destruction" and another of the lodge's chimney.

A temporary solution for the winter was quickly found. In the *Seattle Times* of December 7, 1949, the Milwaukee Road announced it would operate the Ski Bowl despite the loss of the lodge. Temporary facilities would be built near the site of the lodge with a spur track to the lodge site for kitchen and dining cars. A ski train would be used as a "warming hut." All ski tows, including the popular Skiboggan, would be in operation by opening day, January 7, 1950. The *Times* concluded that the railroad contemplated the permanent operation of the Ski Bowl and the construction of a modern lodge to replace the one destroyed by fire. There would be space for two hundred skiers taking paper-sponsored ski lessons.

On January 6, 1950, the *Seattle Times* praised the Milwaukee Road's actions to keep the area operating in a piece titled "Community Grateful for Such Real Service":

On December 2, the railroad's $180,000 lodge at the Ski Bowl near Lake Keechelus burned to the ground. Recognizing the responsibility to continue to provide safe transportation to one of the state's best all-around ski areas… officials of that railroad promptly announced plans for temporary facilities to accommodate the hundreds of young ski enthusiasts of Seattle and King County who had planned to attend The Times Ski School.…

The burning of the Milwaukee Road's lodge at the Ski Bowl last month would have interrupted the ski school this season if the railroad had not decided immediately to provide temporary facilities to replace it.…In helping thus to assure another season of safer skiing for the collegiate and high school skiers of Seattle and King County, the Milwaukee and its officials have earned again the appreciation and gratitude of this community.

The *Milwaukee Magazine* of February 1950 said that "in response to interest from the *Seattle Times* and the Seattle PTA," the Ski Bowl opened on January 7, 1950, with a crowd of 2,400 "wildly enthusiastic young skiers, despite the fact that the large Ski Bowl Lodge had been completely destroyed by fire in December." Operations were "back near normal." However, the Ski Bowl faced another problem: too much snow. "Record-breaking snowstorms which even brought the unfamiliar sight of heavy snow into Seattle itself, laid a white mattress more than 10 feet thick over the Bowl… and kept skiers at home a few weekends." The Ski Bowl was looking for one of its most successful years.

Skiing continued through the winter of 1950, using the temporary facilities. Thirty ski instructors taught the usual number of students the fundamentals of controlled skiing under the supervision of Ken Syverson. The All-City downhill and slalom races were held there in early March 1950. "Maestro Ken Syverson's corps of 30 instructors centered action on racing techniques by having their pupils run though slalom gates to give those inexperienced in racing a chance to gain confidence for the coming tournament." The Seattle Ski Club's 1950 jumping tournament at the Ski Bowl attracted an outstanding field of Class A, B and senior skybusters, including Gustav Raaum, Gunner Sunde, Reidar and Olav Ulland, Kjell Stordalen and others, who "will match distances off towering Olympian Hill, famed Ski Bowl jumping slope."

In spite of the optimism expressed after the fire, the Milwaukee Road announced in September 1950 that it would not reopen the Ski Bowl. A letter from John P. Kiley, Milwaukee Road president, explained the decision in the *Seattle Times* on September 13, 1950:

We have been very proud of the fact that the Milwaukee Road Ski Bowl has become an integral part of life in Seattle, Tacoma and a dozen or more other communities. Our company had put a lot of time, money and energy into the building and operation of the Ski Bowl….In return, we have enjoyed the active support from your newspaper with its popular Ski School [and many others in the community]. *We have decided to suspend operation of the Milwaukee Road Ski Bowl at Hyak. Our directors have concluded that we cannot justifiably continue in this operation….*

To replace [the lodge and train shed destroyed by fire] *would cost about $125,000. Our engineers estimate that to build less elaborate but adequate facilities will cost at least $75,000. Unless we provide these new facilities, there is always the risk, anytime during the season, that a large number of people, youngsters and grownups alike, might be marooned at the Bowl without shelter in case of a heavy snowstorm. Furthermore, we feel that committing ourselves now to new construction of this type when the world outlook is so uncertain might be construed as an unjustified use of materials which may be needed urgently elsewhere….*

It may come as a surprise to many people that the Milwaukee Road has been taking substantial financial losses in running the Ski Bowl. As much as we would like to keep the Ski Bowl in operation, we cannot afford to do so.

Because of the Korean War, rail traffic to Pacific ports had increased greatly, and more equipment and rail personnel would be diverted to the war effort in the future. The Milwaukee Road offered to work with any responsible organization that wished to take over the Ski Bowl.

The *Seattle Times* offered financial aid to the Milwaukee Road to help rebuild the ski lodge but was forced to cancel its ski school when a rebuilding program could not be worked out. "Times Regrets Abandoning Ski School" announced the paper on September 14, 1950. Its ski school operated from 1939 through 1942 and from 1947 through 1949 and taught over twenty thousand students the fundamentals of controlled skiing. PTA and school officials expressed regret that the ski lessons had come to an end. No organization stepped forward to operate the Ski Bowl, and the area remained unused until 1959, when the Hyak Ski Area was opened nearby.

The May 1950 *Milwaukee Magazine* reported that the Ski Bowl fire was the railroad's largest fire loss of the year, causing a total loss of $190,000. The

fire burned the lodge and show shed as well as a diesel switch engine ($23,000), seven older-type passenger cars ($15,800) and $10,000 of freight cars.

Milwaukee Railroad later faced financial difficulties and got out of passenger service. The last Milwaukee Road passenger train passed through the Snoqualmie Tunnel in 1961, the company filed for bankruptcy in 1977 and the last freight train used the Snoqualmie Pass line in 1980. The Milwaukee Road right of way, including the Snoqualmie Tunnel, was acquired by Washington State for a trail and is now open to foot traffic, bicycles and horses as the John Wayne Pioneer Trail, part of Iron Horse State Park.[40]

The closing of the Milwaukee Ski Bowl ended an era in Washington skiing. The most successful modern alpine area in the state was lost, as was the ski jumping facility that rivaled any in the world, where national championships were held, Olympic teams were selected and multiple national distance records were set. Although skiing continued to grow in the 1950s and the '60s, it took many years before skiing in Washington recovered from this loss.

12

Overview of Skiing after 1950

ALPINE SKI AREAS ON SNOQUALMIE PASS EXPAND
AND NEW ONES OPEN

In 1952, a poma lift was installed at the Snoqualmie Summit Ski Area, replacing its original rope tow. In 1955, the first double chairlift on Snoqualmie was installed there, the Thunderbird, along with the Thunderbird Lodge on the top of the highest hill in the ski area.

In 1959, the Hyak Ski Corporation purchased land immediately north of where the Milwaukee Ski Bowl had been located and began operating a new ski area called Hyak. In 1967, a new ski resort named Alpental opened north of the Snoqualmie Summit Ski Area, the fourth ski area on Snoqualmie pass. In 1977, the Hyak Ski Corporation ran into financial trouble, and a lawsuit over a 1972 ski lift accident that left a fourteen-year-old skier with permanent damage sent the company into bankruptcy.

In 1980, Ski Lifts Inc., owned by the Webb Moffett family, purchased the Ski Acres area from Ray Tanner and operated it in conjunction with the Summit ski area. That same year, Hyak was purchased by Pac West, which operated it until filing bankruptcy in 1988. Pac West was one of the few ski resorts in the Northwest to allow snowboarding, along with the Mount Baker ski area. In 1983, Alpental was sold to Ski Lifts Inc. In 1992, the Hyak ski area was sold out of bankruptcy court to Ski Lifts Inc., giving the company control of all four Snoqualmie Pass ski areas. In

1997, Ski Lifts Inc. was sold to Booth Creek Holdings, and the ski areas were renamed the Summit at Snoqualmie, with each area given a new name: Summit West, Summit Central, Summit East and Alpental at the Summit. In 1998, Booth Creek purchased the ski areas from Ski Lifts Inc., and in 2007, the company sold all four areas to CNL Investment Properties. Booth Creek signed a management agreement with CNL. On September 19, 2007, the management of the Snoqualmie Pass ski areas was sold to Boyne USA.

Alpine skiing grew as other Washington ski areas expanded or were started in the 1950s and '60s. Major investments were made at Stevens Pass, Mount Baker, Hurricane Ridge (opened in 1957), Mission Ridge (opened in 1962), Crystal Mountain (opened in 1962), White Pass, Mount Spokane, 40 Degrees North, Badger Mountain, Bluewood and elsewhere as skiing became more popular. The one exception was Mount Rainier, one of Washington's original ski areas, where National Park Service policies discouraged development and organized skiing died. The Silver Skis race was run in 1947 and 1948 but never regained its luster and was not run again.

Crystal Mountain Ski Area opened in 1962, not far from the Sunrise Entrance to Mount Rainier National Park. In 1965, it hosted the National Alpine Championships, attracting the best American and Europeans skiers, including Jean Claude Killy, Jimmie Heuga and Billy Kidd. The ski area was later acquired by Boyne USA and significant investments made there. [41]

SKI JUMPING CONTINUES
AT LEAVENWORTH AND ELSEWHERE

Although the loss of the Milwaukee Ski Bowl and its Olympic-caliber jumps represented the end of an era for ski jumping, the sport continued at Leavenworth, Snoqualmie Pass and elsewhere until the 1970s. Seattle-area ski jumpers played significant roles in Olympic games in the 1950s and '60s. However, interest in ski jumping had died off by the 1970s.

Leavenworth had a series of glory years until the 1970s, hosting national ski jumping tournaments and seeing several national distance records set. Hermod and Magnus Bakke, who emigrated from Norway in the early 1930s, worked for decades with the Leavenworth Winter Sports Club, competing, coaching, helping to build ski jumping facilities and organizing

meets. Both were inducted into the U.S. Ski and Snowboard Hall of Fame in 1972 and into the Northwest Ski Hall of Fame in 1990. Longtime Leavenworth official Earl B. Little was also inducted into the U.S. Ski and Snowboard Hall of Fame in 1972.

In 1954, "a hardy group of Norwegian ski jumpers" led by Olav Ulland, Gustav Raaum and others left the Seattle Ski Club and formed the Kongsberger Ski Club to promote ski jumping. The name came from Kongsberg, the town in Norway that produced the country's best ski jumpers. Club members built a ski jump and warming hut at Cabin Creek eleven miles east of Snoqualmie Pass. The club held jumping competitions, provided ski jumping instruction and assisted with jumping competitions at several Winter Olympic Games and international competitions. Northwest colleges included ski jumping as part of their ski team events, attracting Norwegian exchange skiers who dominated local ski jumping for several decades, and high schools had jumping programs.

In 1955, Ragnar Ulland, Olav Ulland's seventeen-year-old nephew, a student at Roosevelt High School in Seattle, won the junior National Leavenworth Tournament, becoming the national junior class ski jumping champion with jumps of 252 and 256 feet. He had a jump of 296 feet in practice, which was the unofficial hill record. Ragnar was on the 1956 U.S. Olympic Jumping Team coached by his uncle Olav and went to Cortina, Italy, where he was hurt in practice and did not compete in the Games.

In 1956, Olav Ulland was coach of the U.S. Ski Jumping Team for the Olympic Games at Cortina, Italy. In 1958, he was coach of the U.S. Jumping Team at the World Championships in Finland, and Gustav Raaum was the team manager.

In 1960, the Kongsberger Ski Club ran the jumping events at the Squaw Valley Olympic Games. Northwesterners who participated included Olav Ulland (chief of competition), Gustav Raaum (assistant chief of competition), Corey Gustaffsson (chief of hill), Magnus Bakke (measurer), Hermod Bakke, John Berg and John Ring. Ski jumping was the highlight of the Squaw Valley Olympics. Gus Raaum helped plot Squaw Valley's eighty-meter jumping hill and said the jumps should be "very good," as the critical point was nearer to ninety meters, so jumpers should be able to go for good distance. Ski jumping was the "grand finale" of the Games. "It is the glamour spectacle of the frigid frolics. More kibitzers will throng Squaw Valley to watch it than any other event in the 11-day Games....Like Icarus of the myth, we all want to fly. The jumper nearly makes it. Each strives to soar farther in perfection than the other."

At the 1980 winter Olympics at Lake Placid, New York, Gustav Raaum was chief of competition and Olav Ulland and Magnus Bakke were measurers.[42]

The Leavenworth Winter Sports Club continued to host ski jumping tournaments until the late 1970s, including national championship tournaments in 1959, 1967, 1974 and 1978. Between 1965 and 1970, three North American distance records were set on Bakke Hill. In 1965, Toralf Engan (who won a gold medal at the 1964 Olympics) set a new record of 324 feet. In 1967, at the International and National Championship Tournament, Bjorn Wirkola (who held the world record in ski-flying) jumped 335 feet, beating the record held by John Blafanz from Illinois, who also competed at the tournament. In 1970, Gene Swor from Minnesota jumped 340 feet, setting the third national record at Leavenworth in five years.

In 1972, the Leavenworth Winter Sports Club hosted the tryouts for the U.S. jumping team for the 1972 Olympic Games in Sapporo, Japan. Ron Steele, a Leavenworth High School graduate, turned the tournament "into a dream day for himself and his hometown" by clinching the number two spot on the Olympic team after soaring 285 feet, becoming its youngest member. Steele placed forty-first in the Olympic jumping competition.

Interest in ski jumping in North America began to flag in the 1960s and fell off significantly in the 1970s. Declining interest in ski jumping in the United States coupled with money problems led to the end of national ski jumping tournaments at Leavenworth in 1978. The Kongsberger Ski Club also faced decline in interest in ski jumping. In 1974, the club celebrated its twentieth anniversary. The club had seventy-four members, but Olav Ulland complained, "Interest in ski jumping has faded, and the scaffold had fallen down and the original dream of the founders did not materialize. Due to the change of times we were probably trying to do something that could not be accomplished." The organization became a cross-country facility and continued operations into the 1990s.

The 1975 Leavenworth Jumping Classic was canceled when conflicts with other tournaments resulted in a lack of competitors. In 1976, Leavenworth canceled the North American Ski Jumping Championships because of lack of snow. The 1977 tournament was also canceled, and the Leavenworth Winter Sports Club mourned, "The traditional Leavenworth event—it dates back to 1929—now has been called off three straight years because of a lack of snow, unavailability of competitors or both." The last Leavenworth ski jumping tournament took place in 1978, a National Championship Tournament that took place in difficult conditions. On February 6, 1978,

the *Seattle Times* reported, "Bassette wins ski-jumping title despite fog, mist, rain." National jumping tournaments were not held at Leavenworth thereafter due to the lack of top-caliber jumpers and money to make the needed improvements to the hill. "Bakke Hill, lacking the funds to be re-contoured to meet the revised USSA requirements, shut down after hosting the US Nationals in the 1978 season....Leavenworth's closing marked the end of United States' West Coast major jumping competitions."

Though the Leavenworth Winter Sports Club was still going strong, tournaments declined in the 1970s with the construction of newer and larger ski jumps throughout the country in places such as Steamboat Springs, Colorado and Iron Mountain Springs in Michigan. The ski club tried to resurrect interest with the planned construction of two new ski jumping hills from 1986 to 1988, but unfortunately, this did not repeat the popularity of the old days.[43]

In 1982, the *New York Times* discussed the decline of interest in ski jumping:

But in the United States, ski jumpers, clad in their distinctive skin-tight synthetic finery, appear to be heading for the endangered species of sports, going the way of gladiators and jousting knights. While the popularity of cross-country skiing has soared in the last decade, interest in the other Nordic skiing sport, jumping, has nosedived, and now its struggling to hold its own....Last year, the National Collegiate Athletic Association dropped ski jumping as a national championship sport and as a sport that counted toward team standings in the national championships.

In May 2006, The Mountaineers' rustic three-story lodge on Snoqualmie Pass burned down. The lodge had been built by club labor in 1948 on seventy-seven acres of land between the Snoqualmie Summit and Ski Acres ski areas. The property remained vacant and was sold in 2016 to Boyne Properties, which manages the Summit at Snoqualmie Ski Complex. The purchase permitted a connection between the Summit West and Summit Central ski areas. It would also allow relocation of the Pacific Crest Trail.

On February 8, 2014, The Mountaineers held its first Patrol Race since 1941. The race was coordinated by Nigel Steere, whose grandparents were involved with The Mountaineer's Meany Ski Hut at Martin in the early 1930s. Nine three-man teams and one two-man team (whose third member

was unable to race because of an injury) started at ten-minute intervals from the base of the chairlifts at Summit West, between 6:00 a.m. and 8:00 a.m. A three-woman team entered, but only one woman finished, Anne Brink. She tagged along with the Wenatchee team near the end. She is thought to be the first woman to complete the route during a formal race. The club plans to run more Patrol Races in the future if there is sufficient snow.[44]

July 2013: Ski Museum Visit to the Old Milwaukee Ski Bowl Site at Hyak

Milwaukee Ski Lifts Inc., the operator of the ski lifts at the Milwaukee Ski Bowl, left much of its equipment on the Ski Bowl hill when it shut down operations after the spring of 1950, where some of it remains today.

The following pictures were taken by the author during a trip to the old Milwaukee Ski Bowl site by those involved in planning the Washington State Ski and Snowboard Museum in July 2013. We found pilings for the

Milwaukee Ski Bowl site, July 2013, Matt Broze inspecting abandoned motor for rope tow. *Author photo.*

Left: Milwaukee Ski Bowl site, July 2013, abandoned rope tow wheel in tree. *Author photo*.

Below: Milwaukee Ski Bowl site, July 2013, footings for warming hut at top of Skiboggan lift and cable for lift. *Author photo*.

Milwaukee Ski Bowl site, July 2013, John Lundin and Kirby Gilbert inspecting remnants of sled tow. *Author photo.*

foundation of the Olympic Ski Jump tower on which the judges stood next to the Olympic jump and pilings for the Class A and B jumps. We also found a large amount of equipment on the hill, including the electric motor that drove one of rope tows on the east side of the Ski Bowl and a wheel attached to a tree over which the rope ran.

Other pictures show the wreckage of the building that was at the top of the Skiboggan lift, which was built for the 1946–47 ski season, abandoned cable and remnants of the sleds that were used as part of the lift system.

Notes

Introduction

1. "Facts: Cold, Icy and Arctic," Athropolis, accessed July 17, 2017, http://www.athropolis.com/arctic-facts/fact-baker.htm; Borak, "Chicago, Milwaukee and St. Paul Railroad: Recent History of the Last Transcontinental," 87, 88, 96; Lundin and Lundin, "Milwaukee Ski Bowl, 1938–1950: Revolution in Local Skiing"; "I-90 Snoqualmie Pass East—History," Washington State Department of Transportation, accessed July 17, 2017, https://www.wsdot.wa.gov/Projects/I90/SnoqualmiePassEast/History.htm; Johnson, "Evolution of Interstate 90 Between Seattle and Missoula"; Ott, "Sunset Highway"; Pacific Northwest Ski Areas Association, "Northwest Winter Sports Industry Overview, 2014–2015," 2, 3; Briceno and Schundler, *Economic Analysis of Outdoor Recreation in Washington State*, 68, 69; Hill, "Does the Future of Skiing Look Like Plastic?"

Chapter 1

2. "A Short History of Ski Jumping," Winter Sport, accessed July 17, 2017, http://library.la84.org/OlympicInformationCenter/OlympicReview/1994/ore315/ORE315w.pdf; Anson, *Jumping through Time*, 15, 17–22, 27, 28, 33; Helgerud, "Are Norwegian Americans 'Born on Skis?'," 23; Skoog, "Written in the Snows, A Far White Country."
3. Materials about and pictures of the Cle Elum Ski Club came from the John "Syke" Bresco collection, courtesy of the Maybo family of Cle Elum, and from an article by Sue Lichfield, "When the World Came

to Cle Elum," *NKC Tribune*, February 16, 2012 (page A10). The Bresko collection is now at the James E. Brooks Library at Central Washington University in Ellensburg, Washington. Also see Lundin and Lundin, "Cle Elum Ski Club, 1921–1933"; Prater, *Snoqualmie Pass*; Kershner, "Cle Elum–Thumbnail History."

4. Prater, *Snoqualmie Pass*, 129–31; Wormington, *Ski Race*, 317; Litchfield, "When the World Came to Cle Elum"; Lundin and Lundin, "Cle Elum Ski Club, 1921–1933."

5. Lundin and Lundin, "Cle Elum Ski Club, 1921–1933"; Roe, *Stevens Pass*, 128–32; Raaum, "Scandinavian Influence on Northwest Skiing"; Anson, *Jumping through Time*, 142–44.

Chapter 2

6. "The I-90 Skier, Alpental, Ski Acres, Snoqualmie," 11, an October 1967 advertising brochure put out by Ski Lifts Inc. to advertise skiing issues on Snoqualmie Pass, Moffett family collection.

7. Galvin, "Ski Racing and the PNSA from the 1930s to the '50s."

Chapter 3

8. Kjeldsen, *The Mountaineers*, 11–13, 39–43, 80–83, 85, 68; Lundin, "Skiing at Martin, the Northern Pacific Stop at Stampede Pass," "Mountaineers Patrol Races at Snoqualmie Pass: A Grand Tradition Revisited"; Ball, "Story of Meany Ski Hut," 55; "Washington Ski Lodge a Step Back in Time," *Tacoma News Tribune*, March 10, 2013; "Women Can Ski Expertly as Men, Milady Advised to Desert Tea Table for Snowy Slopes," *Seattle Times*, March 12, 1930, 21.

9. "I-90 Skier," 12; Kinnick, *Snoqualmie Pass*, 32.

10. Kjeldsen, *The Mountaineers*, 82; Gilbert, "Anderson & Thompson Ski Company Was Ski Industry Pioneer"; Lund, "Timeline of Important Ski History Dates."

11. Lundin and Lundin, "Seattle's Municipal Ski Park at Snoqualmie Summit (1934–1940)." The Seattle Municipal Photo Archives has pictures from the Municipal Ski Park.

12. Alpenglow Ski Mountaineering History Project.

13. Lundin and Lundin, "Cle Elum Ski Club, 1921–1933"; Lichfield, "When the World Came to Cle Elum."

14. Lang, *Bird of Passage*, 106, 107; Galvin, "Silver Skis Races on Mount Rainier"; Skoog, "Silver Skis Race."

Chapter 4

15. Clifford, "Tacoma Ski Queens"; Pfeifer, *Gretchen's Gold*, 9.
16. Pfeifer, *Gretchen's Gold*, 9–10.
17. "1936 Winter Olympics," Colorado Ski & Snowboard Museum, http://www.skimuseum.net/pdf/1936-52.pdf; Lundin, "Washington Skiers in the 1936 and 1948 Winter Olympics"; Little, "Leavenworth Sports Area."
18. Lundin, "Mountaineers Patrol Races at Snoqualmie Pass."
19. Lang, *Bird of Passage*, 128.
20. Seattle Municipal Archives, 5801-02, box 23, folder 14 and 5801–01, box 44, folder 3.
21. Files regarding the Seattle Municipal Ski Park and Ski Lift Inc's rope tow are in the Seattle Municipal Archives, Don Sherwood Parks History Collection (5801-01) and the Ben Evans Recreation Program Collection (5801-02). Also see Lundin, "Ski Lifts Inc. and the First Northwest Rope Tows."
22. Hellyer, *At the Forest Edge*, 185.
23. Lang, *Bird of Passage*, 145–46; Lucas, *Ancient Skiers of the Northwest*, 53, 54; Seattle Municipal Archives.

Chapter 6

24. "Snoqualmie Ski Bowl," *American Ski Annual 1938–1939*, 218; Gruber, "Snow Train Parade."
25. Lundin, "Skiing at Martin"; Proctor, "Northwest Ski Guide." Documents relating to the Martin Ski Lodge are found in the Northern Pacific Archives, Minneapolis, Minnesota.
26. Lundin, "Washington Skiers in the 1936 and 1948 Winter Olympics"; "1940 U.S. Ski Team Squad," *American Ski Annual 1939–1940*, 104.

Chapter 7

27. Skoog, "Legend of Sigurd Hall"; Lundin, "Sigurd Hall."

Chapter 8

28. Huston, "There Are No Wet Blankets at Snoqualmie"; Moffett, "Brief History of Skiing in the Northwest."
29. Skoog, "Mountain Scrapbook."

Chapter 9

30. "Nature Determined the Best Routes for a Cascade Tunnel," *Seattle Times*, August 3, 1958, 8; Lundin, "Skiing at Martin"; *University of Washington Daily*, February 1, 1945.
31. Lundin, "Skiing at Martin"; Hanson, interview.
32. Ulland, "Seattle Ski Club Jumping."

Chapter 10

33. Lundin and Lundin, "Milwaukee Ski Bowl, 1938–1950."
34. Pfeifer, "One and Only Gretchen."
35. Lundin, "Washington Skiers in the 1936 and 1948 Winter Olympics."

Chapter 11

36. Lundin, "Skiing at Martin."
37. Pfeifer, "One and Only Gretchen."
38. Lang, *Bird of Passage*, 269–73; Lundin, "Washington Skiers in the 1936 and 1948 Winter Olympics."
39. Lundin, "Skiing at Martin."
40. Galvin, "Railroads."

Chapter 12

41. Lundin, "Ski Lifts Inc. and the First Northwest Rope Tows."
42. Raaum, "Scandinavians' Influence in the History of Ski Jumping in the Northwest."
43. Ibid.; Kinney-Holck, *Leavenworth*, 247; Anson, *Jumping through Time*, 196.
44. Lundin, "Mountaineers Patrol Races at Snoqualmie Pass."

Bibliography

American Ski Annual. "1940 U.S. Ski Team Squad." 1939–40.

Anson, Harold. *Jumping through Time*. Florence, OR: Port Hole Publications, 2010.

Ball, Fred. "The Story of Meany Ski Hut." *Mountaineer Bulletin*, 1956. Accessed July 17, 2016. http://www.alpenglow.org/ski-history/notes/period/mtneer-a/mtneer-a-1950-59.html#mtneer-a-1956-p55.

Borak, Arthur M. "The Chicago, Milwaukee, and St. Paul Railroad: Recent History of the Last Transcontinental." *Journal of Economic and Business History* 3 (November 1930).

Briceno, T., and G. Schundler. *Economic Analysis of Outdoor Recreation in Washington State*. Tacoma, WA: Earth Economics, 2015.

Brinkley, Douglas. *Rightful Heritage: Franklin D. Roosevelt and the Land of America*. New York: HarperCollins, 2016.

Clifford, Howard. "The Tacoma Ski Queens." *American Ski Annual*, 1944. Last modified July 15, 2004. http://hyak.net/lost/skiqueens.html.

Corrock, Jack. Interview with author, October 2013.

Durrance, Dick, John Jerome, Miggs Durance and Warren Miller. *The Man on the Medal: The Life and Times of America's First Great Ski Racer*. Aspen, CO: Durrance Enterprises, 1995.

Figge, John, and Cathy Townsend. "The Cascade Episode: Evolution of the Modern Pacific Northwest." University of Washington Burke Museum. Last modified October 2002. http://www.burkemuseum.org/geo_history_wa/Cascade%20Episode.htm.

Galvin, Dave. "Early Ski Tows." Sahalie Ski Club. Last modified March 26, 2012. http://www.sahalie.org/documents/History/EarlySkiTows.pdf.

————. "The Railroads." Sahalie Ski Club. Last modified October 26, 2011. http://www.sahalie.org/documents/History/TheRailroads.pdf.

————. "Silver Skis Races on Mount Rainier." Sahalie Ski Club. Last modified February 23, 2011. http://www.sahalie.org/documents/History/SilverSkisRaces.pdf.

————. "Ski Racing and the PNSA from the 1930s to the '50s." Sahalie Ski Club. Last modified March 9, 2012. http://www.sahalie.org/documents/History/Ski%20Racing%201930s%20-%201950s.pdf.

————. "The Snoqualmie Pass Ski Lodges." Sahalie Ski Club. Last modified March 26, 2012. http://www.sahalie.org/documents/History/EarlyLodges.pdf.

Gilbert, Kirby. "Anderson & Thompson Ski Company Was Ski Industry Pioneer." *Ancient Skiers Newsletter* (Winter 2014): 2.

Gruber, John. "Snow Train Parade: Special Train Rides to Ski Resorts Helped Railroads Make Money during the Depression." *Trains Magazine*, December 19, 2011.

Hanson, John. Interview with author, March 2013.

Helgrude, Kristofer Moen. "Are Norwegian Americans 'Born on Skis?': Exploring the Role of Skiing in North America Ethnic Identity in the 1930s through the Adventures of Sigmund and Birger Ruud." Master's thesis, University of Oslo, 2013.

Hellyer, David. *At the Forest Edge: Memoir of a Physician-Naturalist*. Seattle: University of Washington Press, 2016.

Hill, Jae. "Does the Future of Skiing Look Like Plastic?" *Eye on Sun Valley*, December 3, 2016.

Horn, Huston. "There Are No Wet Blankets at Snoqualmie." *Sports Illustrated*, January 6, 1964.

Johnson, Erick. "The Evolution of Interstate 90 Between Seattle and Missoula" Eastern Washington University, October 1995, revised 2006. http://www.nwhighways.amhosting.net/intersta.html.

Kershner, Jim. "Cle Elum—Thumbnail History." HistoryLink. Last modified October 11, 2013. http://historylink.org/File/10646.

Kinney-Holck, Rose, and the Upper Valley Museum at Leavenworth. *Images of America: Leavenworth*. Charleston, SC: Arcadia Publishing, 2011.

Kinnick, John, and Chery Kinnick. *Images of America: Snoqualmie Pass*. Charleston, SC: Arcadia Publishing, 2007.

Kjeldsen, Jim. *The Mountaineers: A History*. Seattle, WA: Mountaineers, 1998.

Lang, Otto. *A Bird of Passage: The Story of My Life.* Missoula, MT: Pictorial Histories Publishing, 2004.

Litchfield, Sue. "When the World Came to Cle Elum." *NKC Tribune*, February 16, 2012.

Little, Earl. "Leavenworth Winter Sports Area." *Ski* (Winter 1936).

Lucas, Joy. *The Ancient Skiers of the Pacific Northwest.* N.p.: Ancient Skiers, 2006.

Lund, Mort. "Timeline of Important Ski History Dates." *Skiing History Magazine.* Accessed July 17, 2017. https://www.skiinghistory.org/history/timeline-important-ski-history-dates.

Lundin, John. "Mountaineers Patrol Races at Snoqualmie Pass: A Grand Tradition Revisited." HistoryLink. Last modified March 14, 2014. http://historylink.org/File/10755.

———. "Sigurd Hall—Ski Racer & Mountaineer, Northwest Four-Way Champion, A Life Tragically Ended to Soon in the Silver Skis Race on Mt. Rainier in 1940, 1910–1940." Alpenglow Gallery. Last modified October 27, 2016. http://alpenglow.org/climbing/sigurd-hall-2006/JLundin-paper-on-Sigurd-Hall-20161027.pdf.

———. "Skiing at Martin, the Northern Pacific Stop at Stampede Pass." HistoryLink. Last modified September 12, 2013. http://historylink.org/File/10615.

———. "Ski Lifts Inc. and the First Northwest Rope Tows." HistoryLink. Last modified January 19, 2014. http://historylink.org/File/10716.

———. "Washington Skiers in the 1936 and 1948 Winter Olympics." HistoryLink. Last modified May 17, 2014. http://historylink.org/File/10786.

Lundin, John, and Stephen J. Lundin. "Cle Elum Ski Club, 1921–1933." HistoryLink. Last modified August 27, 2012. http://historylink.org/File/10169.

———. "Milwaukee Ski Bowl, 1938–1950: Revolution in Local Skiing." HistoryLink. Last modified March 16, 2012. http://historylink.org/File/10060.

———. "Seattle's Municipal Ski Park at Snoqualmie Summit (1934–1940)." HistoryLink. Last modified March 29, 2013. http://historylink.org/File/10362.

Maxwell, William J. "Skiing at Snoqualmie Pass." *Ski* (Winter 1936).

McNeil, Fred H. "The Death of Sigurd Hall." *American Ski Annual*, 1940–1941, 38. Accessed July 17, 2017. http://www.alpenglow.org/ski-history/notes/period/asa/asa-1940.html#asa-1940-p38.

Milwaukee Railroad Magazine. "Ski Bowl Gets a Pair of Wings." December 1949.

Moffett, Web. "A Brief History of Skiing in the Northwest." *Puget Soundings Magazine* (December 1978): 20.

National Ski Book, 1936.

Nydin, Al. "Our Mountain Rendezvous." *Ski* (Winter 1936).

Ott, Jennifer. "Sunset Highway." HistoryLink. Last modified May 9, 2013. http://historylink.org/File/10383.

Pacific Northwest Ski Areas Association. "Northwest Winter Sports Industry Overview, 2014–2015." Accessed July 17, 2017. https://olis.leg.state. or.us/liz/2015I1/Downloads/CommitteeMeetingDocument/82898.

Pfeifer, Luanne. *Gretchen's Gold: The Story of Gretchen Fraser, America's First Gold Medalist in Olympic Skiing.* Missoula, MT: Pictorial Histories Publishing, 1996.

———. "The One and Only Gretchen." *Skiing Heritage* (Fall 1994).

Prater, Yvonne. *Snoqualmie Pass: From Indian Trails to Interstate.* Seattle, WA: Mountaineers Books, 1983.

Proctor, Gordon. "Northwest Ski Guide." *Town Crier*, December 1936, 6.

Raaum, Gustav. "Scandinavians' Influence in the History of Ski Jumping in the Northwest." Unpublished paper available at the Nordic Heritage Museum, Seattle, Washington.

Railway Age. "Snoqualmie Ski Bowl a Traffic Builder." March 26, 1938.

Roe, JoAn. *Stevens Pass: The Story of Railroading and Recreation in the North Cascades.* Caldwell, ID: Caxton Press, 2002.

Seattle Municipal Archives, Don Sherwood Parks History Collection 5801–01, and Bens Evans Recreation Program collection 5801–02, containing files regarding the Seattle Snoqualmie Ski Lift Inc's rope tow proposals for Snoqualmie Summit.

Ski Lifts Inc. Historical files. Moffett family, Mercer Island, WA.

Ski, the Northwest Winter Sports Club Edition. (Winter 1936).

Skoog, Lowell. "The Legend of Sigurd Hall." Alpenglow Gallery. Accessed July 17, 2017. http://alpenglow.org/climbing/sigurd-hall-2006/index.html.

———. "Mountain Scrapbook." Alpenglow Gallery. Accessed July 17, 2017. http://www.alpenglow.org/ski-history/notes/ms/dw-scrapbook. html#dw-scrapbook-p511.

———. "Silver Skis Race." Alpenglow Gallery. Accessed July 17, 2017. http://alpenglow.org/ski-history/subjects/S-info.html#silver-skis.

———. "Written in the Snows, Across Time in Skis in the Pacific Northwest, A Far White Country." Accessed July 17, 2017. Alpenglow Gallery. http://alpenglow.org/written-in-the-snows.

Ulland, Olav. "Seattle Ski Club Ski Jumping—Past and Present." *American Ski Annual*, 1947. Accessed July 17, 2017. http://hyak.net/lost/skijumping.html.

Wormington, Sam. *The Ski Race.* Sandpoint, ID: Selkirk Press, 1980.

Index

About the Author

John W. Lundin is a Seattle lawyer who learned to ski on Snoqualmie Pass using wooden skis, leather boots and cable bindings and riding rope tows. He was a member of Sahalie Ski Club, which began on Snoqualmie Pass in 1931, and has homes in Seattle and Sun Valley, Idaho. His mother, Margaret Odell Lundin, learned to ski on Mount Rainier and Snoqualmie Pass in the 1930s, was faculty advisor to Seattle's Queen Anne High School Ski Club from 1938 to 1941 and took her students on the ski train to the Milwaukee Ski Bowl at Hyak for free ski lessons courtesy of the *Seattle Times*. Lundin has written extensively about early skiing in Washington and the history of the Wood River Valley in Idaho, where his great-grandparents settled in 1881. He is a frequent lecturer on history topics in both states and is currently writing several other history books.